200 FAIR ISLE MOTIFS

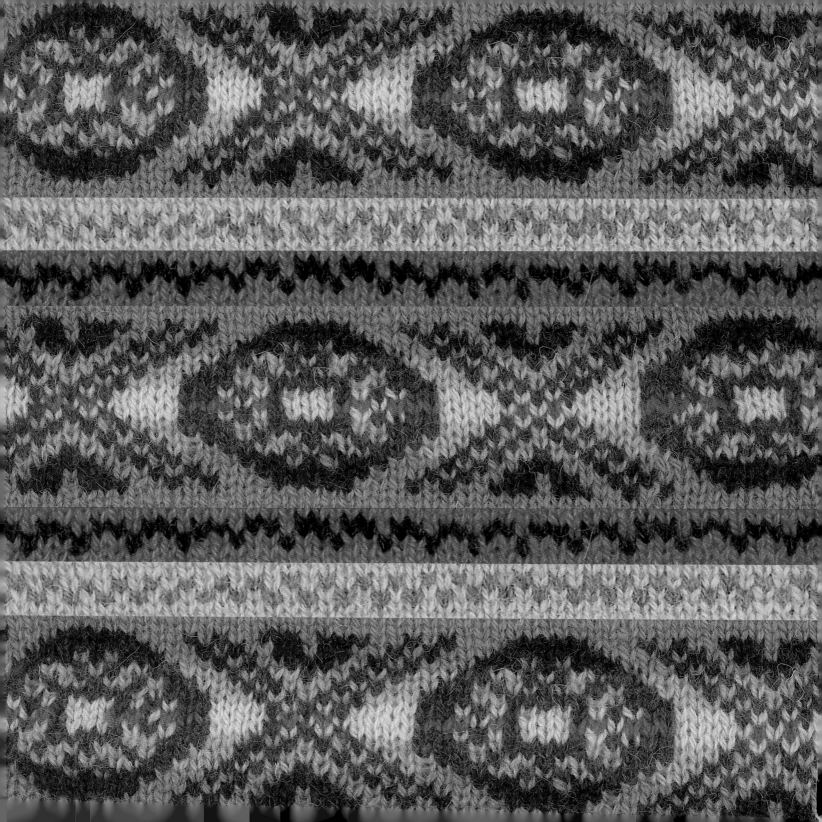

200 FAIR ISLE MOTIFS

A KNITTER'S DIRECTORY

Mary Jane Mucklestone

INTERWEAVE.
interweave.com

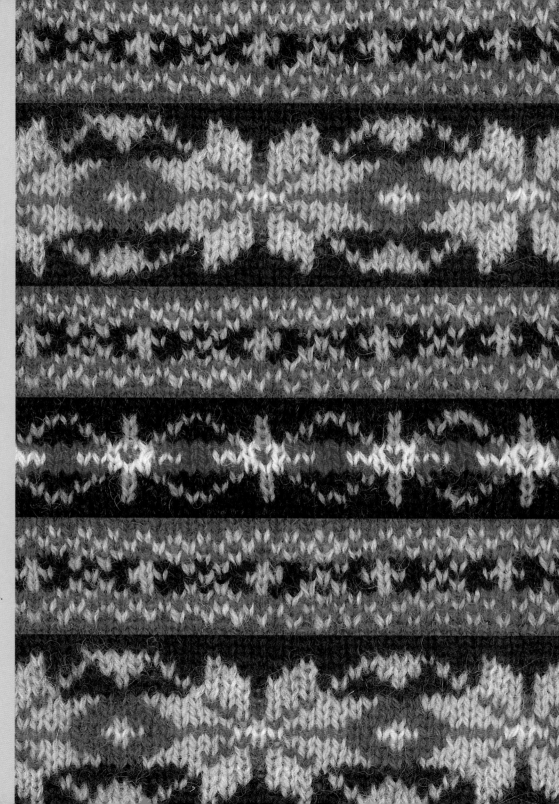

A QUARTO BOOK

Published in North America by
Interweave, a division of F+W Media, Inc
4868 Innovation Dr.
Fort Collins, CO 80525
www.interweave.com

Conceived, designed, and produced by
Quarto Publishing plc
The Old Brewery
6 Blundell Street
London N7 9BH

QUAR.FIPA

Project Editor: Victoria Lyle
Art Editor and Designer: Julie Francis
Illustrator, all charts: Luise Roberts
Illustrator, pages 36–39: Tracy Turnbull
Photographer: Phil Wilkins
Copyeditor: Sarah Hoggett
Proofreader: Lindsay Kaubi
Indexer: Helen Snaith
Art Director: Caroline Guest
Creative Director: Moira Clinch
Publisher: Paul Carslake

Library of Congress Cataloging-in-
Publication Data
Mucklestone, Mary Jane.
 200 Fair Isle motifs / Mary Jane
Mucklestone.
 p. cm.
Includes bibliographical references and
index.
ISBN 978-1-59668-437-9 (pbk.)
1. Knitting--Scotland--Fair Isle--Patterns. I.
Title. II. Title: Two hundred Fair Isle motifs.
TT819.S35M83 2011
746.43'2041--dc23
 2011025135

Color separation in Hong Kong by Modern
Age Repro House Ltd
Manufactured in China by 1010 Printing
International Ltd

10 9 8 7 6

FSC
www.fsc.org
MIX
Paper from
responsible sources
FSC® C016973

CONTENTS

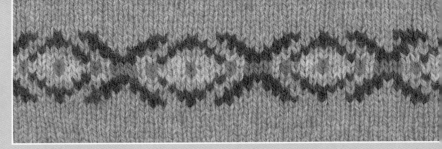

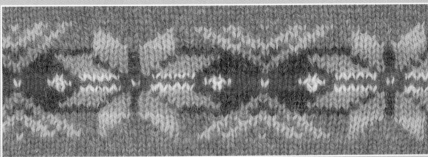

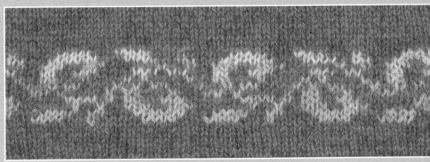

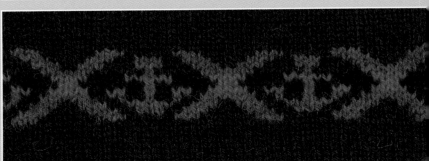

FOREWORD

I love to knit and I love working with colors, so it is surprising how long it took me to try my hand at Fair Isle knitting.

Like many people, I was a little worried about all the colors used, not understanding that there were never more than two colors in any given row. I also thought there must be complicated techniques involved that were beyond my limited knitting skills. The truth is, over the course of 300 years, the knitters of Fair Isle developed their craft in a way that makes the knitting easy, logical, and efficient.

One day, I chose some lovely colors of Shetland wool and began to knit a hat without any planning at all. I picked some motifs I liked, and when my math didn't work out exactly, I just added or subtracted a stitch here and there ... and do you know what? The hat was gorgeous, perhaps not perfect, but beautiful just the same!

It is my hope that this book will inspire knitters of all stripes to pick up their needles and join in the colorful fun of Fair Isle knitting.

Mary Jane Mucklestone

ABOUT THIS BOOK

This book is a knitter's directory of 200 Fair Isle motifs. Each motif is designed to inspire, the style of the charts is easy to read, and the layout of the book means that, whether you are looking for a combination of motifs or just one to use as the focal point of a garment, you will find numerous possibilities here.

ESSENTIAL SKILLS

This section explores the essential skills you will need to knit Fair Isle motifs. Covering everything from casting on, to steeking, to color theory, it will demystify the techniques involved and give you the confidence to start right away.

MOTIF SELECTOR

This colorful visual selector displays all the motifs side by side. Flip through for inspiration and to choose your design, then turn to the relevant page to create your chosen motif.

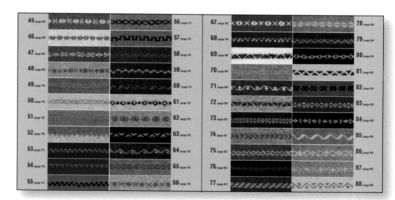

MOTIF DIRECTORY

The directory is organized by row and stitch count. It includes a stunning, actual-size photograph, a black and white chart, a color chart, a color variation chart, and a suggested all-over repeat chart for each of the 200 motifs.

Charts are organized by row count and then by stitch count so you can easily find the one most appropriate to your needs.

Black and white, traditional-style charts help experienced knitters to pick out the pattern. A square with a black dot indicates a pattern stitch and a blank square indicates a background stitch.

Numbers indicating round numbers. When knitting in the round, read the chart from right to left and from bottom to top. If you wish to work in rows, read every odd-numbered row from right to left, knitting every stitch on the front of the work, and read even-numbered rows from left to right, purling every stitch across the wrong side of the work.

Description and explanation of the design principles of the mix-and-match.

Large, actual-size photograph of the knitted swatch.

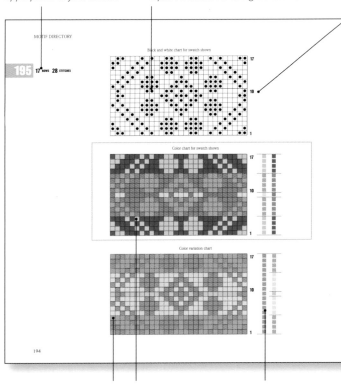

Color variation chart.

Easy-to-read, color-accurate chart for the knitted swatch. Each square is colored to represent the color used for each individual stitch.

Columns of color blocks represent pattern (left) and background (right) stitches. Horizontal rules indicate each color change.

Black and white chart showing a suggested all-over repeat. These are created in a number of different ways; by inserting a round of plain knitting between the repeats or offsetting the motif by half, for example. Occasionally, additional pattern stitches are added to make the repeat more visually appealing. Though not strictly traditional, these are included to open your eyes to the endless number of patterns that can be made from a single motif.

Photographic mix-and-match suggestions demonstrate how to combine motifs to make large designs.

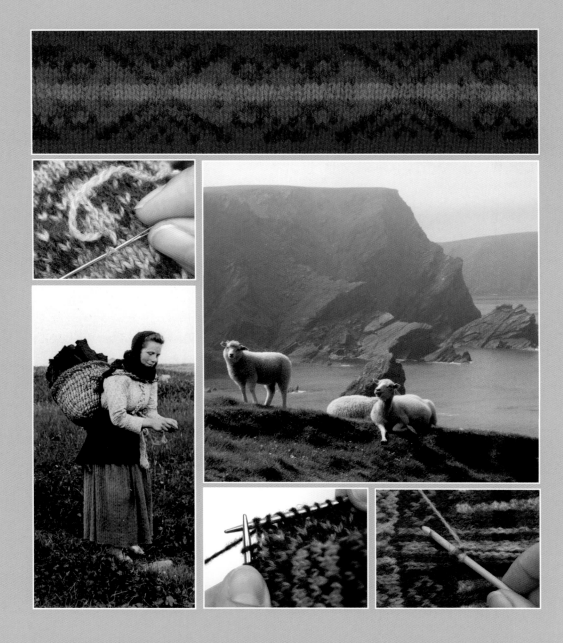

Essential Skills

This section explores the essential skills you will
need to knit Fair Isle motifs. Covering everything
from casting on, to steeking, to color theory, it will
demystify the techniques involved and give you the
confidence to start right away.

YARN

For the purist, there is no substitute for genuine Shetland wool for Fair Isle knitting—although there are, of course, plenty of other yarns that you can try.

SHETLAND WOOL

The ancient, native Shetland breed of sheep, a small yet hardy animal, grows a very soft and well-crimped fleece with bouncy resilience that is especially prized in knitwear. Yarn spun from the fleece is perfect for stranded knitting. The natural crimp helps the floats stay in place, and assists in holding a garment together when steeks (see pages 28–29) are cut.

Shetland wool is light and airy and occurs naturally in an amazing variety of colors. Although white and moorit (a reddish brown) are the most common, there are no fewer than 11 distinct named colors that can be further blended, producing a huge range of natural colors without the need for dyeing. In traditional Fair Isle knitting, these natural sheep colors were complemented with two natural dyestuffs procured from trading—indigo for blue and madder for red. Local plants also yielded a yellow dye, which could

be overdyed with indigo to produce green; this is a more labor-intensive process, and so green is traditionally used less often or in smaller amounts.

The advent of synthetic dyes further expanded the Fair Isle knitter's repertoire of colors. Nowadays, local Shetland companies produce hundreds of colors of dyed Shetland wool, allowing infinite color combinations.

After washing, or dressing, the garment, Shetland wool "blooms," creating a wispy haze over the knitted surface, muting color changes and creating the inimitable look of traditional Fair Isle colorwork.

Shetland sheep occur in 11 recognized colors, many of which have Shetland dialect names. Solid white and solid moorit (a reddish brown) are the most common; the other colors found are light gray, gray, emsket (a dusky bluish-gray), musket (light grayish-brown), shaela (dark steely-gray), fawn, mioget (yellowish-brown), dark brown, and black.

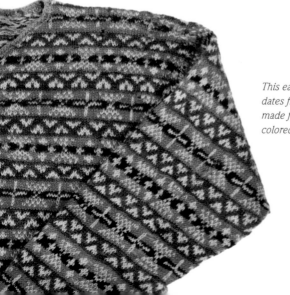

This early Fair Isle jumper dates from the 1890s and is made from handspun wool colored using natural dyes.

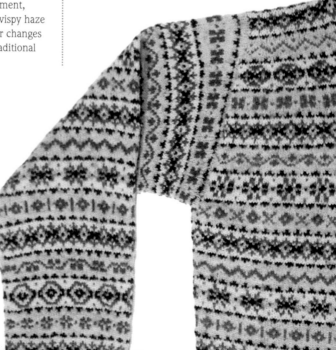

Dating from the 1930s, this cardigan was made using undyed Shetland wool—a striking example of the range of colors naturally available.

OTHER YARNS

Fair Isle knitting can, of course, be done using yarns other than Shetland. Although some of those listed below are far from traditional, it's always worth experimenting as the range of effects can be stunningly beautiful.

1 BABY AND SOCK YARNS

These are usually highly processed yarns, allowing them to be machine washed. This processing removes most of the "stickiness" from the yarn, which makes them a less-than-ideal choice for garments that require steeking. It can be done, but make sure to reinforce the steeks with machine sewing.

2 NORWEGIAN YARN

Scandinavian countries also have a strong tradition of stranded knitting and have developed yarns specifically for stranding. These yarns are often double knitting (DK) weight, producing a thick, "ski sweater" type of garment. Since the stitches are larger, the floats will be longer, often requiring wrapping of the float every 4–5 stitches.

3 ICELANDIC WOOL

Iceland is known for its attractive stranded yoked sweaters made with their loosely spun, bulky weight single-ply yarns. Although bulky yarn produces long strands, the "sticky" nature of the soft Icelandic wool allows for long floats, as the yarns cling to each other.

4 MOHAIR

Made from the hair of the angora goat, mohair is a wildly non-traditional choice for Fair Isle knitting; it can nonetheless be intriguing. Stranding with mohair will soften the outlines of any pattern, as the long fibers make a thick, blooming halo. Although this is usually seen as a drawback in patterned knitting, it can be used to great effect.

5 COTTON AND OTHER PLANT FIBERS

These are infrequently used in traditional Fair Isle knitting. Cotton is often heavy to begin with and stranding will make your garment even heavier. The floats will not mat, so wrapping the floats every few stitches is recommended. Even so, an adventurous knitter can make any drawback work to their advantage with careful designs that factor in the fibers' characteristics.

6 NOVELTY YARNS

Combined with traditional yarns, novelty yarns, such as metallic or chenille, can produce amusing effects, adding a disco dash to an otherwise staid garment.

7 MARLED YARNS

Marled yarns are formed by twisting together plies of different colors. The color effect in a marled yarn is determined by the kinds of colors used together. When choosing a marled yarn, make sure that the colors within the yarn have enough contrast with the yarn it will be paired with; otherwise the pattern may disappear.

"Rovings"—wool that has been washed, combed, carded, and then twisted slightly to hold the fibers together in preparation for spinning—in natural Shetland colors.

BALL BAND INFORMATION

Ball bands will give you varying amounts of information about your yarn.

- Company logo (**1**)
- Yarn name (**2**)
- Fiber content and place of origin (**3**)
- Length of yarn in the ball (**4**)
- Weight of yarn in the ball (**5**)
- Recommended knitted gauge/ needle size (**6**)
- Color (**7**)
- Dyelot (**8**)
- Care instructions (**9**)

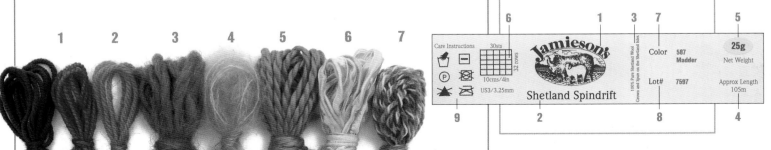

NEEDLES AND OTHER EQUIPMENT

There is a whole array of materials and equipment at your disposal, from essentials such as a tape measure and scissors, which you will probably already have in your sewing or knitting kit, to useful gadgets to make your life easier. This section provides an overview of what is available.

KNITTING NEEDLES

Knitting needles are an investment because you will use them time and time again. Look after your needles carefully and they will last for years—but when the points are damaged or the needles are bent, it is time to throw them out and buy new ones. Since most Fair Isle knitting is done in the round, you will be using circular needles and double-pointed needles of various sizes and lengths.

CIRCULAR NEEDLES

Circular needles allow you to work in the round, using plain, or knit, stitches, to create a seamless fabric. The weight of the knitted piece rests on your lap, so this type of needle is useful if you are working with a heavy or bulky yarn.

They consist of two rigid tips of metal, plastic, wood, or bamboo, joined by a length of plastic or nylon cord. The material your needles are made from is purely a matter of personal choice, but it is essential to get needles that have a smooth join between the cord and the needle.

Like straight needles, circular needles come in a range of sizes (diameters) to suit different weights of yarn. The size depends on what kind of yarn you are using and on your own personal gauge. If you are following a pattern, your gauge must match that of the pattern.

Circular needles are also available in different lengths, from 12 to 60" (30 to 150 cm) or more. The length of the needle you use depends on the number of stitches needed for the item you are knitting: 24–32" (60–80-cm) lengths are customary for sweaters, 16" (40-cm) lengths for sleeve tops and hats. However, the needle length must be shorter than the circumference of your work.

DOUBLE-POINTED NEEDLES

If the circumference of the piece you are knitting is smaller than 16" (40 cm) double-pointed needles are used. Double-pointed needles are customarily used for small items such as mittens, gloves, socks, and the crowns of hats. Double-pointed needles come in sets of four or five. Like circular needles, they allow you to work in the round and change direction. This is useful when turning the heel on a sock, for example. They were traditionally made of steel, but aluminum needles are more usual now, with bamboo and plastic in some sizes.

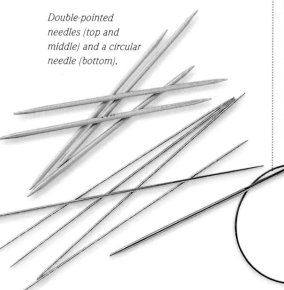

Double-pointed needles (top and middle) and a circular needle (bottom).

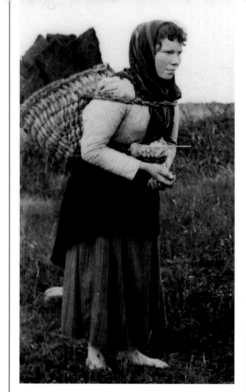

THE MAAKIN' BELT (KNITTING BELT)

On Fair Isle and Shetland, the maakin' belt (or knitting belt) is employed in combination with a set of 14" (36-cm) steel double-pointed needles. It is a cushion made of leather pierced with small holes and stuffed with horsehair that is worn on a belt around the waist. One end of a knitting "pin" is inserted in one of the small holes. This helps to support the knitting, acting as a "third hand," allowing the knitter, with practice, to achieve great speed, as well as mobility.

The maakin' belt enabled old-time knitters to knit throughout the day while doing other tasks, such as hauling peat home for the fires.

OTHER EQUIPMENT

Although all you really need are needles and yarn, the little extra accessories help to make your projects go much smoother. Choose beautiful gadgets that you will treasure for years.

NEEDLE GAUGE

Not all needles are marked with a size and the small ones look frustratingly similar. A needle gauge is really handy for checking the size of unidentified needles. It has a series of holes to indicate size: just push the needle thorough the holes until you find the one nearest to its diameter.

STITCH MARKERS

Stitch markers come in a variety of styles and you will want to try them all. Bright plastic rings close in size to that of your needle are very helpful for marking off stitch repeats. Use a different color to indicate the beginning of the round. Locking stitch markers are useful for making vertical notations, such as counting rounds. They are also useful to mark the beginning of the round when using double-pointed needles, where ring markers would slide off.

SCISSORS

Small, sharp scissors should be used to cut yarn. Never try to break yarn with your fingers—some yarns are very strong and will cut your skin.

TAPE MEASURE

The best tape measures for knitters are the retractable dressmaking type. It is best to have one marked with both inches and centimeters.

TAPESTRY NEEDLE

For weaving in ends and grafting stitches, you need a blunt-tipped needle with a large eye (like a tapestry needle). These are available in a range of sizes to suit different yarn types.

STITCH HOLDERS

These devices work like large safety pins and are useful for holding the stitches at the bottom of a steek or at the tops of shoulders, for instance.

ROW COUNTER

A row counter is helpful for keeping track of rows or rounds, provided you remember to click it! The barrel type is fitted onto a straight needle; for large-sized straight needles or for circular knitting, you need the clutch type.

PINS

Large-headed pins are the best type to use when measuring your gauge or pinning garments in place while blocking, because the large colored heads won't get lost between the stitches.

PENCIL, NOTEBOOK, TAPE

Pencils are handy for making notations on patterns, ticking off rows, and jotting down adjustments. A notebook is nice for making a note of new ideas and inspirations. Little ones with graph paper are especially useful for making up your own Fair Isle motifs. You could tape snips of yarn from your colorways, next to the chart, corresponding to their order of use.

BLOCKING AIDS

Although neither of these are things that you would normally associate with knitting, they are useful to have around: balloons are great for blocking hats, while dinner plates between 9 and 11" (23–28 cm) in diameter can be used for blocking tams.

POM-POM MAKER

Fantastic for fashioning perfectly spherical pom-poms.

HELPFUL FOR KEEPING YOUR PLACE ON THE CHART

Post-it notes, a magnetic ruler, and/or a clear plastic ruler can be moved along a chart as you work, making it easy to keep track of exactly where you are in the pattern.

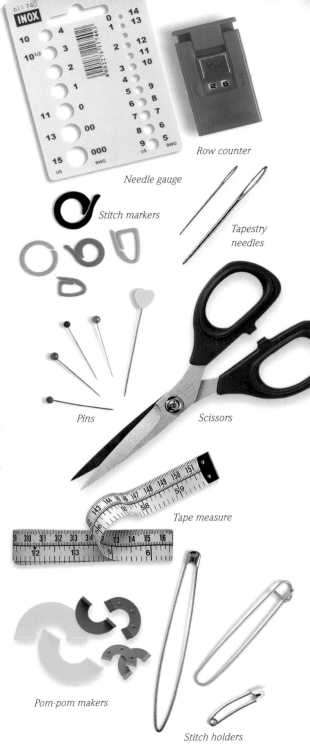

Row counter

Needle gauge

Stitch markers

Tapestry needles

Pins

Scissors

Tape measure

Pom-pom makers

Stitch holders

GAUGE

Before you start a knitting project, it is absolutely essential that you knit a swatch to measure your personal gauge. The gauge of a piece of knitting is the number of stitches and rows (or rounds) counted over a given measurement—usually a 4" (10-cm) square.

Whether you are following a written pattern or designing your own, you will need to know your gauge—in the first case to make sure that the garment will come out to the desired size and in the second case to calculate the number of stitches and rounds you need for your design.

Fair Isle gauge swatches should be knit in the round. Ideally, this means casting on enough stitches to be able to knit comfortably on a 16" (40-cm) circular needle. The number of stitches you need to cast on will vary depending on the yarn used—a rough guide is to multiply the desired stitch gauge per inch of the pattern you are following by 16 or the length of your circular needles in inches. Knitting a swatch of this size will allow you to measure 4" (10 cm) of your work without having to cut it to measure it. Work rounds in the Fair Isle pattern until the swatch measures about 5" (13 cm) long, then bind off or place your stitches on a piece of scrap yarn.

If you don't want to devote that much time or yarn to a making a gauge swatch, use fewer stitches and double-pointed needles. You will need to cut your swatch so that you can measure it flat, so this is also a good opportunity to practice steeking.

SPEED SWATCH

Even more pressed for time? A speed swatch is a great cheat.

On double-pointed needles or one circular needle with a diameter appropriate for your yarn, cast on enough stitches for a generous-sized swatch—ideally, the projected number of stitches for 5" (13 cm). If you are following a written pattern, cast on the number of stitches the gauge calls for, plus 1" (2.5 cm) worth of stitches.

Using the same stitch pattern as in your project, knit across. When you reach the end of the row, break both yarns and slide the work back to the right-hand end of the needle. Join in the yarn again, and knit across as before. In this way, you will be creating only knit stitches, just as you would if knitting circularly.

Continue knitting in this manner until you have a square about 5" (13 cm) in size, then bind off.

ALTERNATE METHOD

Instead of breaking the yarns, leave very, very long floats that span the swatch from behind. You will then cut the floats, so you can measure the swatch accurately.

A speed swatch, knitted using the same stitch pattern as the planned project, showing broken yarns at each end.

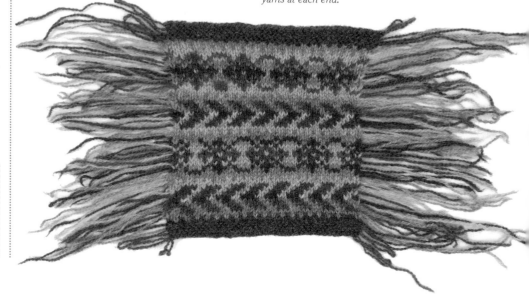

MEASURING YOUR SWATCH

When you've completed your swatch, wash it and block it (see page 30). When it is dry, place it on a hard surface, and measure it as shown (right).

If you find that you have more rows or stitches than the pattern suggests, the gauge is too tight and you should change to a larger needle. If there are fewer stitches or rows, change to a smaller needle.

1 Using a ruler or a tape measure, place two pins exactly 4" (10 cm) apart at the center of the swatch, as shown. Count the number of stitches along a straight row between the pins.

2 Now place the pins 4" (10 cm) apart vertically and count the number of rows between them, along a straight line of stitches.

CREATING A FABRIC TO SUIT YOUR NEEDS

Altering the size of the needles you use will affect the type of fabric you create: the fewer the number of stitches and rounds to the inch, the looser the fabric. Conversely, the more stitches and rounds to the inch, the tighter the knitted fabric will be. If you are designing your own project, make swatches using different sizes of needles to help you decide which fabric best suits your needs.

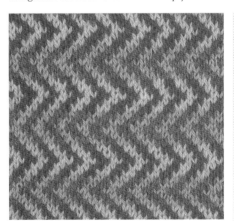

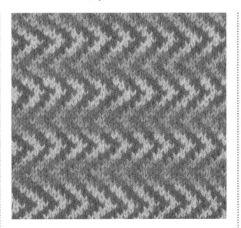

Swatch 1 was made using size 4 (3.5 mm) needles. It has a gauge of 7 stitches and 7 rounds to the inch, making a relaxed fabric with large stitches and visible spaces between them. This might be a nice fabric for a throw, or a garment that does not need to be windproof.

Swatch 2 was made using size 3 (3.25 mm) needles. It has a gauge of 8 stitches and 8 rounds to the inch. This is a standard gauge for sweaters; the stitches are even, with no spaces between them. The resulting fabric is flexible, yet firm.

Swatch 3 was made using size 2 (2.75 mm) needles. It has a gauge of 9 stitches and 9 rounds to the inch. This is a good gauge for mittens and gloves, creating a dense fabric with very small stitches.

CASTING ON

To begin knitting, you need to cast on some stitches. Here are four of the most versatile ways to cast on.

The cast-on method you choose depends on the outcome you require—an elastic or firm cast-on, decorative or plain. Different methods of casting on give different results, suitable for different purposes. Sometimes, an extra-strong cast-on may be required—for example, on children's garments where edges may be prone to hard wear. For other garments, a cast-on that has more stretch may be needed. Try them out to see and feel the difference. In all cases, the tail ends can be used for sewing up seams or woven in unobtrusively (see page 23).

All the methods shown here begin by making a slipknot, which serves as the first stitch.

TIPS
- To ensure that your cast-on stitches are not too tight, use a needle one size larger than called for.

- A more delicate cable cast-on is made by taking the needle into the newest stitch each time, instead of between the stitches. This creates a useful edge for hems.

MAKING A SLIPKNOT
Putting a slipknot on the needle makes the first stitch.

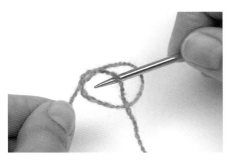

Loop the yarn in the direction shown, leaving a tail of desired length (see tips box, left). Use the needle tip to catch the yarn inside the loop. Tighten the knot gently in the needle.

BACKWARD LOOP CAST-ON
Not recommended for the foundation of a garment, this cast-on is perfect for adding stitches at the end of a row or over a buttonhole opening.

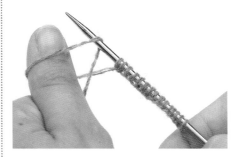

Leaving a short end, make a slipknot on the needle. Tension the yarn in your left hand and make a loop around your thumb. Insert the needle into the loop, slip your thumb out, and pull the yarn to make a stitch on the needle.

CABLE CAST-ON
This cast-on is made by knitting a stitch, then transferring it from the right needle back to the left needle. It is a firm cast-on that makes a strong edge with a ropelike twist.

1 Put a slipknot on one needle. Holding this needle in your left hand, insert the other needle into the front of the slipknot. Take the ball end of the yarn around the right-hand needle and pull through a stitch, then transfer it to the left-hand needle.

2 Insert the right-hand needle between the new stitch and the next stitch and make another stitch as before. Continue in this way for the desired number of stitches.

LONG-TAIL, OR CONTINENTAL, CAST-ON

This method creates a firm foundation row that mimics a row of knit stitches. Although it seems tricky at first, requiring nimble fingers, it is the fastest cast-on once mastered. Begin by measuring off about three times the length of the edge to be cast on. Make a slipknot and place it on the needle. Keep the yarn coming from the ball at the back and the shorter tail end in the front of the work.

TIP
Measuring out three times the length of the cast-on edge can be challenging. To work out how much yarn you will need, cast on 10 stitches and then unravel them. By measuring the unraveled yarn, you can calculate how much yarn you will need. An alternate method is to use two balls of yarn. Join both ends on the needle with a slipknot, then cast on using both balls. Cast on one extra stitch. Break off one ball, and undo the slipknot.

1 Hold the needle in your right hand and both ends of the yarn in your left hand. Wrap the tail around your left thumb from back to front and loop the other strand around your left index finger. Grasp both strands in the palm of your hand with your remaining fingers.

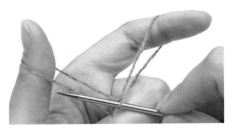

2 Slide the needle up through the loop on your thumb.

3 Take the needle over the top of the yarn on your index finger and draw this through the thumb loop.

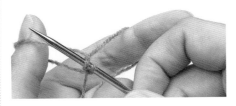

4 Release the thumb loop and pull to tighten it around the needle. Repeat until you have the required number of stitches.

THUMB CAST-ON

This method achieves the same edge as the long-tail cast-on.

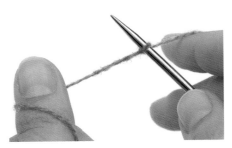

1 Measure off about three times the length of the edge to be cast on and make a slipknot on the needle. Hold the needle and yarn from the ball in your right hand.

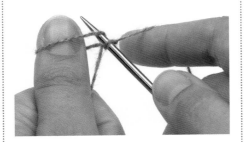

2 Tensioning the other end of the yarn in your left hand, make a loop around your thumb and insert the right needle into the loop.

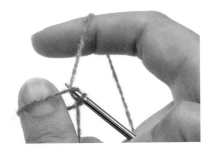

3 Take the yarn around the needle, then draw a loop through to make a stitch. Gently pull the end to close the stitch up to the needle. Repeat until the required number of stitches, including the slipknot, have been cast on.

CIRCULAR KNITTING

Circular knitting, or knitting "in the round," creates a tubular fabric with no seams. Traditional Fair Isle garments are almost always knitted in the round, because by knitting circularly, the right side always faces you, allowing you to see your work and watch your pattern progression.

WORKING WITH FOUR DOUBLE-POINTED NEEDLES

Knitting in the round is worked on double-pointed needles when the stitches are too few to fit on a circular needle—when knitting sleeves, the tops of hats, socks, or other small projects, for example.

Double-pointed needles should be long enough to hold one-third of the required stitches (to work on four needles) or one-quarter (to work on five needles). If the needles are too short, the stitches will tend to drop off the tips.

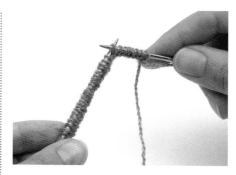

1 Cast the required number of stitches onto one long, ordinary knitting needle. Slip one-third of the stitches purlwise onto one of the double-pointed needles.

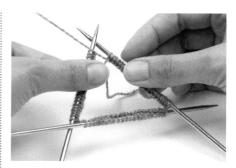

2 Slip the remaining two-thirds of the stitches onto two more double-pointed needles. Some patterns stipulate an exact number of stitches on each needle; otherwise just divide the number of stitches into three. Arrange the needles in a triangle, so that the working yarn is at top right. The cast-on edge should be inside the triangle. Push each group of stitches toward the center of each needle. The leading tip of each needle should overlap the next needle.

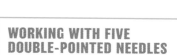

TIP
When using double-pointed needles, arrange the stitches so that entire pattern repeats are on each needle; this will make it easier to "read" your work.

WORKING WITH FIVE DOUBLE-POINTED NEEDLES

Sometimes it is more convenient to work on a set of five needles. In this case, divide the stitches evenly between four of the needles and use the fifth needle to begin the round.

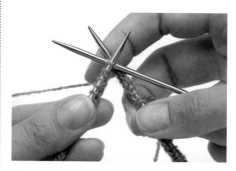

3 Pick up the work, bringing the needle tips with the working yarn toward you. The working yarn should be outside the triangle, not down through the center. Use the fourth needle to knit all the stitches on the first needle. Arrange the new stitches together at the center of the fourth needle. The first needle is now empty: use it to work the stitches on the second needle, and so on.

4 Work the first and last stitches on each needle quite tightly, keeping the needles close together to prevent gaps caused by loose stitches. To mark the beginning/end of the round, place a ring marker one stitch from the end of the last needle—that is, one stitch from the end of round (otherwise it will fall off). Slip the ring marker on every round.

WORKING WITH CIRCULAR NEEDLES

Knitting in the round is worked on a circular needle for the body of the garments.

With circular needles, the needle length should be 2" (5 cm) or more shorter than the circumference of the piece to be knitted: a circular needle will accommodate stitches equivalent to approximately twice its length. A circular needle that is too long for the number of stitches will stretch the knitting, and the stitches will not easily slip around it, making the knitting process difficult.

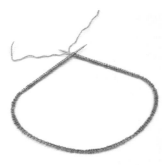

1 Cast on the required number of stitches. Lay the needle on a flat surface, with the tips away from you and the tip with the working yarn on the right. Arrange the stitches evenly around the needle, with the cast-on edge to the inside all around. Make sure that the cast-on edge is not twisted around the needle, or the knitting will be twisted, too.

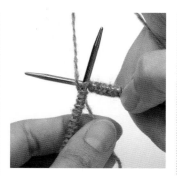

2 Pick up the needle, lifting the needle tips toward you. The tip with the working yarn should be on the right. The yarn itself should lie loosely outside the circle, not down through the center.

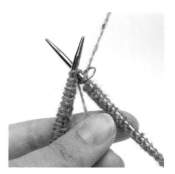

3 To mark the beginning/end of the round, slip a ring marker onto the right needle tip. Knit the stitches as required. Every few stitches, push more stitches to be worked up the left needle tip, and spread out and slide the new stitches away from the right needle tip, so that all the stitches slip around the flexible cord. When you reach the marker again, one round is complete. Slip the marker and begin the next round.

PURLING

Traditionally, Fair Isle knitting is done in the round with the right side always facing, using only knit stitches. This creates stockinette-stitch tubes, eliminating the need to purl. There are, however, some instances when purling is necessary. For example, some knitters prefer not to steek for neck openings so instead they knit the sides of the opening flat, purling while stranding on the back of the work. Purling is also used when working regular and corrugated ribbing.

CORRUGATED RIBBING
Corrugated ribbing is beautiful and complex-looking two-colored ribbing. It is often used to punctuate the edges of garments as bottom borders, sleeve cuffs, necklines, and even button bands.

Happily, it is easy to work: knit stitches are worked in one color and purl stitches in another. You can keep all knit stitches one color and all the purl stitches another, or change them every few rows. In traditional garments, the colors are separated into background colors and pattern colors, with each assigned to either knits or purls.

Corrugated ribbing is worked over an even number of stitches,

usually 2 x 2 or 1 x 1. Due to the stranding, it is not as elastic as ordinary ribbing.

BUMPS AND NO BUMPS
When you introduce a new color, there will be a bi-colored purl bump, which can be a nice design element. If you'd rather have a smooth transition, knit every stitch in the round where the new color is introduced. This will affect the flexibility of the ribbing, making it even less stretchy. In this case, you will not want to change colors on every round—or it would not be ribbing at all!

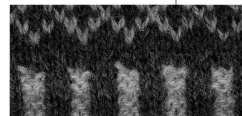

Purl bump

No purl bump

HOLDING THE YARN

In traditional Fair Isle knitting, there are never more than two colors in any row, so you only have two yarns to control at a time. Experiment to find a method that you feel comfortable with.

There are several different ways of holding the yarn in Fair Isle knitting; three are shown, right. Try them all to find out which works best for you. Though they may feel funny at first, remember, you learned to knit with one strand of yarn, you can learn to knit with two, it just takes practice. Keep the tips of your fingers as close to the needles as you can to make working the stitches and controlling the tension easier.

You will want to hold your pattern color in the most dominant position (see yarn dominance, page 21), which is usually the strand farthest to the left, in whichever method you are using. However, the most important thing is to be consistent with the position of both yarns throughout the piece.

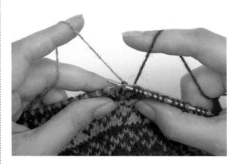

ONE YARN IN EACH HAND
Hold the background color in your right hand and the pattern color tensioned between the fingers of the left hand. Knit the background yarn by moving it into place with your right index finger, and the pattern yarn by picking it up with the tip of the right needle, pulling it forward through the loop, and off the needle.

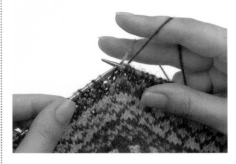

BOTH YARNS IN RIGHT HAND,
OVER INDEX AND MIDDLE FINGERS
Hold both yarns in the right hand, with the background color over the index finger and the pattern color tensioned over the middle finger. Knit the background color by manipulating the index finger; for pattern stitches, turn the hand slightly to flick the yarn from the middle finger around the needle.

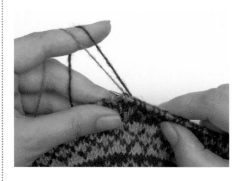

BOTH YARNS IN LEFT HAND,
OVER INDEX FINGER
Wrap both yarns around your index finger from front to back, with the pattern color to the left of the background color. To knit, insert the right needle into the next stitch and, with the tip, select the yarn required, pulling forward through the loop, and off the needle.

TIP
Try practicing on a project with just two colors and a simple motif with a repeat of eight stitches or fewer, until the stranding becomes easy for you.

STRANDING

In this type of knitting, the color not in use is carried loosely across the wrong side of the work. The loose strands formed are called "floats." For a neat appearance on the right side of the work, one color float should always lie "below" and the other color float "above," all across each row. Simple stranding is effective for pattern motifs with fewer than nine stitches between color changes, as the floats are not long. Longer floats can be tamed by using the weaving technique (see pages 22–23).

SIMPLE STRANDING

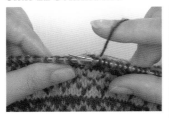 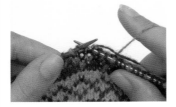

1 To change from the pattern yarn to the background yarn, simply begin knitting with the background yarn, stranding it above the pattern yarn, and knit the required number of stitches. Keep the previous pattern stitches spread out along the right needle so that the the strand of background yarn behind the stitches is not too tight.

2 To change from the background yarn to the pattern yarn, begin knitting with the pattern yarn, stranding it below the background yarn, and knit the required number of stitches.

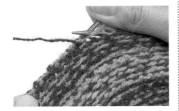

On the reverse of the fabric the floats or yarn strands should lie parallel and should not be twisted around each other. For an even appearance, it is important that the floats of each yarn lie consistently either under or over the other.

MANAGING FLOATS

While stranding, make sure that the floats do not become too short, as this will cause a puckered fabric. As you knit, take care to smooth your work out along the right-hand needle. In this way, the yarn not in use will strand along behind the just-knitted stitches, and will automatically be the correct length. With practice, smoothing out your just-knitted stitches will become second nature. Floats that are too long are less of a problem, but they can make the stitches too tall, making your work look uneven.

YARN DOMINANCE

In stranded knitting, one yarn will appear slightly more dominant than the other. Yarn dominance occurs because one yarn's strand travels slightly farther than the other, making it slightly tighter, causing it to recede, and be less dominant. The yarn traveling the shortest distance is the dominant yarn. Another way of putting it is that the yarn that comes from below will dominate, while the yarn from above makes a slightly smaller stitch.

Usually the pattern yarn is held to the left of the background yarn, making the pattern color dominant, but there are slight differences in individual technique.

The most important thing is to be consistent in holding your yarn. Assign one position to the pattern color and one to the background color; always keep them in the same position while knitting your piece.

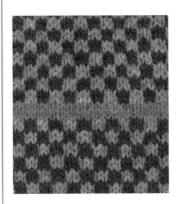 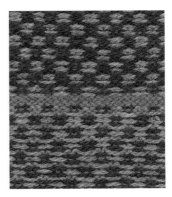

On the bottom half of this swatch, the dark green stitches are larger; on the top half, the pale jade stitches are larger.

When we look at the wrong side of the swatch, on the lower half, the dark green strands are beneath the pale jade strands. On the top half, the pale jade strands are beneath.

WEAVING

Where a color passes behind more than eight stitches, it should be woven over and under one or more of those stitches to prevent long, loose floats that can catch on fingers and jewelry.

Weaving is used when the yarn not in use has to be carried across the back of the work for more than eight stitches. There are also other instances when you might care to weave in floats: Some yarns, such as superwash baby yarn do not have the same "sticky" properties as 100 percent Shetland wool. Thicker yarns make larger stitches, therefore longer floats, which you may want to tack down, so that fingers and jewelry don't snag them. Weaving is also a good option for some children's items such as mittens, so little fingers will be less likely to be caught up in a long float.

Weaving in makes a denser and therefore less flexible fabric than simple stranding; if you weave every stitch, the resulting fabric will almost mimic a woven fabric.

Sometimes the woven float shows through on the right side of the garment; this is most noticeable with highly contrasting colors.

When you need to weave, take care to stagger where you catch the floats. If you catch one right above another, you may inadvertently create a vertical line.

The orange centerline of this motif has been carefully woven into the reverse of the fabric.

WEAVING WITH BOTH HANDS

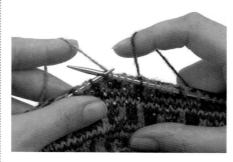

WEAVING BACKGROUND YARN
1 Work to the point where the background yarn needs to be caught.

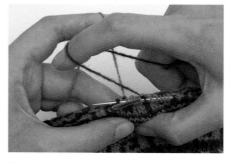

2 Lay the background yarn across the pattern yarn.

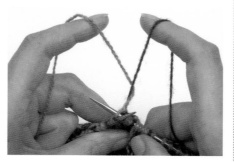

3 Insert the needle through the next stitch, over the background yarn, catching the pattern yarn, and pulling it through the loop and off the needle.

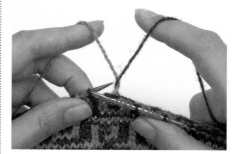

4 Bring the background yarn back to its original position.

WEAVING PATTERN YARN
Work to the point where the pattern yarn needs to be caught. Insert the needle into the next stitch, and under the pattern yarn, wrapping the background yarn as usual, pulling through the loop and off the needle. Continue knitting the background color as usual.

WEAVING WITH THE LEFT HAND

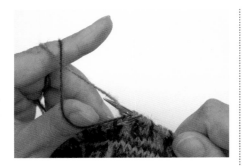

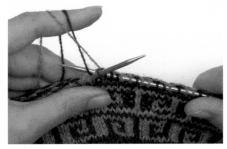

WEAVING BACKGROUND YARN
Work to the point where the background yarn needs to be caught. Insert the right needle into the next stitch; use the left thumb to bring the background color forward. Bring the right needle tip behind the pattern yarn, from right to left, and scoop it forward, through the loop, and off the needle. Release the background yarn on your thumb and resume knitting as usual.

WEAVING PATTERN YARN
Work to the point where the pattern yarn needs to be caught. Insert the right needle into the next stitch and, with the tip, reach under the pattern yarn to catch the background yarn from right to left, and pull it through the stitch and off the needle. Resume knitting as usual.

WEAVING WITH THE RIGHT HAND

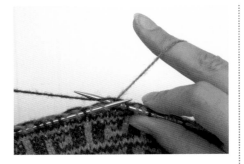

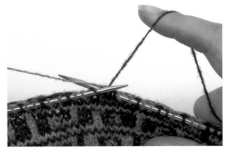

WEAVING BACKGROUND YARN
Work to the point where the background yarn needs to be caught. Drape the background yarn across the pattern color. Knit the pattern color. Move the background color back to the original position.

WEAVING PATTERN YARN
Work to the point where the pattern yarn needs to be caught. Lay the pattern yarn across the background yarn, and knit the background yarn. Move the pattern yarn back to the original position.

WEAVING IN ENDS
Weaving in the loose ends may seem overwhelming, but it is a task that needs to be done. One approach is to weave in the ends of the old yarn while joining in the new yarn. Leave a tail of yarn about 6" (15 cm) long when you join in the new yarn, then thread the yarn end onto a tapestry needle and run it along the back of a row, up and down through about ten stitch loops. After completion, pull gently to tighten the yarn, then snip off any excess.

Try to weave them back into the same row in the direction they are coming from. You may weave them into the purl "bumps" on the back of the work, but you might choose to be more exacting and follow the course of the stitches.

In Shetland, they sometimes don't weave in the ends at all, but knot them and leave them to felt.

You might consider eliminating ends altogether by spit-splicing old and new colors together.

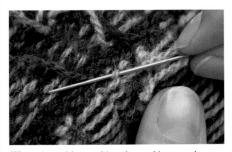

Weave in end by catching the purl bumps along the same round of knitting.

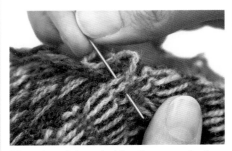

Weave in ends by embedding the yarn under the floats, following the course of the stitches.

INCREASING AND DECREASING

Although traditional Fair Isle garments are made with very little increasing or decreasing (and most increases or decreases will not show very much, because of the complexity of the two-color surface), these are basic knitting skills that you need to master.

INCREASING

A traditional Fair Isle garment has a blocky shape, with increases usually made only on the edges of garments, at the beginning of a round, at the halfway point or "seam line," or just before or just after steek stitches. To place them in the middle of a row/round upsets the pattern motif, requiring a total redesign of all subsequent patterning, and is rarely done. Increasing in the middle of rows/rounds can be done on plain rounds of only one color. Keep in mind, increasing in this manner will affect pattern motif placement on subsequent rounds, so design your garments accordingly.

Increases are also used when knitting sleeves from the cuff up, where stitches are increased on either side of a center underarm "seam stitch." Increases can also be decorative, as in the gusset shaping on the thumb of mittens or gloves.

There are many ways to increase and most knitters have their own favorite method. Patterns do not always specify how to increase and may just give the instructions to "make" a number of stitches.

Here are three increase methods that work well.

KNITTING INTO THE STITCH ONE ROW BELOW
This is worked by picking up and knitting into a stitch one row below.

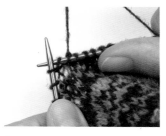

1 Work to where the extra stitch is needed. Put the right needle through the top right side of the knitted stitch one row below.

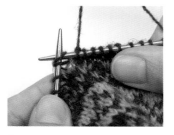

2 Place this stitch on the left needle without twisting and knit it as normal.

KNITTING INTO THE BACK OF THE BAR BETWEEN STITCHES
This increase is worked in between two stitches.

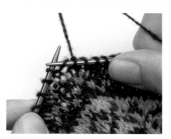

1 Work to where the extra stitch is needed. Pick up the bar created by the yarn between the stitches by putting the right needle through it from front to back and place it on the left needle.

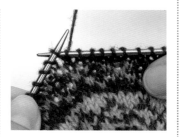

2 Knit through the back of this loop as if it were a stitch and slip it from the left needle.

KNITTING INTO THE FRONT AND THEN THE BACK OF A STITCH
This increase is worked either at the beginning or end of the knitted piece, as it is not particularly neat. Use it on the edge or one stitch in from the edge, so that it will be lost when the pieces are sewn together.

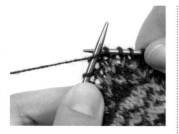

1 Work to where the extra stitch is needed. Knit into the front of the next stitch on the left knitting needle without slipping it off.

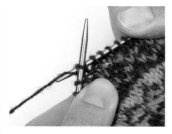

2 With the stitch still on the left needle and the yarn at the back, knit into the back of the stitch and slip it from the needle.

DECREASING

Decreasing is done to shape necklines, sleeve openings, and sleeves. It is important to know how the stitches will lie with different decreases and increases. For example, when losing stitches around a neck detail, it is preferable that the stitches lie in the direction of the decrease: in other words, stitches on the right side of the neck need to form a slope that points to the right, while stitches on the left side need to form a slope that points to the left. That said, Fair Isle knitters often go against this convention and work the decreases pointing away from the decrease in order to have the color of their choice on top.

As Fair Isle knitting is generally done in the round, with the right side always facing, all the methods shown below are on right-side rows.

RIGHT-SLANTING DECREASE (K2TOG)

Knitting two or more stitches together on the right side of the work creates a slope to the right.

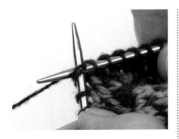 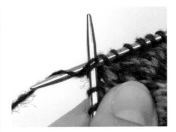

1 Put the knitting needle knitwise through the second and then the first stitches on the left needle.

2 Knit the two stitches together and slide both from the left needle.

LEFT-SLANTING DECREASE (SSK)

This stitch slopes to the left and creates a mirror image of the k2tog decrease.

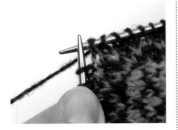 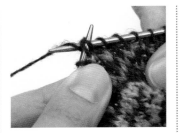 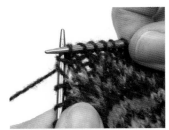

1 Slip the first stitch knitwise. Slip the second stitch knitwise. (They must be slipped one at a time.)

2 Insert the left needle tip through the front loops of both slipped stitches together. Wrap the yarn around the right needle tip, as shown.

3 Lift the two slipped stitches over the yarn and off the needle, leaving one new stitch on the right needle.

WHAT COLOR TO USE?

Work both increases and decreases in whatever color will keep your pattern correct. For instance, in the chart below there is a one-stitch increase on round 4: use the pattern color so that it looks as if the increase stitch is part of the next pattern repeat. In round 8, on the decrease stitch, use the background color, otherwise there would be a superfluous pattern stitch.

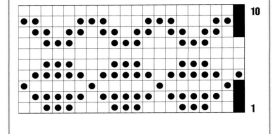

TIP

If you'd like something more than just a blocky-shaped garment, try changing the size of your needles: go down a needle size or two to shape waists. Another idea is to shape by decreasing or increasing evenly around in the plain rows between pattern motifs. The only drawback with this method is that the pattern motifs may not line up vertically.

CORRECTING MISTAKES

You must be able to recognize and correct mistakes in your work. Check for mistakes at frequent intervals as the later you discover a mistake, the more work you will have to do to correct it!

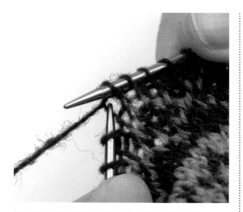

UNRAVELING STITCH BY STITCH

You may need to unravel your work stitch by stitch to reach and correct a mistake.

With the yarn at the back and the right side facing, insert the left needle, from front to back, through the center of the stitch, below the next stitch on the right needle, and pull the yarn to undo the stitch. You will be working back in each color.

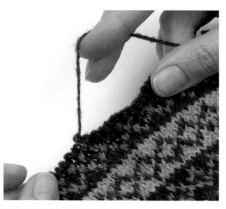

UNRAVELING ROWS

Sometimes you will need to unravel whole rows of knitting and put the stitches back on the needles.

Slip all the stitches from the needle, hold the piece on a flat surface, and pull the yarn gently to unravel the stitches. Keep track of how many rows you have undone, and whether any increasing, decreasing, or design feature has been worked within the area. Place the stitches back on the needle, making sure they are facing the correct way.

DUPLICATE STITCH

Duplicate stitch is embroidery worked on the surface of the knitted fabric that imitates the knitted stitch. The embroidered stitch sits on top of the incorrect stitch. You can use it to cover small mistakes in your work.

You may work a series of horizontal duplicate stitches, along one row of the pattern without breaking your working yarn, by weaving the yarn on the wrong side as you go.

1 Thread a tapestry needle with the correct color. From behind, bring the yarn to the outside at the base of the stitch to be duplicated, pulling the yarn through to the front. Place the needle, from right to left, through the base of the stitch above the one being corrected.

2 Complete the stitch by returning the needle to where you started.

JOINING PIECES TOGETHER

There are several methods of joining pieces together. The ones shown here, when worked on the right side of the fabric, produce a near-invisible join.

GRAFTING (KITCHENER STITCH)

Grafting, or Kitchener stitch, is used to join two sets of unbound stitches together without creating a visible seam.

It simulates a row of stitching, so choose whichever yarn will blend nicely with the two pieces you are joining. If you are simulating the center row of a motif, choose the color that is used in the most stitches; you can go back and duplicate stitches where the contrasting color should be. In the sequence shown, the pattern on the lower needle was completed with a row of blue and grafted with beige stitches.

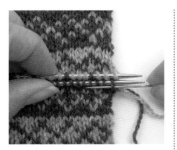

1 Thread a blunt tapestry needle with a length of yarn three times the width of the join. Lay out the pieces to be joined together as shown. Working from right to left, bring the needle through the first stitch of the lower needle as if to purl. Then through the first stitch of the upper needle as if to knit.

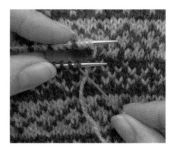

2 Bring the needle back to the front. Thread the needle through the first stitch as if to knit and slip off. Then thread the needle through the next stitch as if to purl, but leave the stitch on the needle.

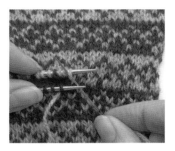

3 Bring the needle through the first stitch on the upper needle as if to purl and slip off. Place the needle through the next stitch as if to knit, but leave on the needle. Repeat steps 2 and 3 until all stitches are worked.

THREE-NEEDLE BIND-OFF

The three-needle bind-off is a great way to join two pieces of knitting together without sewing. It is often used to join the top edges of a knitted piece—for example, the shoulder seams. Instead of binding off each piece separately and then joining them (which creates a noticeable seam), this method involves binding the two sets of stitches off together, using a third needle. It can be done invisibly, on the wrong side, as shown here, or made into a feature by binding off on the right side.

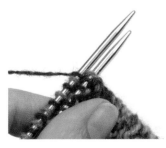

1 Do not bind off the shoulder stitches; leave them on the needle. Hold the right sides together, with the needles pointing in the same direction. Work the bind-off with a third needle held in the other hand.

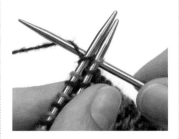

2 Put the right needle through the first stitch on the near needle and the first stitch on the back needle simultaneously and knit both stitches together, so that you now have one stitch on the right needle. Repeat so there are two stitches on the right needle.

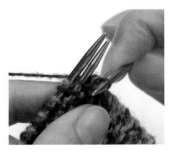

3 Take the first stitch on the right needle over the second, as for a normal bind-off. Continue until all the stitches have been bound off.

STEEKING

Steeking is a technique that enables you to continue knitting in the round without interruptions for openings such as sleeve holes or necklines.

Circular knitting creates seamless tubes, which can form the basis of many garments—scarves, mittens, gloves, hats, socks, skirts, and bags to name but a few. The bodies of sweaters and cardigans, however, need openings for necklines, sleeves, and front openings. Steeks are extra stitches used to bridge the gap where an opening is needed, allowing you to continue knitting in the round. When the knitting is complete, these extra stitches are cut down the center with sharp scissors, creating an opening where sleeves may be attached or a neckline or button band picked up.

Steeks can be as tiny as three extra stitches or as generous as 12; between eight and ten is usual. When knitting steeks, the principal rule is to use both the pattern color and the background color, each every other stitch, creating a dense fabric with very short floats.

It is helpful to keep the stitch closest to the body of your garment in the background color, making a "fold line." Use an even number of stitches for steeks, keeping the center two stitches in the same color, making it clear where to cut.

If you are using a traditional yarn, such as Shetland wool, which grips to itself, it is possible to cut the steek opening without special finishing, as stitches are reluctant to unravel laterally. If you are fearful or are using a less forgiving yarn, try either of the following finishing methods.

MACHINE- OR HAND-SEWN STEEK

This method is highly recommended for use with all "slippery yarns," such as superwash yarns, mixed-blend yarns, or yarns made from plant fibers or synthetics. It is also useful for large-diameter yarns, which may not stick together as readily as finer yarns do. The machine stitching ensures the yarns are locked into place.

Sew down the center of the two columns of stitches that abut the center stitches (white). Cut between the center stitches (red).

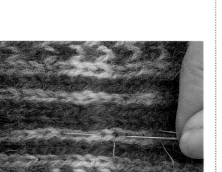

1 Using a sewing machine, sew a line of stitches down the center of the two columns of stitches that abut the two center stitches. If you don't have a sewing machine, you can hand sew your steek with regular sewing thread, using backstitch. I recommend sewing it twice to really nail down the stitches. Work the second line of machine stitching one stitch over from the first line of machine stitching.

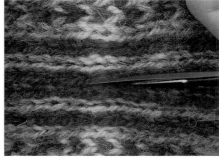

2 Carefully snip between the center stitching lines. You may find it easier to snip from the wrong side, as the sewn stitches will be easier to see, making it less likely that you will accidentally cut through them: they will not be buried in the valley of a knit stitch. Then turn the cut edges to the wrong side just beyond the machine-stitched lines and tack in place if desired. Pick up the stitches toward the body of the garment to add a button band or neckline.

CROCHETED STEEK

Although it is time-consuming to do, the crocheted steek creates a lovely finished edge. Use a crochet hook slightly smaller than the diameter of the knitting needles used.

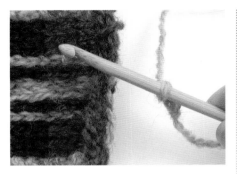

1 Turn your work so that the left side of the opening is nearest to you. We will be working a line of single crochet by connecting the outside half of one of the two center stitches to the neighboring half of the stitch next to it.

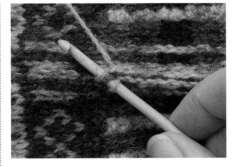

2 Pick up the loops of the closest center stitch (the one at the bottom of the steek) and the one immediately below it on your hook.

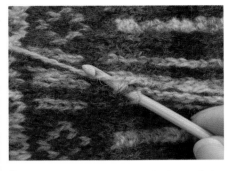

3 Wrap the yarn around the hook, then pull the hook through the two loops on the hook. Repeat to form the first single crochet stitch.

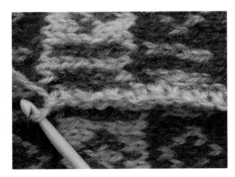

4 Continue, picking up the pairs of stitches immediately to the left. When you reach the top of the steek, cut the yarn and finish off. Turn the work 180 degrees, so the right-hand side of the steek is nearest you. Repeat steps 1 through 4 until you reach the end of the steek, then fasten off.

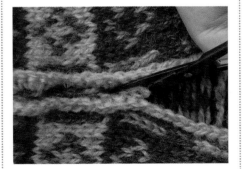

5 Carefully cut down the center of the steek, between the two center stitches. The cut edges will naturally roll to the wrong side along the crocheted stitches, making a tidy finish. Tack in place if desired. Pick up the stitches toward the body of the garment to add a button band or neckline.

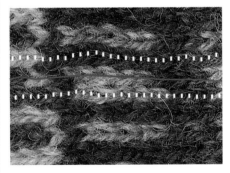

Crochet the outside half of one of the center stitches to the neighboring half of the stitch next to it (white). Cut between the center stitches (red).

BLOCKING AND FINISHING

Proper finishing is essential for Fair Isle knitting. This means gently washing and carefully blocking your items.

When damp, your garment will be surprisingly flexible and ready to be molded into the shape you want. It is easy to make minor adjustments in length and width, narrowing a waist, for instance, or lengthening the sleeves.

With washing and blocking, most, if not all, irregularities in your knitting will magically disappear. The knitting will smooth out, eliminating any surface bumps. If you are using Shetland wool, the yarn will fluff up and "bloom," creating a lovely "halo" of fibers over the surface of the work and subtly blending the colors. The garment itself will relax and soften.

TIPS
• Be generous with pins!

• After drying on the blocking board, the ribbing of your garment will also be stretched. If you'd like it to draw in, wet the ribbing again so that it relaxes, pin it into a narrower shape, and leave to dry.

• Be sure to store your knits flat, carefully folded. If they are to be put away for the winter, fold them in tissue paper to lessen the creases. To discourage moths, slip in a piece of cedarwood.

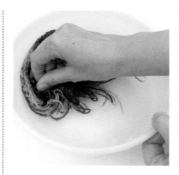

1 First, wash your knitting in tepid water with a mild soap, squeezing gently, not agitating. Rinse thoroughly in water of the same temperature. Press gently against the sides of the basin to squeeze out excess moisture, but do not lift it out or wring as this may cause the garment to stretch; instead, drain the water from the basin.

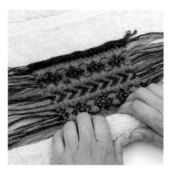

2 Roll the garment up in an absorbent towel and press down to extract as much moisture as possible.

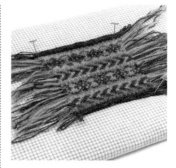

3 Place your garment on a blocking board (see Wooly Boards, below) and gently push it into the correct shape, using your measuring tape for accurate sizing. Pin the garment to the board, using rustproof safety pins or T-pins to hold it in place. Leave the board flat until the garment is completely dry.

WOOLY BOARDS

Traditionally, sweaters are stretched and dried on "wooly boards"—wooden sweater-shaped frames made slightly larger than the knitted item. You can make your own garment board out of thick cardboard or foam core cut to the measurements of your finished garment.

Alternatively, lay your knitting on a flat surface, such as a bed or a rug covered with towels, or make your own blocking board from a piece of plywood, with one side covered with several layers of quilter's batting and covered with a piece of checked fabric so that you can use the grid of the check to assist in garment placement.

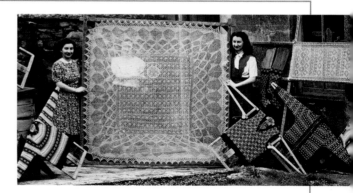

Shetlanders drying an assortment of hand-knitted items on wooly boards. Fair Isle garments include two pullover sweaters, a "sleeveless sweater," a zippered cardigan, and a pair of socks. At the center is a fine lace shawl.

COLOR THEORY

Choosing colors can be intimidating, given the hundreds there are to choose from. It is good to know a little color theory to help you. This sounds complex as there are lots of different technical-sounding terms, but once you grasp the basics, you'll be amazed at how much difference it can make to your designs.

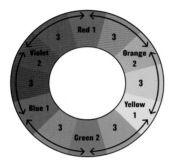

THE COLOR WHEEL
The traditional 12-part artist's color wheel is a useful visual aid. It will help you to think about color in a formal way and assist you in picking out color relationships. The color wheel consists of three primary colors (1), three secondary colors (2), and six tertiary colors (3).

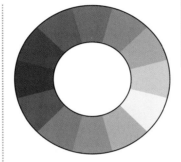

VALUE describes the relative lightness or darkness of a color. Here, the color wheel is seen as a gray scale; it shows the difference in value between yellow and purple and similarity in value of red and green. Value affects how visible a pattern motif will be (see right).

JARGON-BUSTER

Though color theory terms were developed to describe mixing paint, they are useful to help you start looking at and analyzing the colors you see in the world around you.
• HUE is simply another name for color—red, blue, or green. Two different reds might be described as being close in hue, while yellow and purple are different hues.
• SATURATION describes how much pure hue is in the color; fully saturated colors are pure and bright, while ACHROMATIC colors are the least saturated.
• NEUTRALS describes the non-colors of a gray scale that range from white to black.
• TINTS, TONES, and SHADES are colors seen on the color wheel with the addition of various neutrals. A tint is a hue plus white. A tone is a hue plus gray. A shade is a hue plus black.

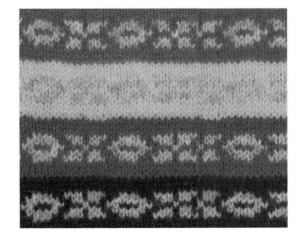

HUE AND VALUE
This swatch demonstrates how the same color pattern can look dramatically different depending on the hue and value of the background color.

The red background brings out gray hues in the beige pattern, the yellow background brings out white flecks, whereas the blues bring out warmer, orangey tones, yet it is the same beige.

A pattern will stand out best if it is paired with a background of a very different value. When the background and the pattern color are of a similar value, the pattern may disappear, no matter how different the hue. A good way to check this is to imagine the colors in monochrome.

TEMPERATURE describes whether a color is "warm" or "cool." People often think that the warm colors are reds and yellows, while the cool colors are blues and greens. However, there are warm and cool versions of all colors. In design, cool colors often seem to recede, while warm colors will come forward. Consider this when selecting background and pattern colors.

Warm red Cool red

This swatch shows a recessive cool blue background with warm pattern foreground detail.

COLOR HARMONIES

There are several recognized color harmonies based on the color wheel. They can be a good starting point for picking out color combinations for Fair Isle projects.

PRIMARY COLORS USED TOGETHER

On Fair Isle, primary colors (red, yellow, and blue) were the first colors introduced after the natural sheep colors. When used together the effect is vivid and lively.

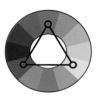

ANALOGOUS COLORS

Analogous colors lie adjacent to each other on the color wheel; for example, greens and blues or reds and oranges. Using them together is almost always a success; they are soothing and harmonious. Subtle blending is easily achieved.

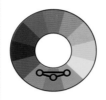

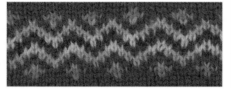

COMPLEMENTARY COLORS

Complementary colors lie opposite each other on the color wheel. Used together, they create high contrast. This dramatic contrast is often just the thing to highlight the center row in a Fair Isle motif. Red and green, as shown here, are just one example.

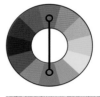

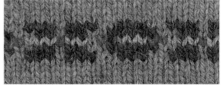

SPLIT COMPLEMENTARY COLORS

If you superimpose an isosceles triangle on the color wheel, the angles will point to one color on one side of the wheel and two on the opposite side; the two on the opposite side will be those on either side of the complementary color. This is usually nicely balanced and harmonious—a good combination to try.

TRIADIC COLORS

Triadic harmony is achieved by using the colors found at the angles of an equilateral triangle superimposed at any point on the color wheel. This is another highly contrasting group that is most useful if you let one of the three colors dominate and use the other two in lesser amounts.

TETRADIC COLORS

If you superimpose a square or rectangle on the color wheel, the corners will point to two cool colors and two warm colors. Try assigning one pair as the background color and the other pair as the pattern motif color.

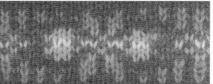

COLOR CHOICE

The apparent complexity of Fair Isle designs can make choosing colors a daunting prospect. However, the amazing color experience is created by using only two colors in a row. In a classic arrangement, colors are arranged in mirror image around the center row of a pattern. Once broken down, Fair Isle patterns and color choice are quite simple.

CHOOSE YOUR COLORS

1 Begin by choosing yarn colors that you like, or by using one of the methods shown opposite. Always choose colors in natural light. Select one group of light colors and one group of dark colors. The most important aspect of each color is its value (see page 31 and tips, below). Line up the colors of each group in a value sequence from dark to light.

Light *Dark*

EDIT THE COLORS

2 Choose three yarns from both the light and the dark groups: the darkest tone, a medium tone, and the lightest tone. Line up your choices next to each other. Is there enough contrast between the groups? Make sure the darkest color of the light group is lighter than the lightest color of the dark group. Decide which group will work best for the background color and which the pattern color.

ADD A HIGHLIGHT

3 When you are happy with your selections, choose your "poison." Poison is a rug hooker's term used to mean that wild bit of color added to make a fabric "sing." Special emphasis on the center row is a hallmark of Fair Isle knitting. An odd rich shade can enliven a somber color scheme, while a neutral shade can bring harmony to a bright grouping; complementary and light colors often work well.

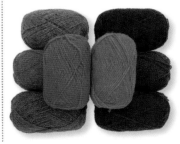

COLOR PLACEMENT

Be aware that where a color is placed will determine how the color is perceived. Using the same colors for the same motif (above), but in different combinations results in strikingly different results. The possibilities are endless!

COLOR LINKING

Sometimes, the trick to overall harmony in a very complex garment is to use at least one color from a large or border pattern in the peerie pattern you choose. The swatch below uses Motifs 120 and 197 and shows that, by using colors from the same colorway, you can combine any of the motifs in this book.

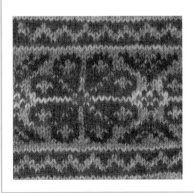

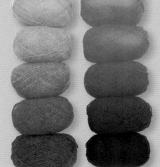

TIPS

In Fair Isle knitting, the value of a color is more important than the actual hue. There are a few tricks to help you find the value of a color:

- Scan yarn samples in black and white, or take a picture of your yarn and convert it to black and white.

- Hold a red or green piece of cellophane over your yarns to cancel out their hues.
- Squint! Squinting squishes some of your eyes' color receptors and grays out your vision.

CLASSIC DESIGN PRINCIPLES

Traditional Fair Isle garments look complex. Although their design requires skill, breaking them down into their component parts reveals that they consist of just three different types of Fair Isle pattern.

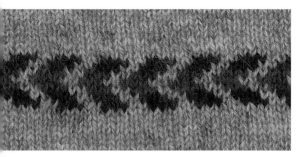

Peerie patterns have 1–7 rows.

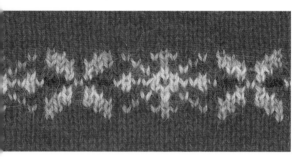

Border patters have 8–15 rows.

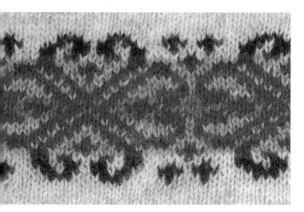

Large patterns have more than 15 rows.

DIFFERENT TYPES OF PATTERN

PEERIE PATTERNS

Peerie is the Shetland dialect word for small, and peerie patterns are those that have 1–7 rows. They are useful for separating larger patterns; but also look cute on their own in small items and baby clothes. Occasionally they can be arranged one on top of another as "seeding patterns"—all-over patterns used for the palms of gloves or to fill out larger areas in panel garments.

BORDER PATTERNS

Border patterns have between 8 and 15 rows. These patterns are sometimes used alone, as the border of a garment. More often, they are alternated with peerie patterns for the familiar "striped" look of a traditional Fair Isle pullover.

LARGE PATTERNS

Large Fair Isle patterns have more than 15 rows. They work well on sweaters in combination with peeries and border patterns. They can also be used singly on the backs of gloves or mittens.

TRADITIONAL ARRANGEMENTS

We've selected a particularly beautiful example from the Shetland Museum (right) to illustrate some of the basic Fair Isle design principles. Traditional Fair Isle garments are made up of horizontal bands, arranged in an alternating sequence of large and smaller pattern motif repeats. The traditional colors—sheep black, indigo, madder, and yellow—are used here with great sophistication. The color placement within the large patterns enlivens the lozenge shapes, without causing them to look striped; the striped appearance in this case comes purely from alternating large pattern and peerie pattern bands.

These same basic design principles can be applied to a range of items. Often just a touch of Fair Isle patterning can add panache to an otherwise plain garment.

A LARGE OXO PATTERNS: These lozenge shapes are staggered in every other band. Note that this particularly fine example employs a different pattern within each lozenge shape, while the Xs remain the same—exquisitely subtle.

B PEERIE PATTERNS: Bands of peeries alternate with large pattern bands. In this case, the peerie remains the same throughout the entire garment and is even picked up and shaped around the neckline to elegant effect. Often, peerie patterns change throughout the garment, although their overall footprint is similar, to keep continuity.

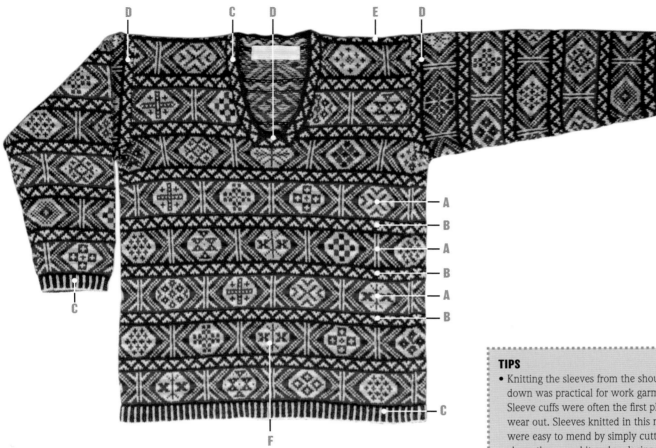

C CORRUGATED RIBBING: This is used to begin the body and to finish off the sleeve cuffs. It is often used to trim necklines, as well. The knit colors and the purl colors are different; the background colors assigned to one and the pattern colors assigned to the other. In this example, indigo and sheep white are used throughout. Corrugated ribbing with many colors can be a delightful design element.

D STEEKING: The sleeve opening and V-neck is bridged by steeks, extra stitches that are cast on, allowing the knitter to continue to knit in the round. Later, these stitches will be cut open. The sleeve stitches are picked up from this cut edge and knit down to the cuff.

E SHOULDER SEAMS: These are centered on a peerie pattern band and are grafted together, graciously finishing the overall design.

F PATTERN PLACEMENT: This has been carefully considered and planned. The OXO patterns are centered at the front of the garment, in a staggered arrangement. The peerie pattern repeat is beautifully centered on the central stitch of the garment front. Although the peerie does not mathematically "fit" within the large pattern, this is inconsequential, as the eye would only perceive the imbalance at the center, where our example is perfect.

PLANNING A PROJECT

This book is first and foremost a collection of pattern motifs. Although it is beyond the scope of this book to teach the nuances of Fair Isle garment design, here are some ideas for using the motifs in your own projects.

START SIMPLY

Fair Isle is a technique that benefits from study and that needs to be practiced. You can study Fair Isle by looking through the motifs in this book and getting a feel for how they are constructed, but there is nothing like knitting the designs yourself to really find out what you enjoy and what you find more of a trial than a pleasure.

A scarf is the traditional starter project for beginners or experienced knitters learning a new technique. Since Fair Isle is most commonly and easily knitted in the round, a good place to start is a knitted tube.

A knitted tube is an extremely flexible and adaptable piece of work: if you have a moment of genius in the first few pattern repeats, you can turn your tube into a hat; if you continue knitting but end up with something you wouldn't wear, you can make your tube into a draft excluder, a small bolster cushion, or a hand warmer; if you are enjoying experimenting you can continue knitting until your tube is 3 ft (1 m) long, when you will have a cozy scarf.

Whatever you decide, you will have made a gauge swatch and a stitch pattern test swatch that you can use to plan other projects.

Start by buying a range of colors in a suitable yarn, cast on enough stitches to fit a 16" (40 cm) circular needle, and work a few rows of corrugated rib. Then select the patterns and yarns that interest you and knit them into your tube. If the stitch patterns do not match exactly the number of stitches you have on the needle, adapt them slightly as indicated on page 38.

ADAPTING AN EXISTING PATTERN

This can be a good starting point for some knitters, rather than designing an entire garment from scratch. By swapping out pattern motifs and choosing your own color scheme, you can produce a totally unique garment, as well as practice some of the guiding principles of Fair Isle design.

Start by knitting a gauge swatch as you would if you were knitting the pattern as described. If you are substituting the yarn, then work the swatch in the yarn you plan to use but using the stitch pattern combinations of the project pattern. This will give you a feel for the pattern and ideas of how you may like to adapt it for your own project.

There are three points to consider when substituting yarns and patterns in a design:

Gauge: The gauge of your yarn must exactly match those specified in the instructions.
Pattern repeat: To make the process an easy one, your chosen pattern motifs must fit exactly into the total number of stitches in the garment.
Row count: The number of rows in your selected pattern motifs must correspond to those making up the garment's length.

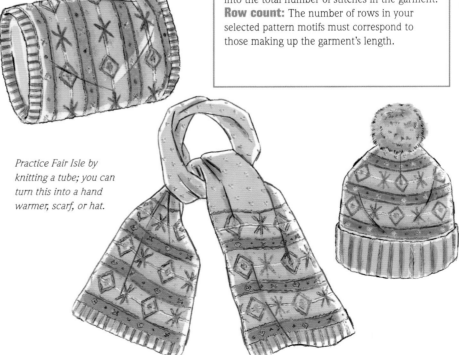

Practice Fair Isle by knitting a tube; you can turn this into a hand warmer, scarf, or hat.

PLANNING A SWEATER

For all projects, careful planning will assure your success and following certain procedures will help you along your way. Even if you are knitting a simple pair of mittens, it is a good idea to take measurements, knit a gauge swatch, and check the fit of the stitches and rows.

1 INITIAL IDEAS

Before tackling a project such as a sweater it is likely that you will have completed a few smaller projects, or at least experimented with various patterns on a gauge swatch. Combine these experiments with inspiration from this book, your yarn stash, or particular colors—wherever you can find it—to generate some initial ideas and draw a rough sketch.

Use your sketch to lay out how you would like to use your chosen pattern motifs. Do you want to alternate peerie and border patterns horizontally, vertically, or as an all-over arrangement? Think about how you will center the motifs with regard to your design. Will you have a circular neckline or a V-neckline? Think about shoulder joins: will the patterns match or will you insert a peerie pattern at the shoulder join?

You can use your sketch to make notes as you mull the project over and start the design process.

Formulate ideas by executing a number of rough sketches—think about pattern placement, neckline, shoulder joins, and color.

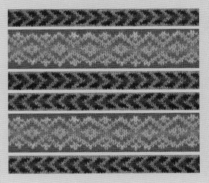

TIP

To experiment with pattern placement, try photocopying the motifs in this book, cutting them into strips, and placing them next to each other. Try different arrangements: you might decide you need to introduce an extra pattern to give your garment balance. You will get a good idea of which patterns look good together, how many times to use a pattern motif, and what kind of centering you will need.

TIP

It is also helpful to measure a favorite sweater or jacket and note how these measurements differ from those taken from the body. Traditionally, a Fair Isle garment has a lot of ease: for a man's garment as much as 5" (12.5 cm) around the chest, for a woman's garment 4" (10 cm) around the chest, for a child's garment 4" (10 cm) around the chest, or, alternatively, about 10 percent of the body measurement. If the measurements are taken from a garment, ease and fit will have been calculated for you.

2 TAKE YOUR MEASUREMENTS

Accurate measurements are the key to success, so note all important measurements on your sketch:
- Bust/chest circumference (**1**)
- Back length—nape of neck to waist or hip (**2**)
- Sleeve length, wrist to underarm (**3**)
- Armhole depth (**4**)
- Neckline width (**5**)
- Wrist circumference (**6**)
- Hem circumference (**7**)

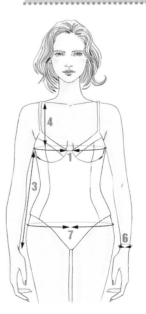
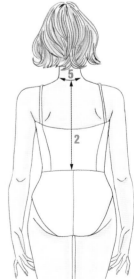

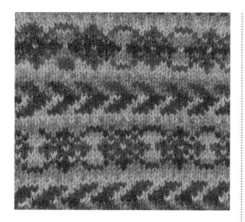

3 DETERMINE YOUR GAUGE

Knit a generous gauge swatch (see pages 14–15), using the type of yarn, the pattern motifs, and the needle size you intend to use for the finished piece.

Pay special attention to the number of plain rows of knitting in your piece. Plain knitting produces a row gauge greater than the stitch gauge, so make sure your swatch has the same ratio of plain rows to stranded rows as your planned garment. This gauge swatch will determine all your final calculations.

4 DETERMINE THE NUMBER OF STITCHES FOR THE WIDTH

To work out how many stitches you need to cast on, multiply the required width of your garment by two (you'll be knitting in the round and need to cast on enough stitches for both the front and the back at the same time). Then multiply this number by the number of stitches in 1" (2.5 cm) of your gauge swatch.

For example, if your stitch gauge comes out at 32 stitches to 4" (10 cm), and you want your sweater to fit a 36" (90-cm) chest, multiply 36" (90 cm) by 8 (the number of stitches in 1"/2.5 cm).

5 DETERMINE THE NUMBER OF ROWS FOR THE LENGTH

To find the total length, multiply the length you want the garment to be by the number of rows in 1" (2.5 cm) of the gauge swatch. For example, if your stitch gauge comes out at 32 rows to 4" (10 cm), and you want your sweater to be 20" (50 cm) long, multiply 20" (50 cm) by 8 (the number of rows in 1"/2.5 cm).

Then, repeat these calculations for all parts of the garment noted on your sketch.

Gauge swatch stitches	32 stitches to 4" (10 cm)
Stitches per inch (cm)	8 stitches to 1" (2.5 cm)
Sweater size	18" (45-cm) chest x 2 (for front and back) = 36" (90-cm) circumference
Total number of stitches for width	8 stitches x 36 = 288 stitches

Gauge swatch rows	32 rows to 4" (10 cm)
Rows per inch (cm)	8 rows to 1" (2.5 cm)
Sweater size	20" (50 cm)
Total number of rows for length	8 rows x 20 = 160 rows

6 CHECK THE MATH OF YOUR MOTIFS

The number of pattern repeats in your chosen motifs must fit into the total number of stitches. So if the total number of stitches is 140, then you can use patterns with repeats of 2, 4, 5, 7, 10, 14, and 20. Similarly, the number of rows must fit into the total length.

If the pattern repeat does not fit exactly, you have a few options: you can adjust it (see box, left), choose another, similar, motif, or change the total number of stitches of the garment, provided this will not change the size of your finished garment too much.

It is easier to adjust the number of rows in a garment as it is possible to add in rows of peeries or plain knitting between motifs or create a band of corrugated ribbing (see page 19).

The motifs in this book are arranged by row, then stitch count, so it should be possible to quickly and easily find a motif that suits your needs.

ADJUSTING STITCH REPEATS

Sometimes the stitch pattern you'd like to use won't fit perfectly into the number of stitches needed for your garment; make patterns fit by adjusting stitch repeats.

For example, Motif 177, a 13 round 16 stitch repeat, can easily be adjusted by making the X smaller or larger (see right).

Experiment with reducing and enlarging other motifs on graph paper.

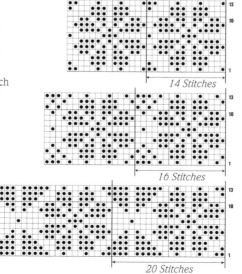

14 Stitches

16 Stitches

20 Stitches

7 PLACING PATTERN MOTIFS

To center a pattern, the midpoint of either the X or the O of a motif must be placed at the center front stitch of the garment. With an even number of repeats, the back and front will not have complete motifs on them. This means the beginning of the round will need to be adjusted accordingly. If the number of repeats is odd, the back and front will have complete repeats on them, but they will not match at the shoulders. To compensate, a peerie pattern can be worked at the shoulder join to camouflage this.

Vertical arrangements should end at the shoulder with a complete motif or at the center of a motif.

PLANNING A CARDIGAN

The design of a cardigan is very similar to that of a sweater, but a cardigan has a front opening. A stitch pattern may still be centered on the front and the design split by the opening or the motif may start either side of the planned opening. Additional considerations are the facing and button placement in relation to the changes of stitch pattern.

PLANNING A YOKED SWEATER

A yoked sweater can either be made from the top down or from the bottom up.

If worked from the bottom up, the lower section of the body and the two sleeves are worked separately to the bottom of the underarm opening, at which point they are joined. The yoke is then knitted in one piece around the shoulders, with decreases worked evenly around the round, on rounds without pattern, and at regular intervals to the neckline.

If worked from the top down, stitches are cast on for the neckline and increases are worked at regular intervals until the yoke reaches the bottom of the underarm opening; at this point the stitches are divided into three sections—one for each sleeve and one for the body—and worked separately.

"Tree"-style motifs (such as Motif 177) work particularly well on yoked sweaters.

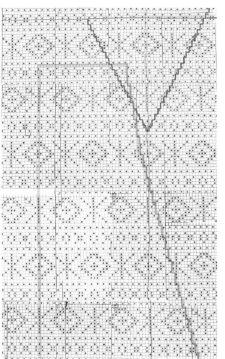

Making a chart on graph paper of your final design. The red line (above) shows where the neckline will be and the yellow line plots the motifs that will be worked for the sleeves.

8 FINAL DESIGN

Finally, write up all your adjustments and calculations. Redraw your sketch with all the correct measurements and with a reminder of where any steeks will be placed and how many stitches they will be. Make a chart of the final pattern motifs on graph paper with the correct placement. It is also useful to tape strands of yarn to the side of the chart, labeled with their shade number, so that you can see instantly which yarn to use and when.

This sweater, made using an analogous palette of grays, greens, and blues, was planned following the steps laid out in this book.

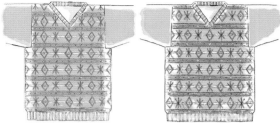

The midpoint of either the X or the O of a motif should be placed at the center of a garment.

Vertical arrangements should end with a complete X or O or at the center of an X or O.

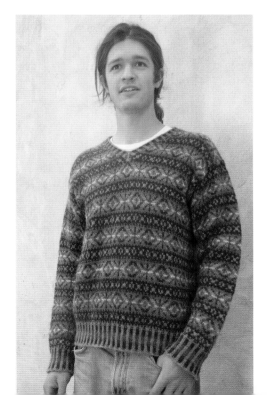

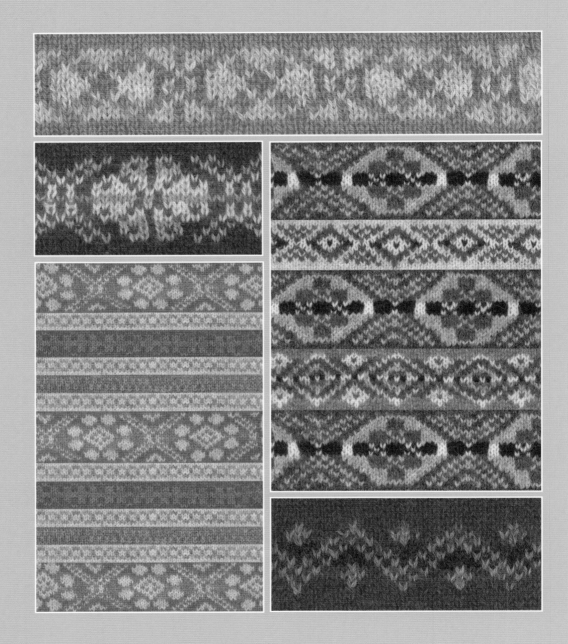

Motif Directory

The directory opens with a colorful visual selector displaying all the motifs side-by-side. Then the motifs themselves are organized by row and stitch count. A stunning actual-size photograph, a black and white chart, a color chart, a color variation chart, and a suggested all-over repeat chart are included for each of the 200 motifs.

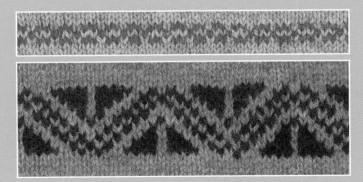

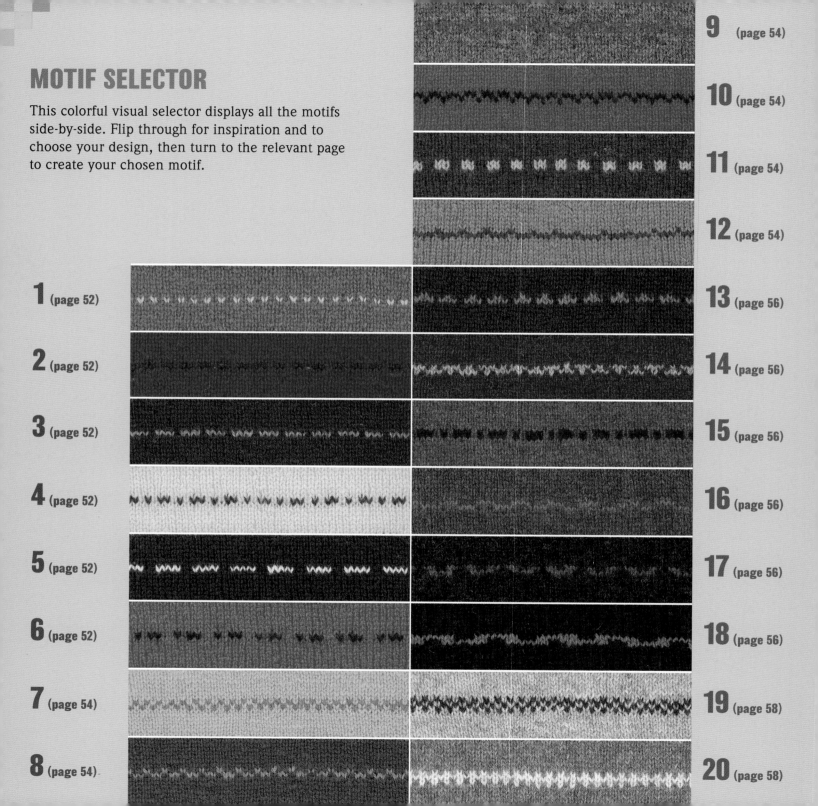

MOTIF SELECTOR

This colorful visual selector displays all the motifs side-by-side. Flip through for inspiration and to choose your design, then turn to the relevant page to create your chosen motif.

9 (page 54)

10 (page 54)

11 (page 54)

12 (page 54)

1 (page 52)

2 (page 52)

3 (page 52)

4 (page 52)

5 (page 52)

6 (page 52)

7 (page 54)

8 (page 54)

13 (page 56)

14 (page 56)

15 (page 56)

16 (page 56)

17 (page 56)

18 (page 56)

19 (page 58)

20 (page 58)

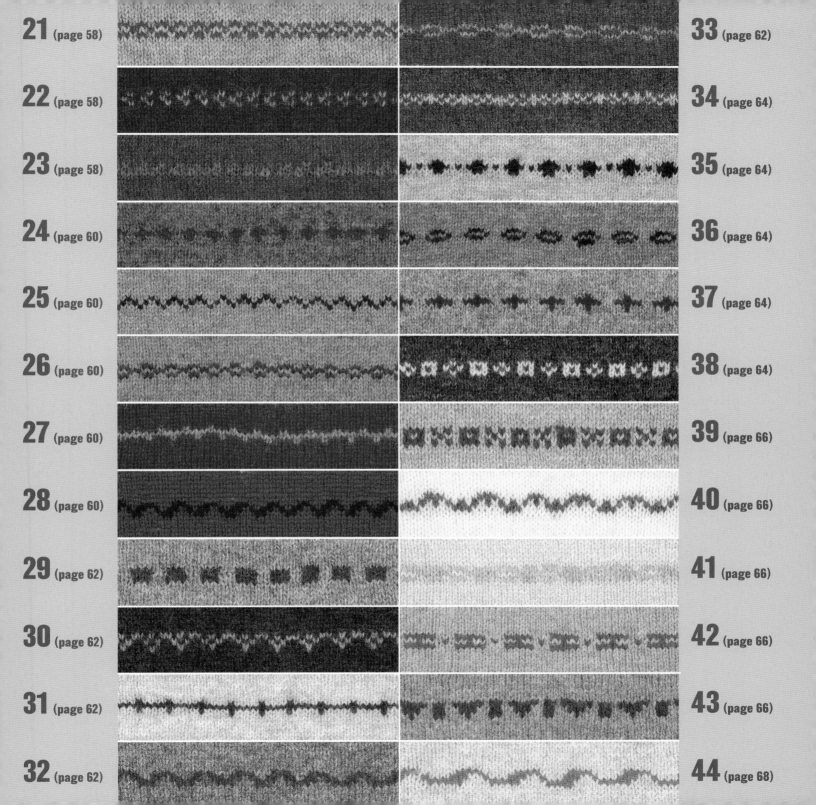

21 (page 58)

22 (page 58)

23 (page 58)

24 (page 60)

25 (page 60)

26 (page 60)

27 (page 60)

28 (page 60)

29 (page 62)

30 (page 62)

31 (page 62)

32 (page 62)

33 (page 62)

34 (page 64)

35 (page 64)

36 (page 64)

37 (page 64)

38 (page 64)

39 (page 66)

40 (page 66)

41 (page 66)

42 (page 66)

43 (page 66)

44 (page 68)

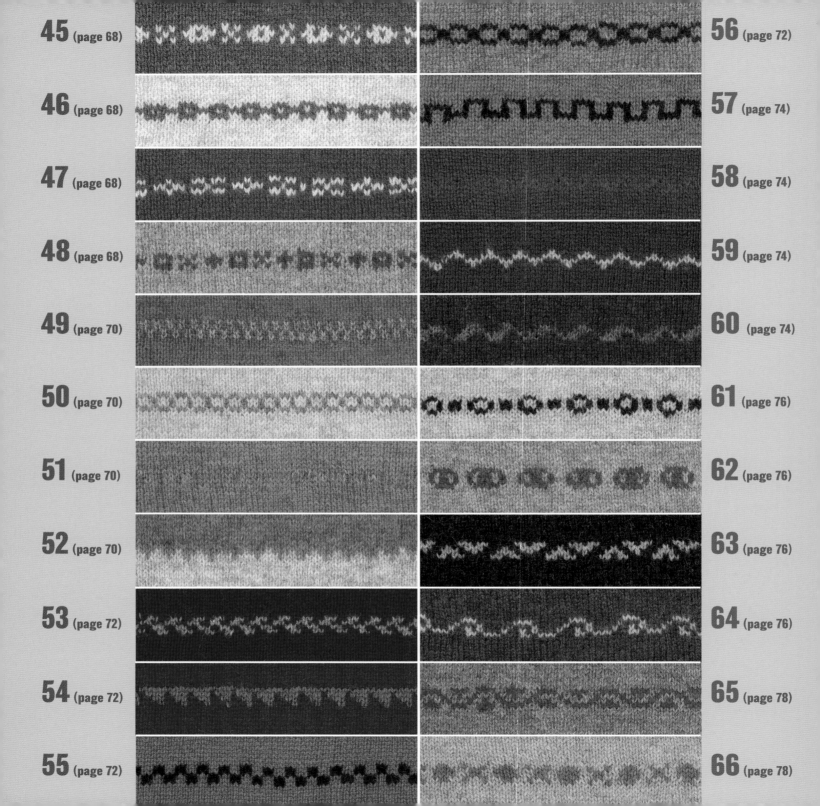

45 (page 68)

46 (page 68)

47 (page 68)

48 (page 68)

49 (page 70)

50 (page 70)

51 (page 70)

52 (page 70)

53 (page 72)

54 (page 72)

55 (page 72)

56 (page 72)

57 (page 74)

58 (page 74)

59 (page 74)

60 (page 74)

61 (page 76)

62 (page 76)

63 (page 76)

64 (page 76)

65 (page 78)

66 (page 78)

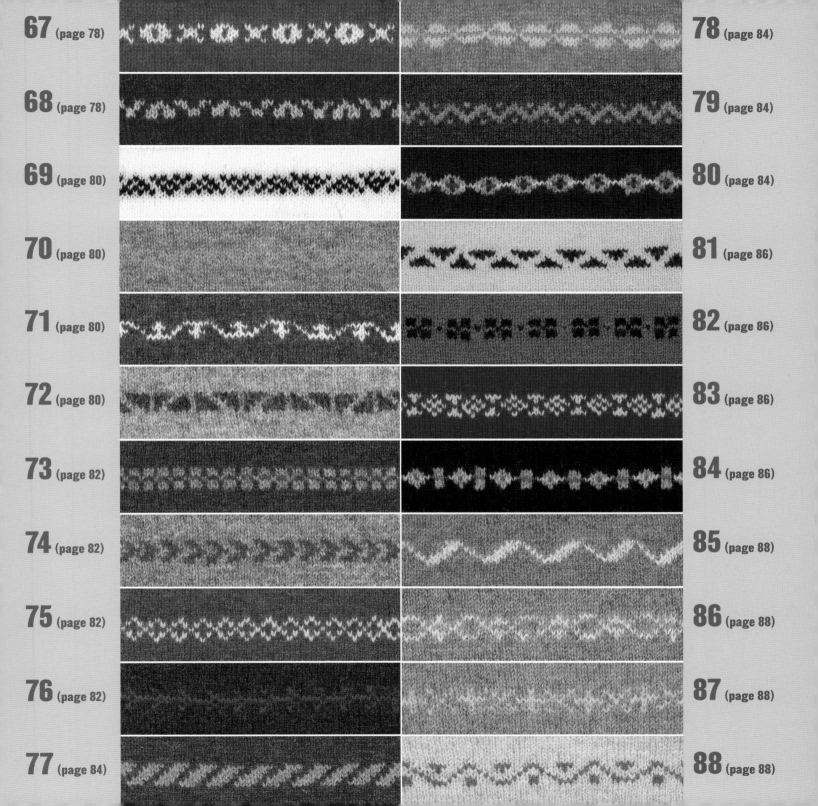

67 (page 78)

68 (page 78)

69 (page 80)

70 (page 80)

71 (page 80)

72 (page 80)

73 (page 82)

74 (page 82)

75 (page 82)

76 (page 82)

77 (page 84)

78 (page 84)

79 (page 84)

80 (page 84)

81 (page 86)

82 (page 86)

83 (page 86)

84 (page 86)

85 (page 88)

86 (page 88)

87 (page 88)

88 (page 88)

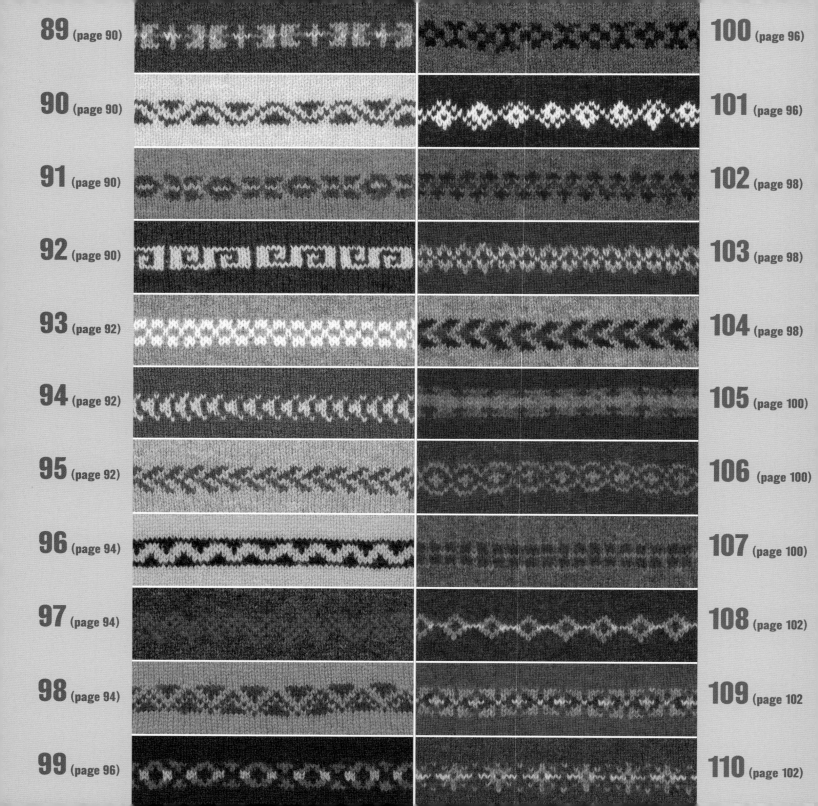

89 (page 90)

90 (page 90)

91 (page 90)

92 (page 90)

93 (page 92)

94 (page 92)

95 (page 92)

96 (page 94)

97 (page 94)

98 (page 94)

99 (page 96)

100 (page 96)

101 (page 96)

102 (page 98)

103 (page 98)

104 (page 98)

105 (page 100)

106 (page 100)

107 (page 100)

108 (page 102)

109 (page 102)

110 (page 102)

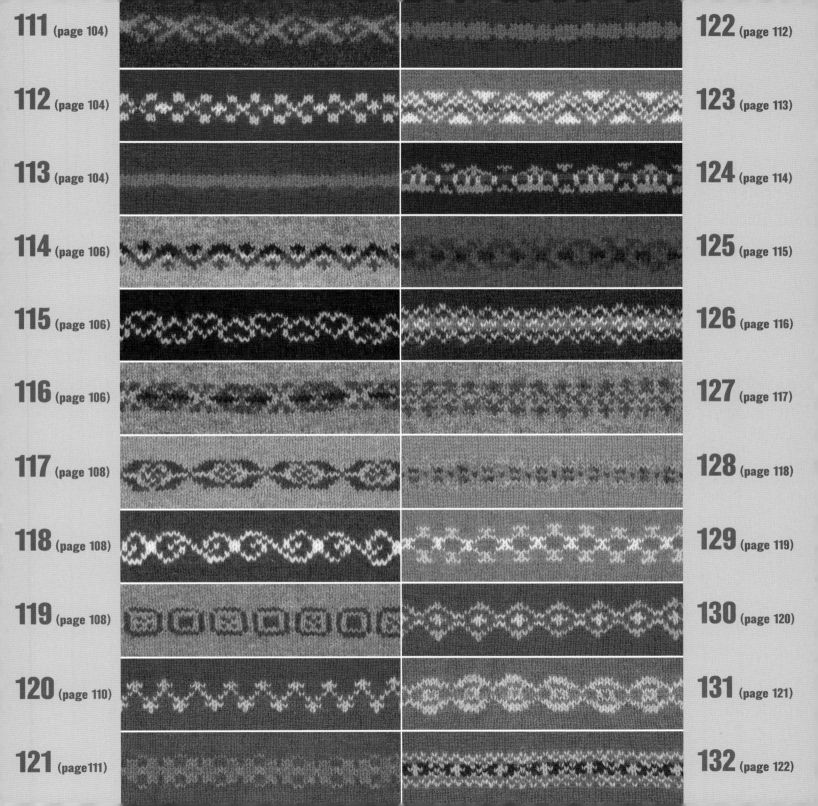

111 (page 104)

112 (page 104)

113 (page 104)

114 (page 106)

115 (page 106)

116 (page 106)

117 (page 108)

118 (page 108)

119 (page 108)

120 (page 110)

121 (page 111)

122 (page 112)

123 (page 113)

124 (page 114)

125 (page 115)

126 (page 116)

127 (page 117)

128 (page 118)

129 (page 119)

130 (page 120)

131 (page 121)

132 (page 122)

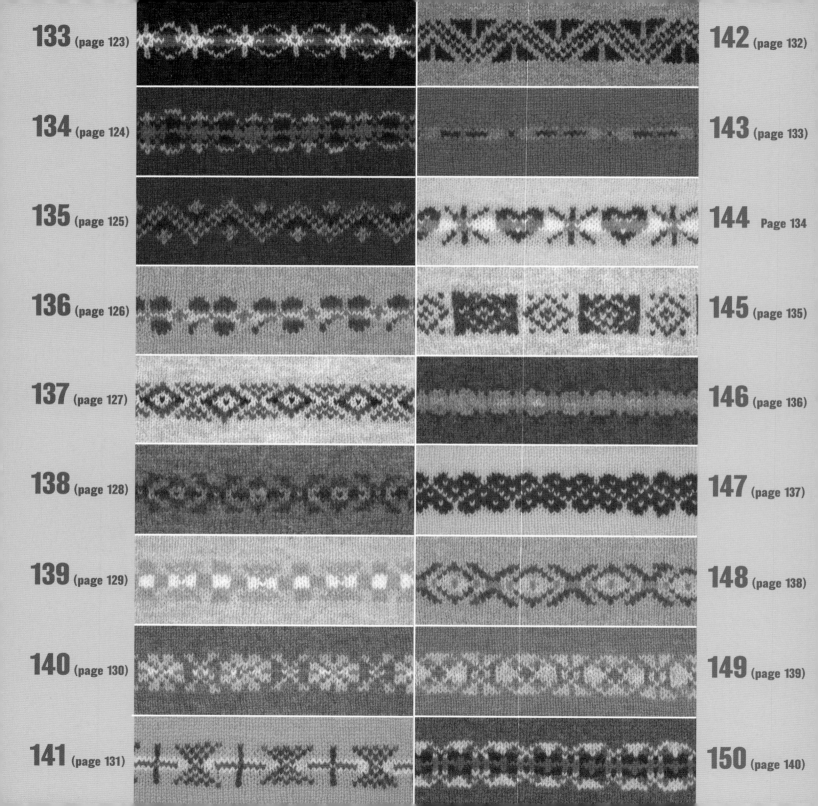

133 (page 123)

142 (page 132)

134 (page 124)

143 (page 133)

135 (page 125)

144 Page 134

136 (page 126)

145 (page 135)

137 (page 127)

146 (page 136)

138 (page 128)

147 (page 137)

139 (page 129)

148 (page 138)

140 (page 130)

149 (page 139)

141 (page 131)

150 (page 140)

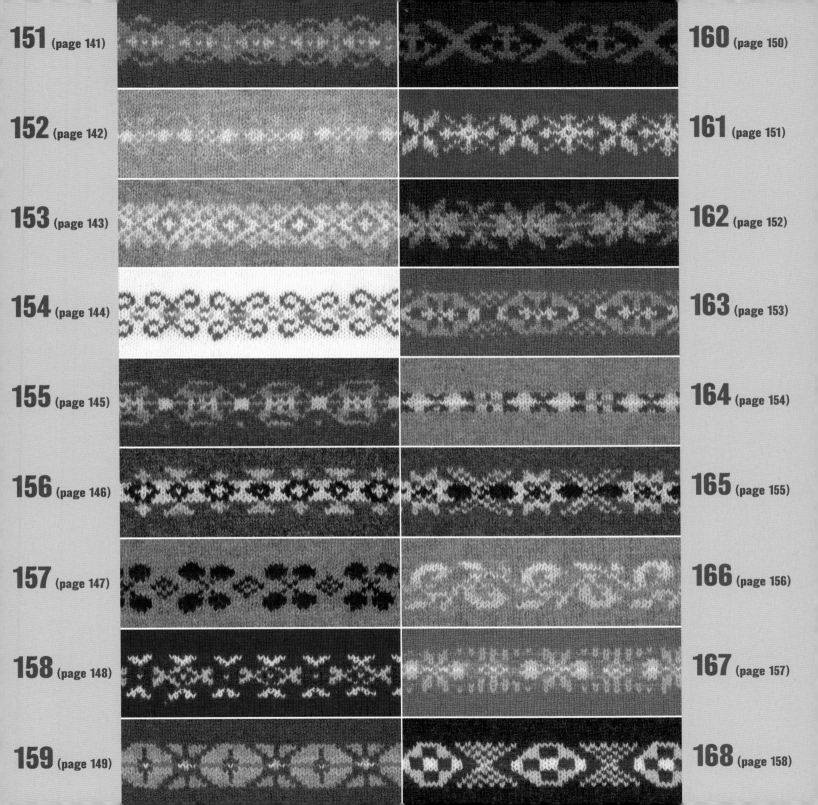

151 (page 141)

160 (page 150)

152 (page 142)

161 (page 151)

153 (page 143)

162 (page 152)

154 (page 144)

163 (page 153)

155 (page 145)

164 (page 154)

156 (page 146)

165 (page 155)

157 (page 147)

166 (page 156)

158 (page 148)

167 (page 157)

159 (page 149)

168 (page 158)

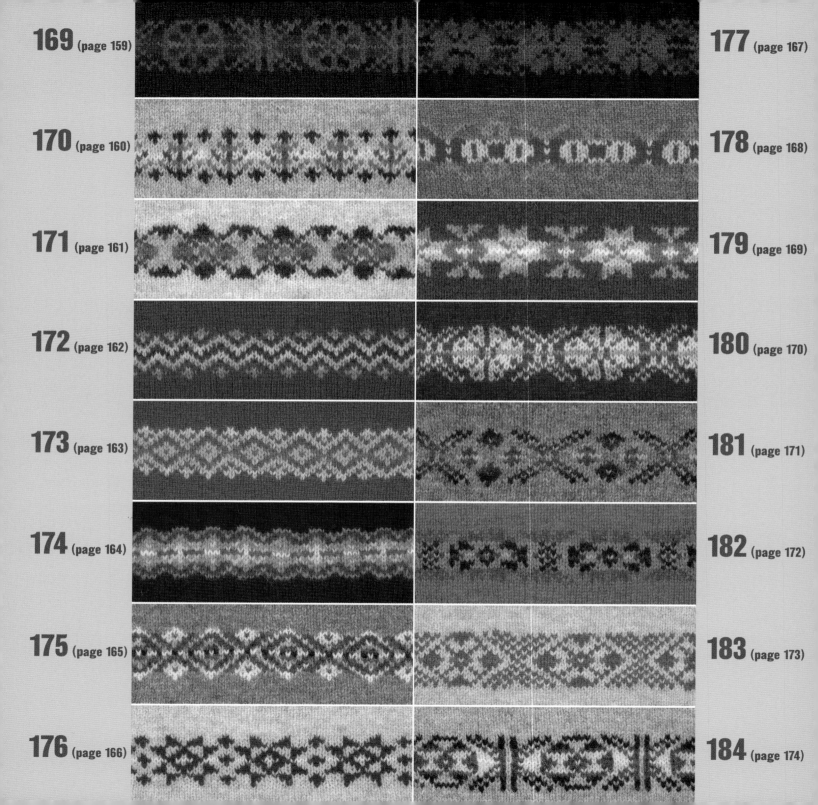

169 (page 159)

170 (page 160)

171 (page 161)

172 (page 162)

173 (page 163)

174 (page 164)

175 (page 165)

176 (page 166)

177 (page 167)

178 (page 168)

179 (page 169)

180 (page 170)

181 (page 171)

182 (page 172)

183 (page 173)

184 (page 174)

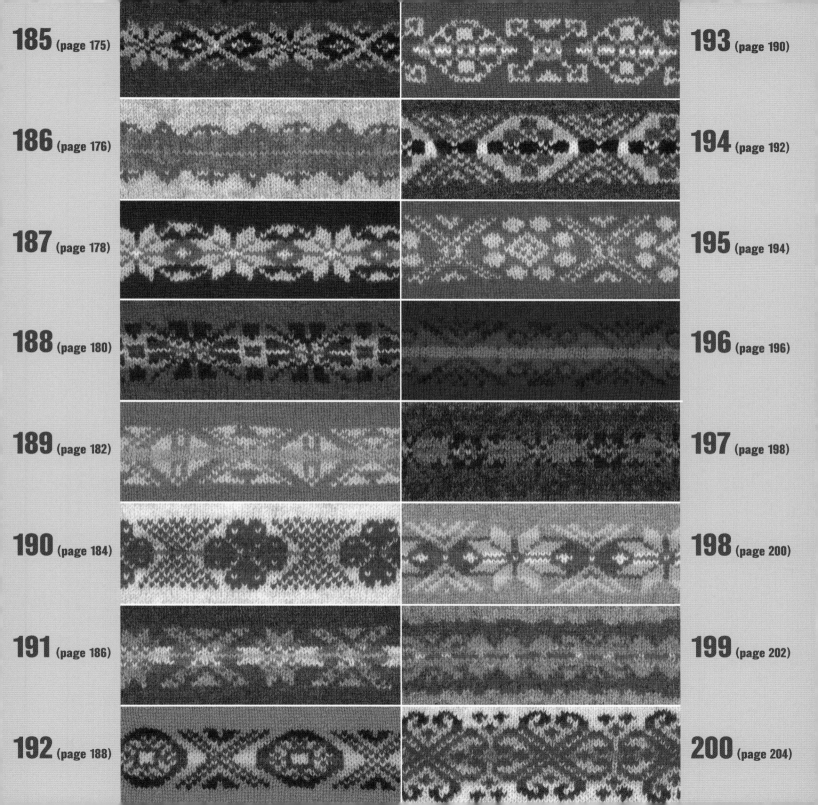

185 (page 175)

186 (page 176)

187 (page 178)

188 (page 180)

189 (page 182)

190 (page 184)

191 (page 186)

192 (page 188)

193 (page 190)

194 (page 192)

195 (page 194)

196 (page 196)

197 (page 198)

198 (page 200)

199 (page 202)

200 (page 204)

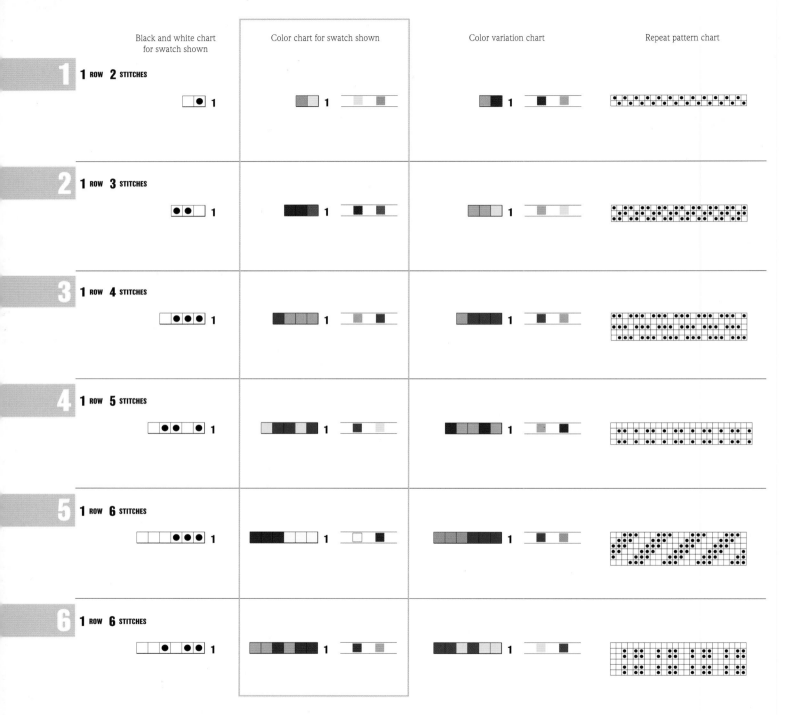

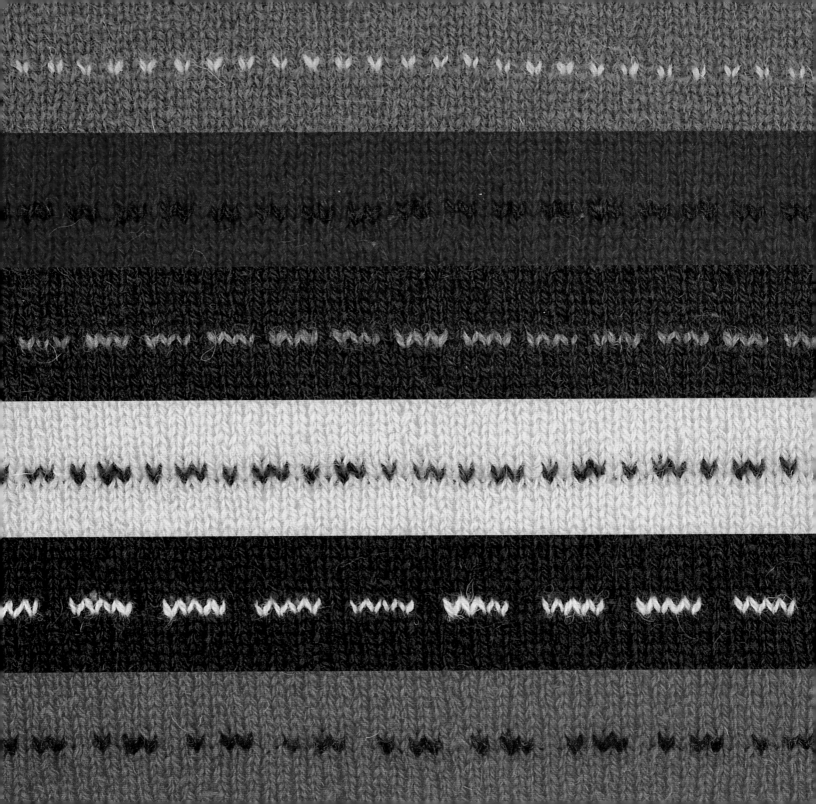

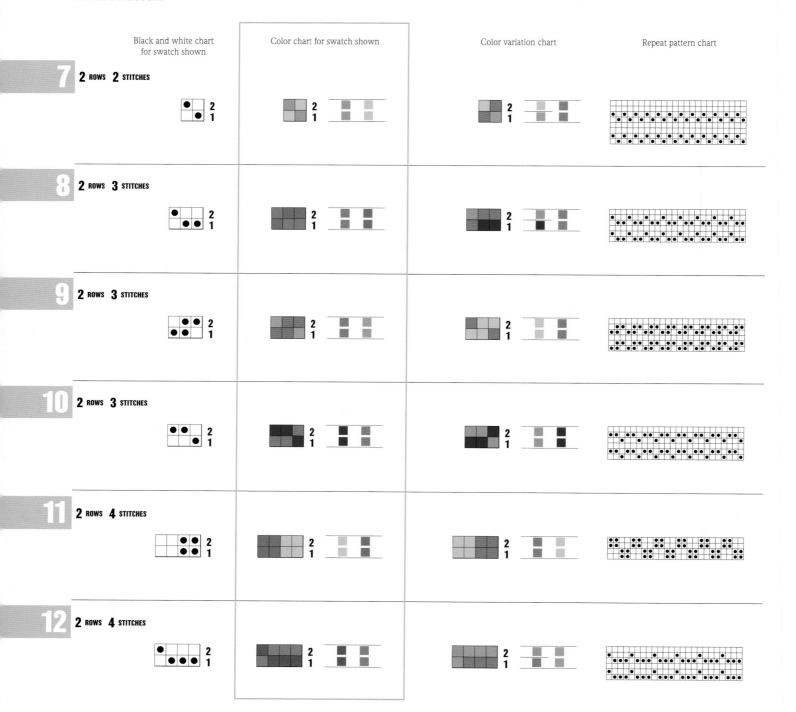

Black and white chart for swatch shown	Color chart for swatch shown	Color variation chart	Repeat pattern chart

7 2 ROWS 2 STITCHES

8 2 ROWS 3 STITCHES

9 2 ROWS 3 STITCHES

10 2 ROWS 3 STITCHES

11 2 ROWS 4 STITCHES

12 2 ROWS 4 STITCHES

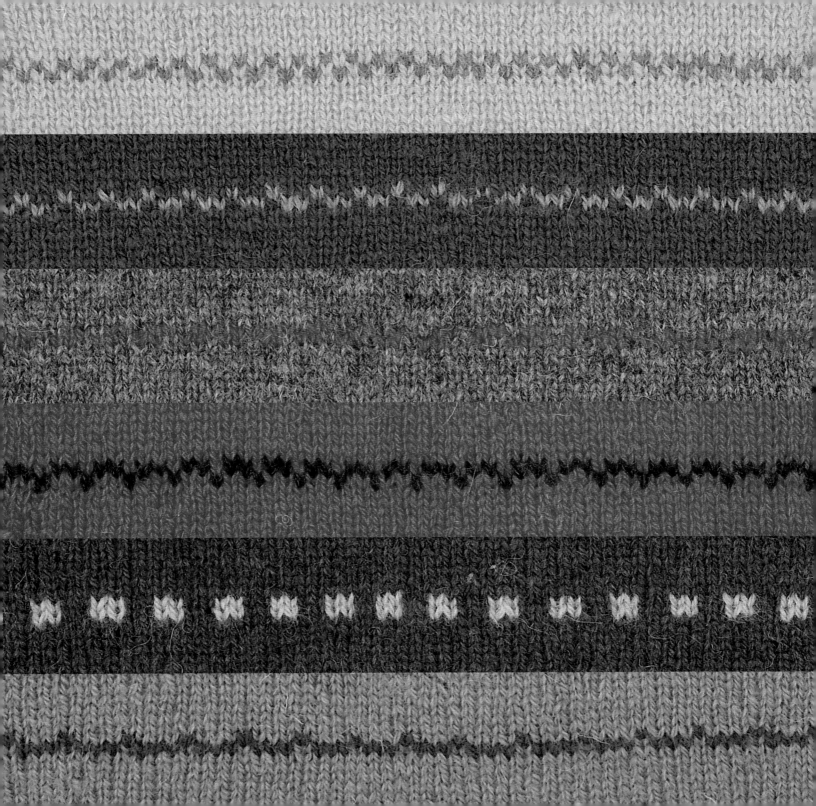

Black and white chart for swatch shown | Color chart for swatch shown | Color variation chart | Repeat pattern chart

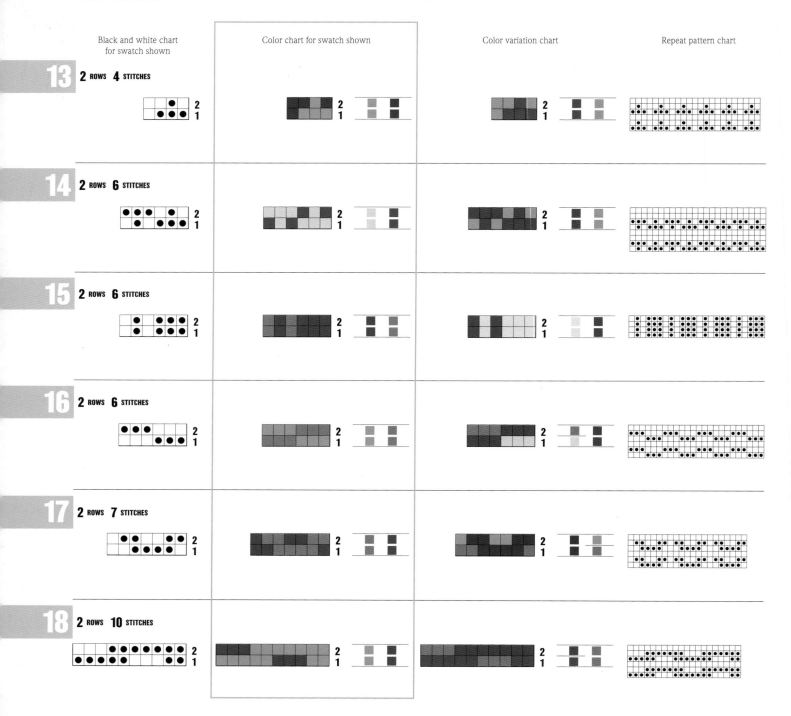

13 2 ROWS 4 STITCHES

14 2 ROWS 6 STITCHES

15 2 ROWS 6 STITCHES

16 2 ROWS 6 STITCHES

17 2 ROWS 7 STITCHES

18 2 ROWS 10 STITCHES

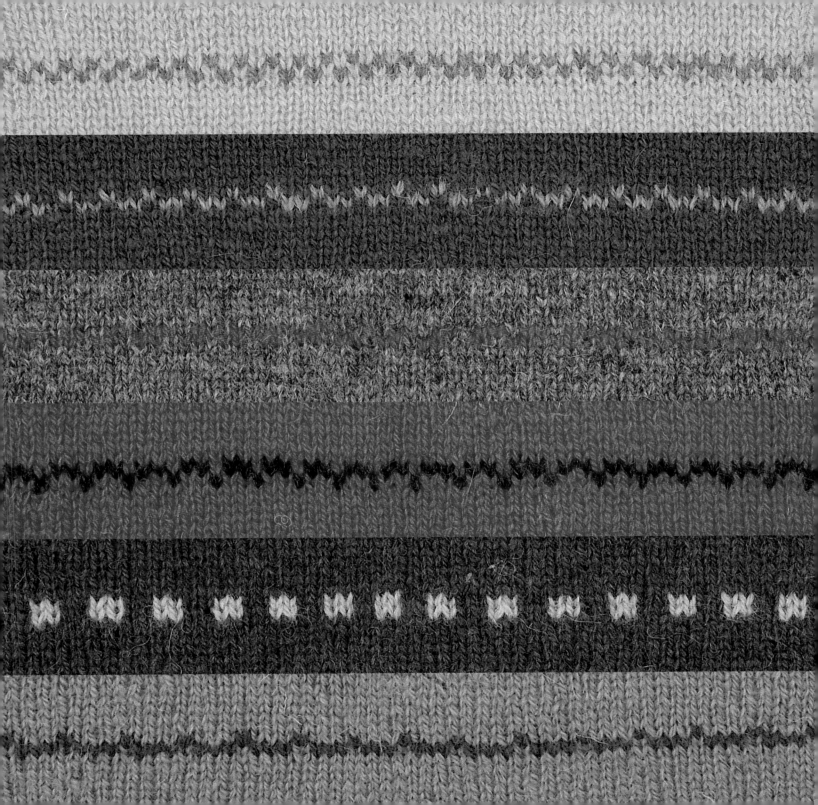

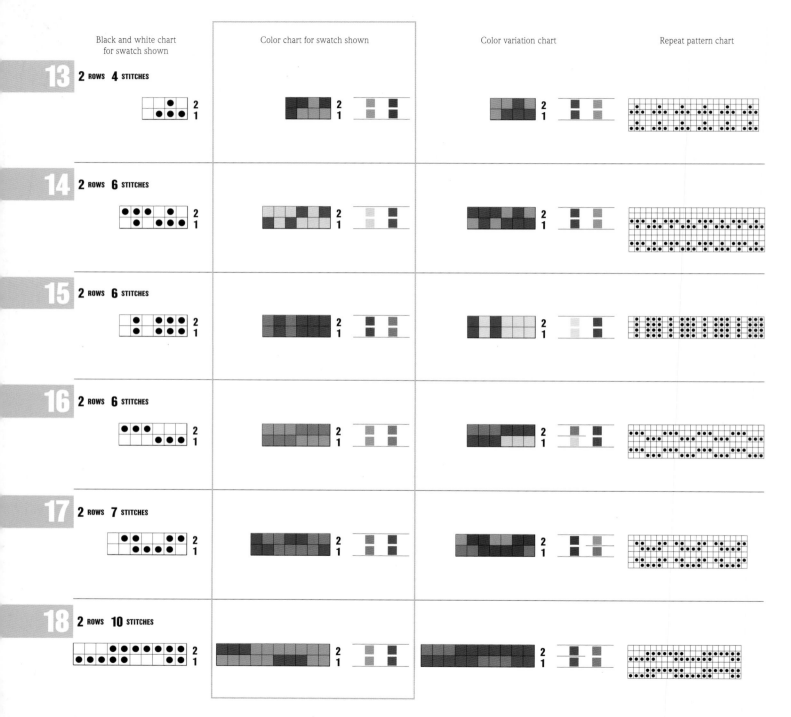

Black and white chart for swatch shown | Color chart for swatch shown | Color variation chart | Repeat pattern chart

13 2 ROWS 4 STITCHES

14 2 ROWS 6 STITCHES

15 2 ROWS 6 STITCHES

16 2 ROWS 6 STITCHES

17 2 ROWS 7 STITCHES

18 2 ROWS 10 STITCHES

	Black and white chart for swatch shown	Color chart for swatch shown	Color variation chart	Repeat pattern chart

19 **3** ROWS **2** STITCHES

20 **3** ROWS **2** STITCHES

21 **3** ROWS **3** STITCHES

22 **3** ROWS **3** STITCHES

23 **3** ROWS **3** STITCHES

The motif has been mirrored horizontally to create this repeat.

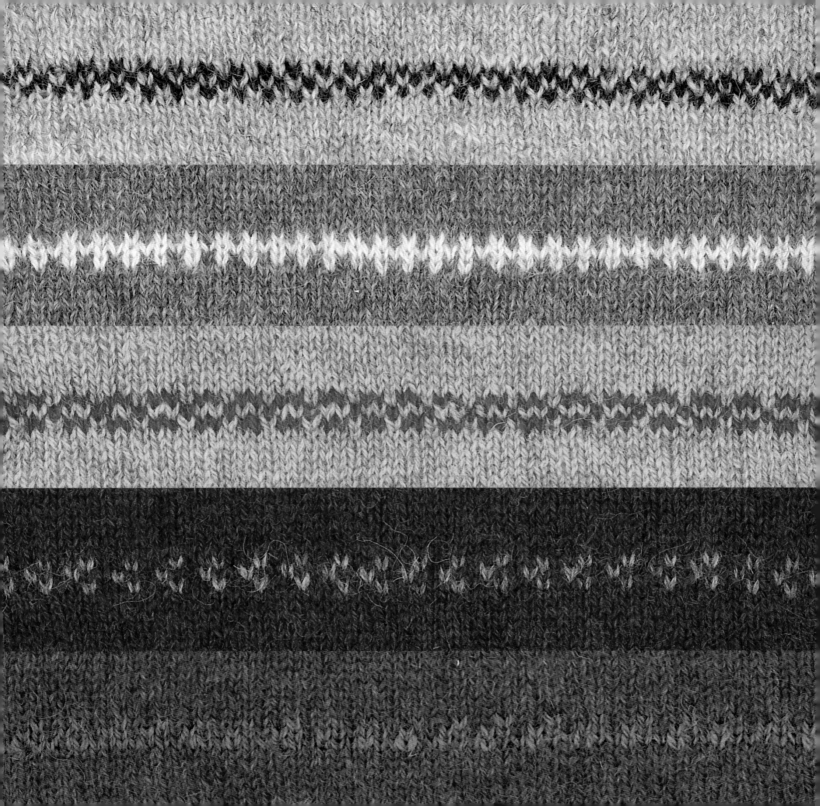

	Black and white chart for swatch shown	Color chart for swatch shown	Color variation chart	Repeat pattern chart

24 **3** ROWS **4** STITCHES

25 **3** ROWS **4** STITCHES

26 **3** ROWS **4** STITCHES

27 **3** ROWS **4** STITCHES

28 **3** ROWS **5** STITCHES

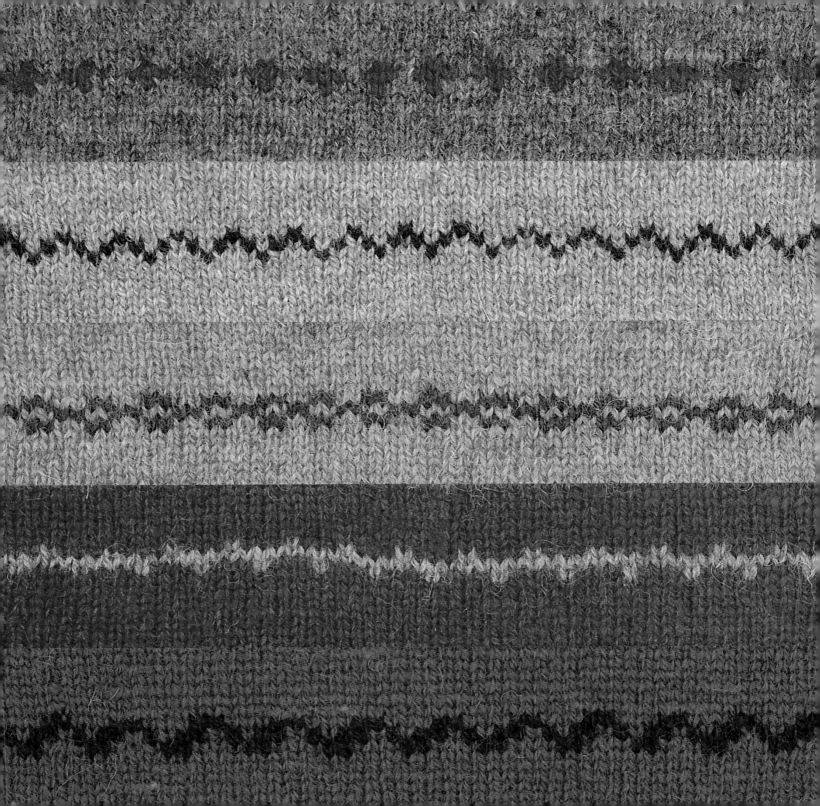

Black and white chart for swatch shown	Color chart for swatch shown	Color variation chart	Repeat pattern chart

29 **3** ROWS **5** STITCHES

30 **3** ROWS **5** STITCHES

31 **3** ROWS **5** STITCHES

32 **3** ROWS **6** STITCHES

33 **3** ROWS **6** STITCHES

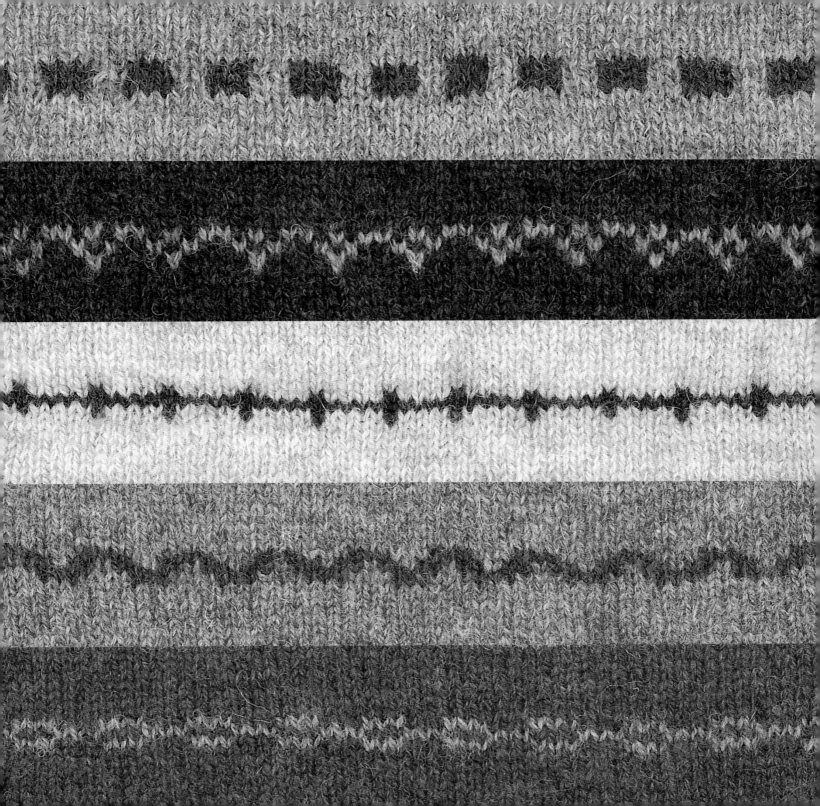

Black and white chart for swatch shown	Color chart for swatch shown	Color variation chart	Repeat pattern chart

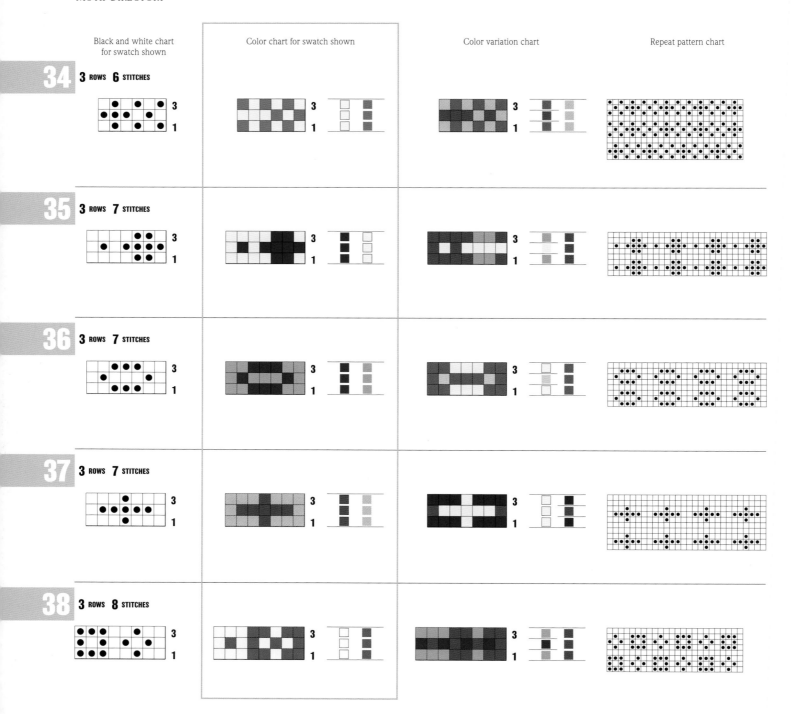

34 3 ROWS 6 STITCHES

35 3 ROWS 7 STITCHES

36 3 ROWS 7 STITCHES

37 3 ROWS 7 STITCHES

38 3 ROWS 8 STITCHES

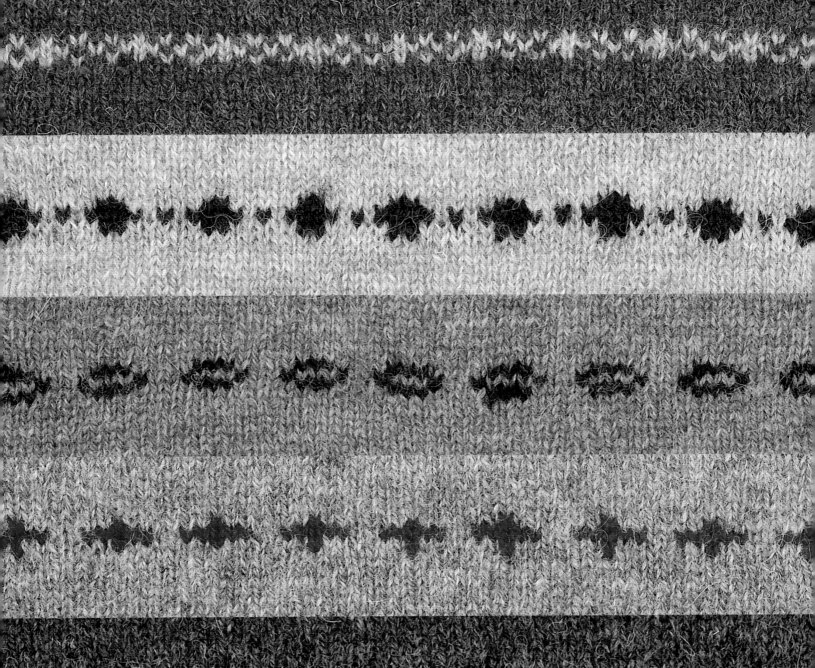

Black and white chart for swatch shown | Color chart for swatch shown | Color variation chart | Repeat pattern chart

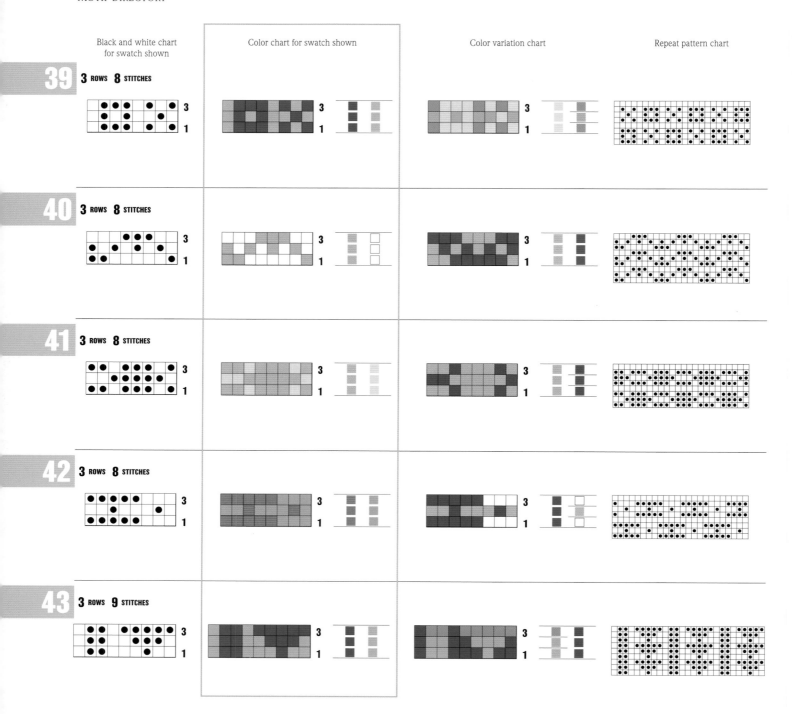

39 3 ROWS 8 STITCHES

40 3 ROWS 8 STITCHES

41 3 ROWS 8 STITCHES

42 3 ROWS 8 STITCHES

43 3 ROWS 9 STITCHES

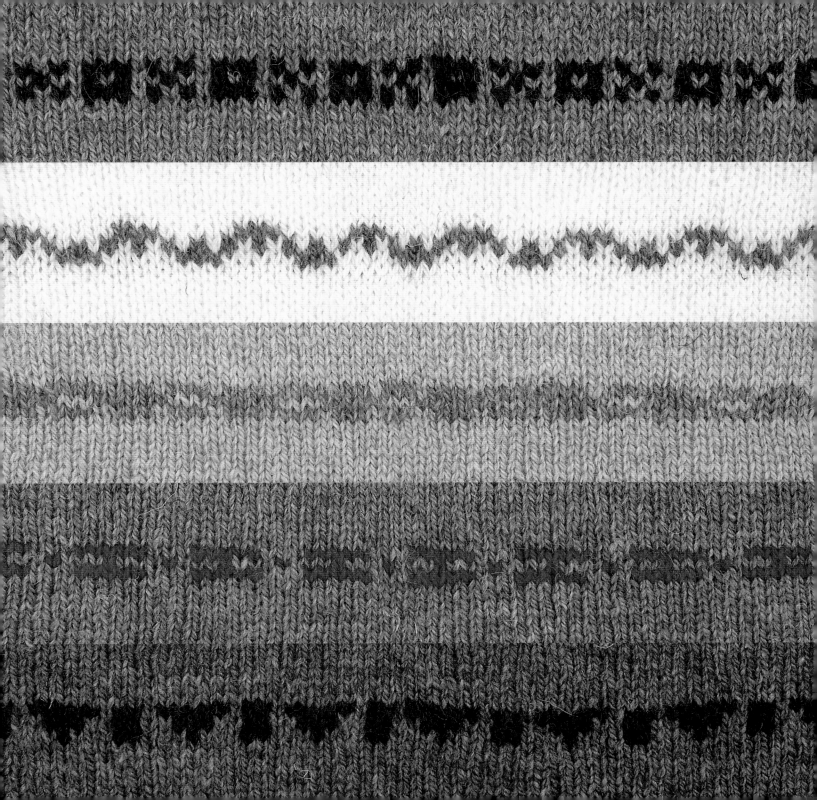

Black and white chart
for swatch shown

Color chart for swatch shown

Color variation chart

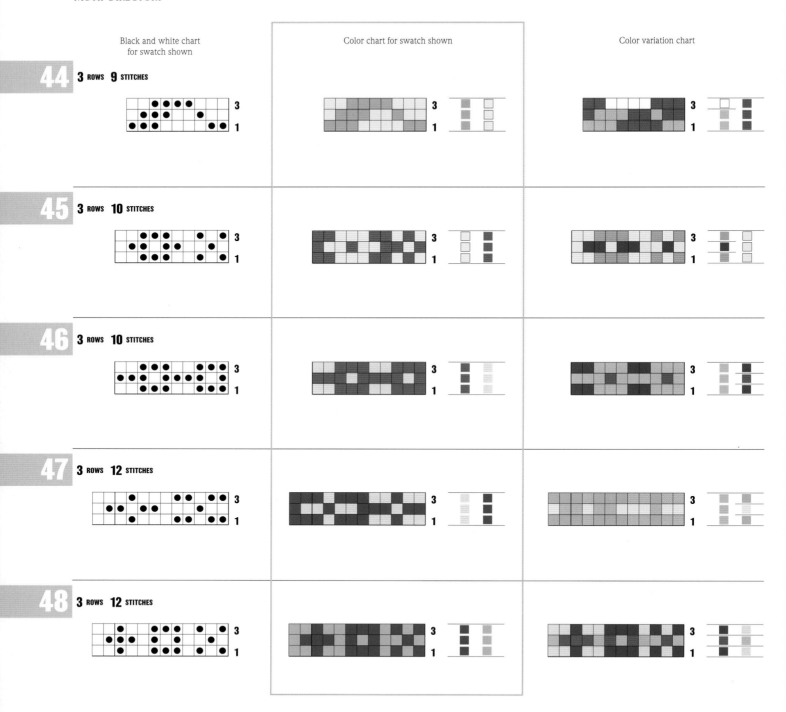

44 **3** ROWS **9** STITCHES

45 **3** ROWS **10** STITCHES

46 **3** ROWS **10** STITCHES

47 **3** ROWS **12** STITCHES

48 **3** ROWS **12** STITCHES

Repeat pattern chart

Black and white chart for swatch shown

Color chart for swatch shown

Color variation chart

Repeat pattern chart

49 4 ROWS 2 STITCHES

50 4 ROWS 3 STITCHES

51 4 ROWS 3 STITCHES

52 4 ROWS 4 STITCHES

Black and white chart for swatch shown	Color chart for swatch shown	Color variation chart	Repeat pattern chart

53 **4** ROWS **4** STITCHES

54 **4** ROWS **4** STITCHES

55 **4** ROWS **4** STITCHES

56 **4** ROWS **5** STITCHES

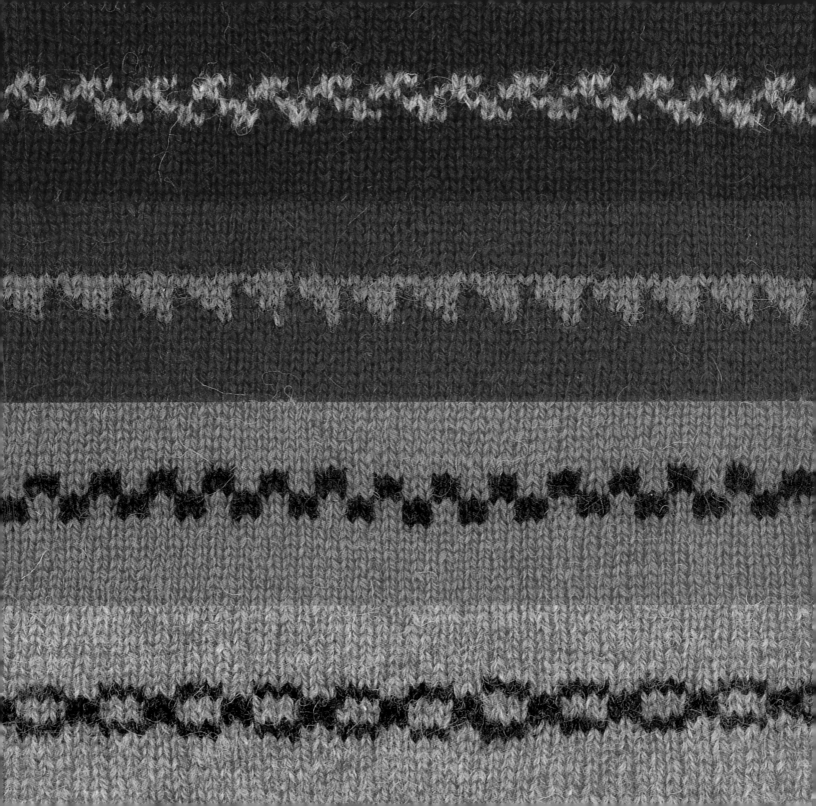

Black and white chart for swatch shown	Color chart for swatch shown	Color variation chart	Repeat pattern chart

57 4 ROWS 6 STITCHES

58 4 ROWS 6 STITCHES

59 4 ROWS 6 STITCHES

60 4 ROWS 7 STITCHES

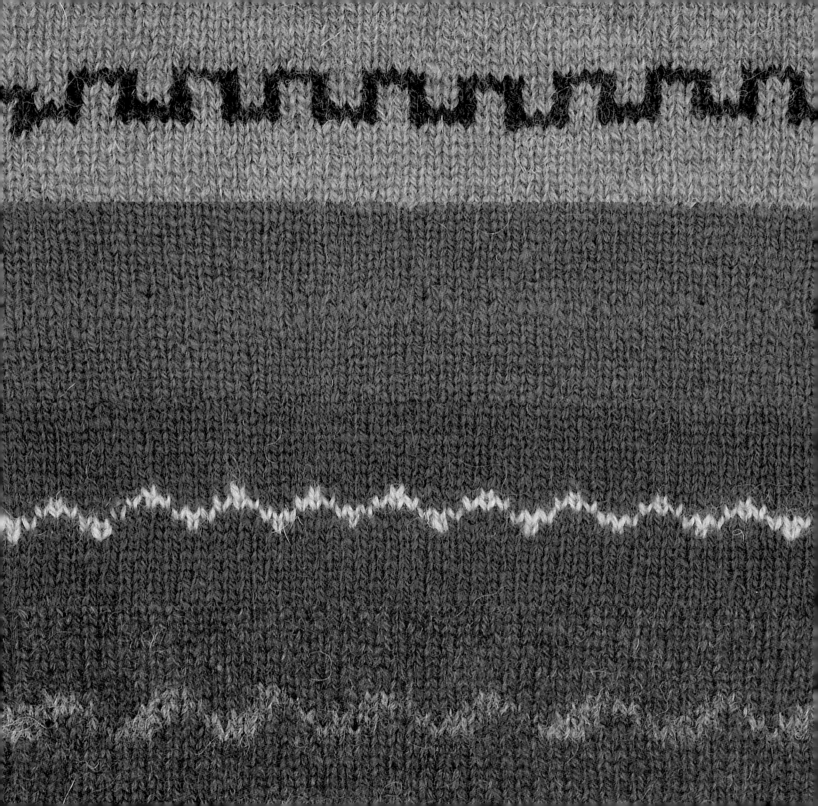

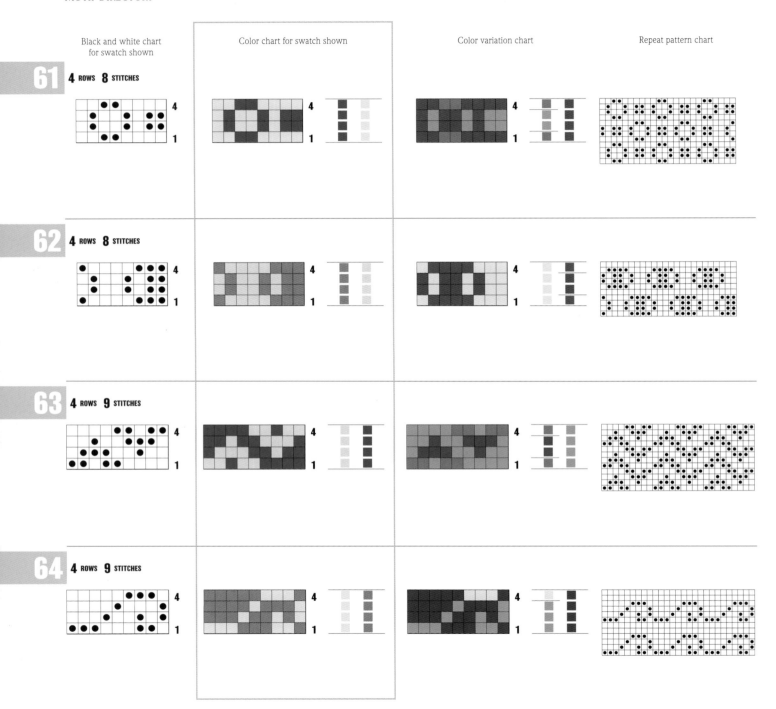

Black and white chart for swatch shown

Color chart for swatch shown

Color variation chart

Repeat pattern chart

61 4 ROWS 8 STITCHES

62 4 ROWS 8 STITCHES

63 4 ROWS 9 STITCHES

64 4 ROWS 9 STITCHES

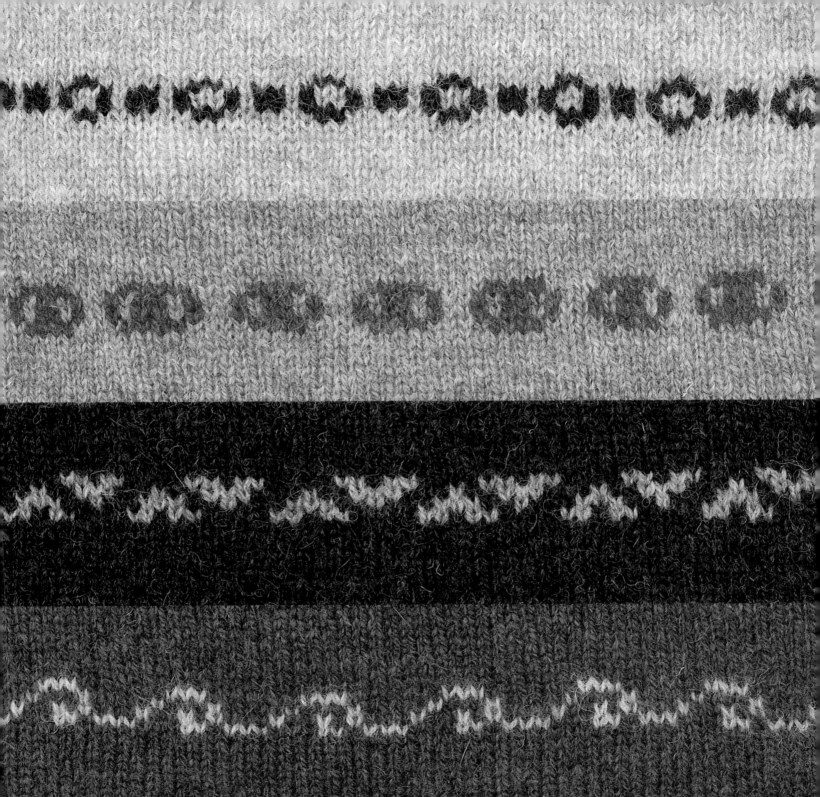

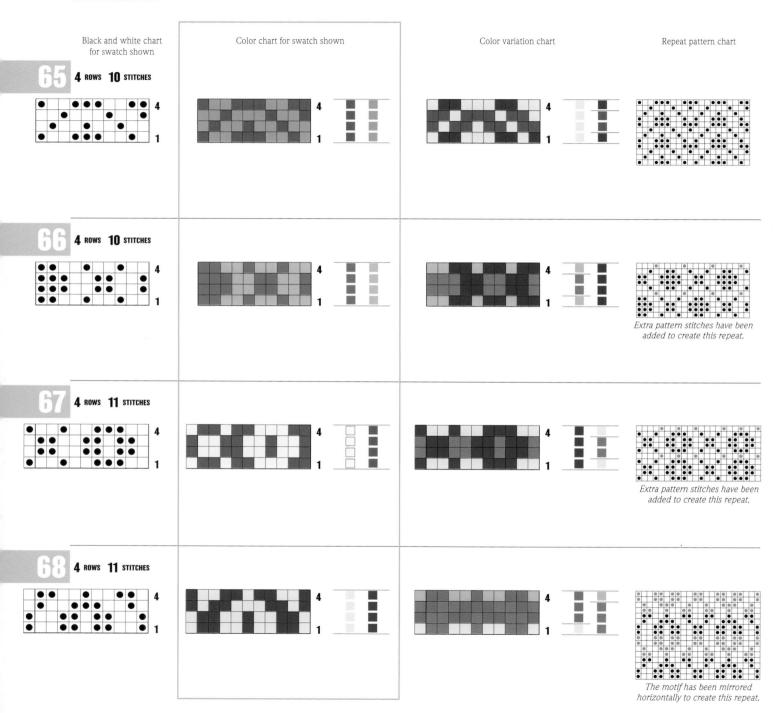

Black and white chart
for swatch shown

Color chart for swatch shown

Color variation chart

Repeat pattern chart

65 4 ROWS 10 STITCHES

66 4 ROWS 10 STITCHES

*Extra pattern stitches have been
added to create this repeat.*

67 4 ROWS 11 STITCHES

*Extra pattern stitches have been
added to create this repeat.*

68 4 ROWS 11 STITCHES

*The motif has been mirrored
horizontally to create this repeat.*

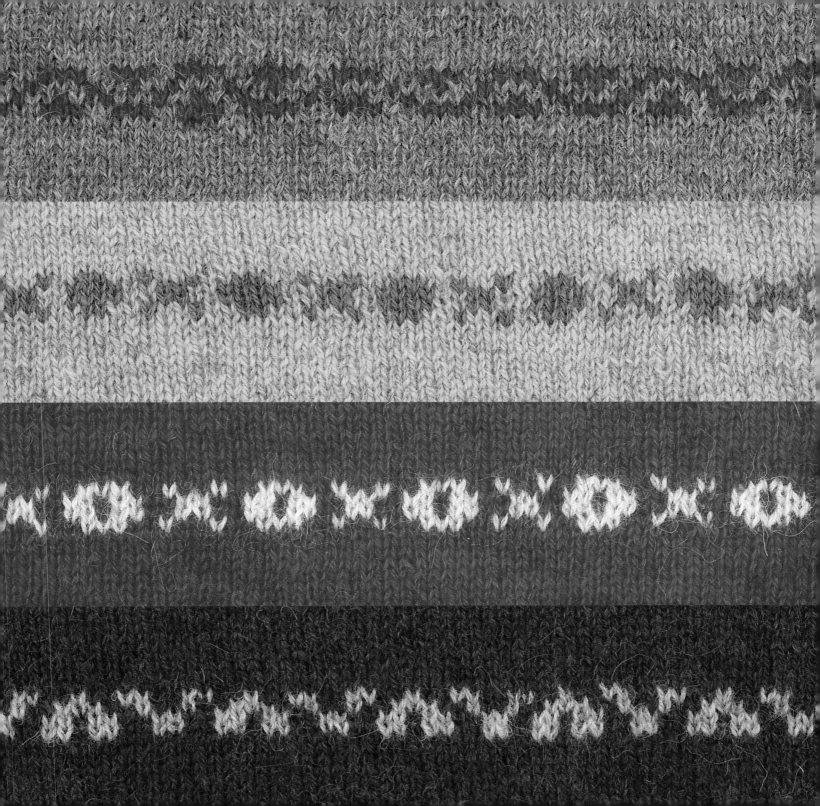

Black and white chart
for swatch shown

Color chart for swatch shown

Color variation chart

69 4 ROWS 12 STITCHES

70 4 ROWS 12 STITCHES

71 4 ROWS 14 STITCHES

72 4 ROWS 16 STITCHES

Repeat pattern chart

*Extra pattern stitches have been
added to create this repeat.*

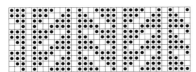

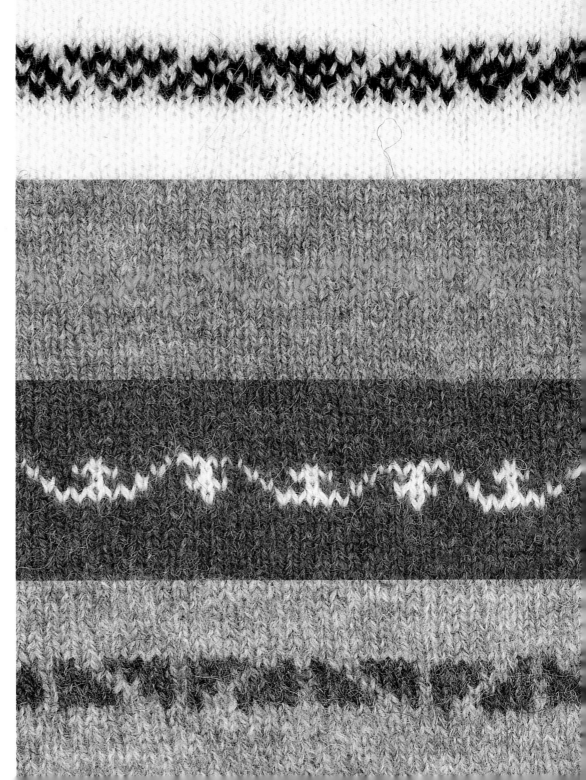

Black and white chart
for swatch shown

Color chart for swatch shown

Color variation chart

Repeat pattern chart

73 **5 ROWS** **3 STITCHES**

74 **5 ROWS** **4 STITCHES**

24

75 **5 ROWS** **4 STITCHES**

76 **5 ROWS** **5 STITCHES**

*This motif has been reversed and
extra pattern stitches have been
added to create this repeat.*

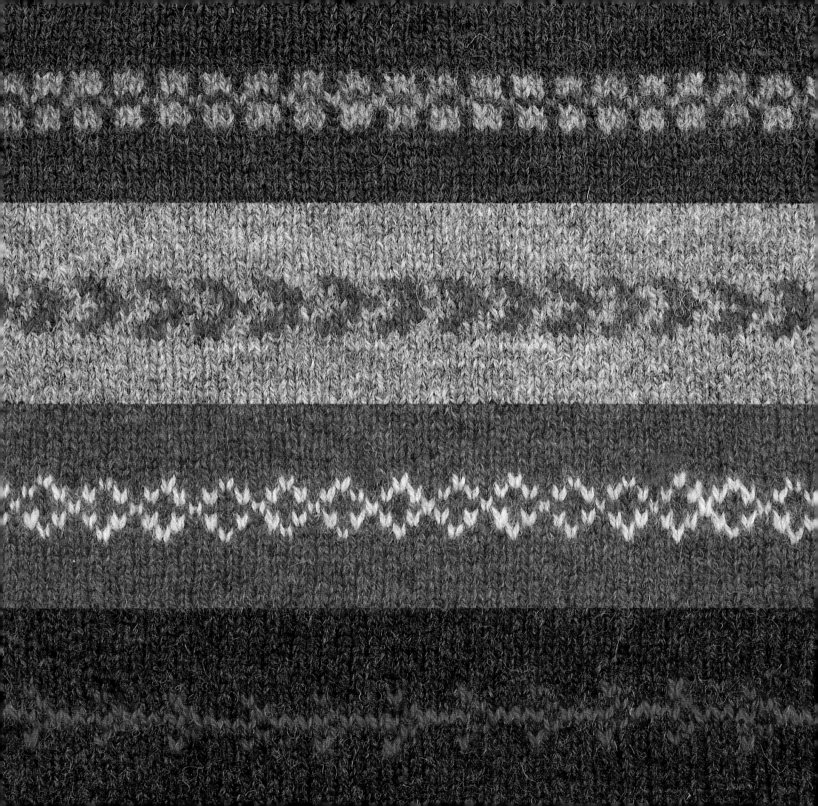

Black and white chart for swatch shown | Color chart for swatch shown | Color variation chart | Repeat pattern chart

77 5 ROWS 5 STITCHES

78 5 ROWS 6 STITCHES

79 5 ROWS 6 STITCHES

Extra pattern stitches have been added to create this repeat.

80 5 ROWS 7 STITCHES

Extra pattern stitches have been added to create this repeat.

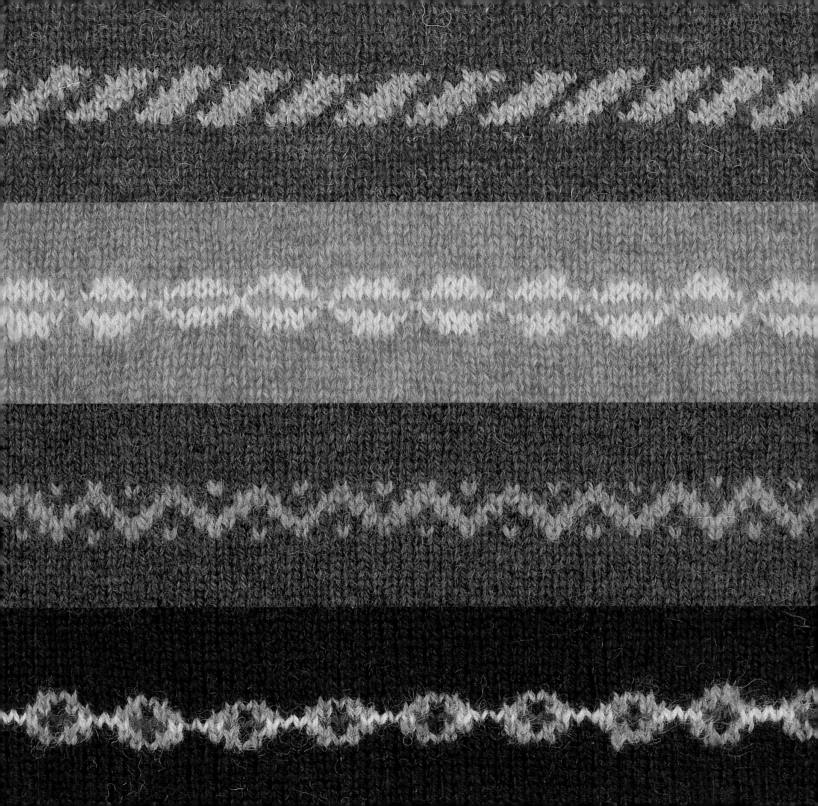

Black and white chart for swatch shown	Color chart for swatch shown	Color variation chart	Repeat pattern chart

81 **5** ROWS **8** STITCHES

82 **5** ROWS **8** STITCHES

83 **5** ROWS **8** STITCHES

Extra pattern stitches have been added to create this repeat.

84 **5** ROWS **9** STITCHES

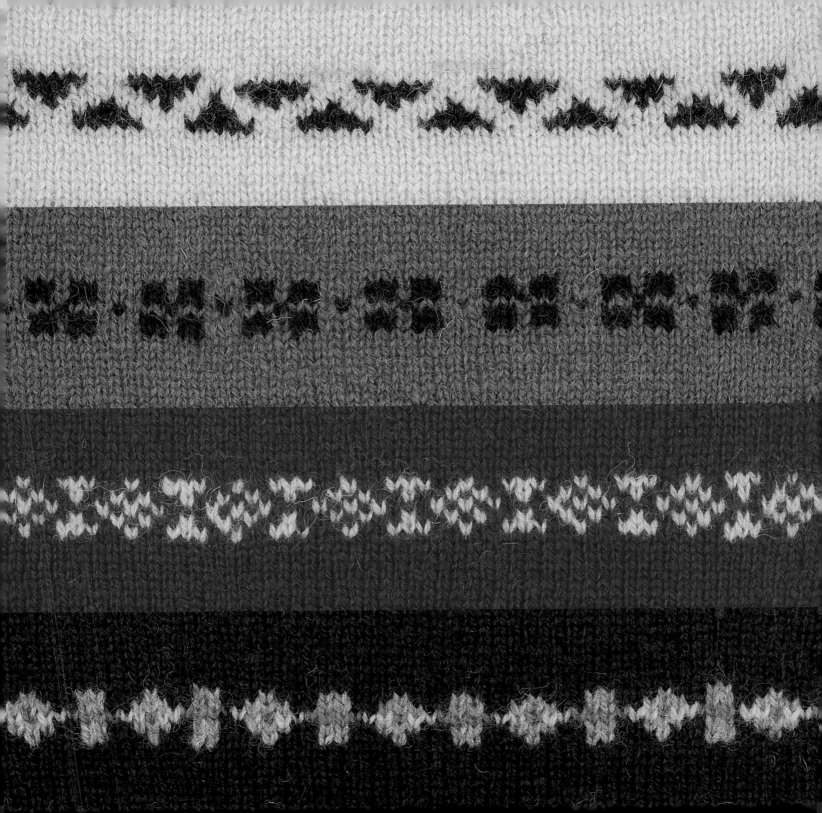

Black and white chart
for swatch shown

Color chart for swatch shown

Color variation chart

85 **5** ROWS **10** STITCHES

86 **5** ROWS **10** STITCHES

87 **5** ROWS **10** STITCHES

88 **5** ROWS **11** STITCHES

Repeat pattern chart

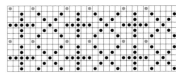

*Extra pattern stitches have been added
to create this repeat.*

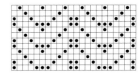

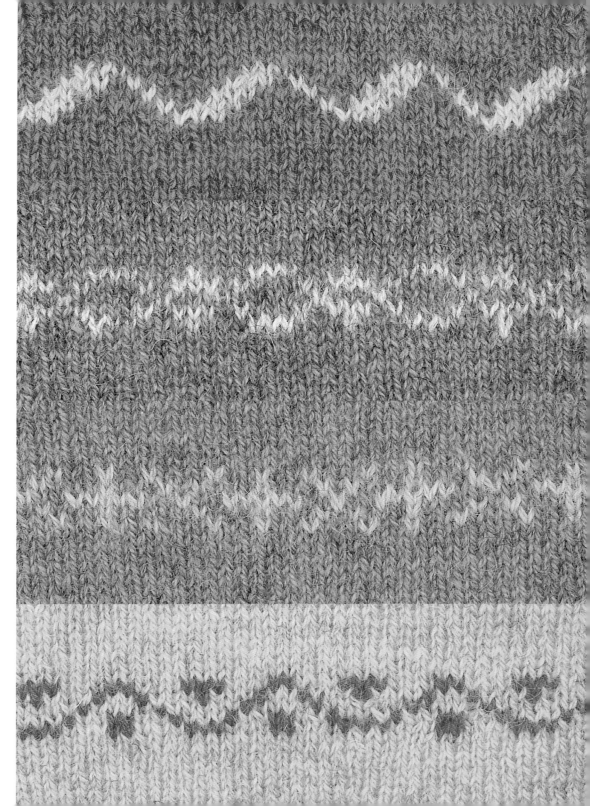

Black and white chart
for swatch shown

Color chart for swatch shown

Color variation chart

89 5 ROWS 12 STITCHES

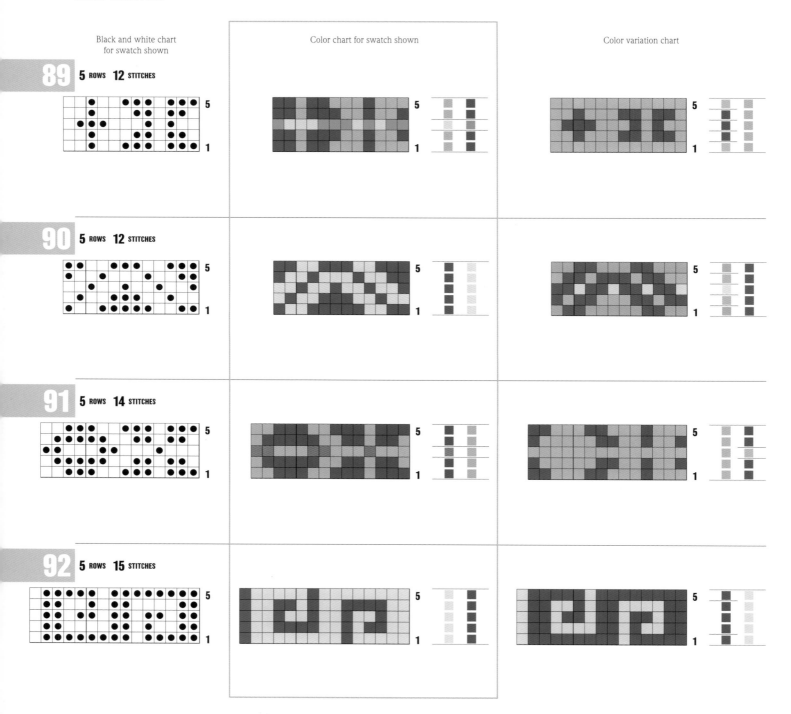

90 5 ROWS 12 STITCHES

91 5 ROWS 14 STITCHES

92 5 ROWS 15 STITCHES

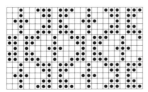

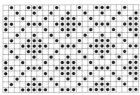

One row has been deleted to
create this repeat.

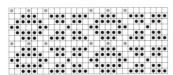

Extra pattern stitches have been added
to create this repeat.

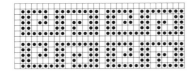

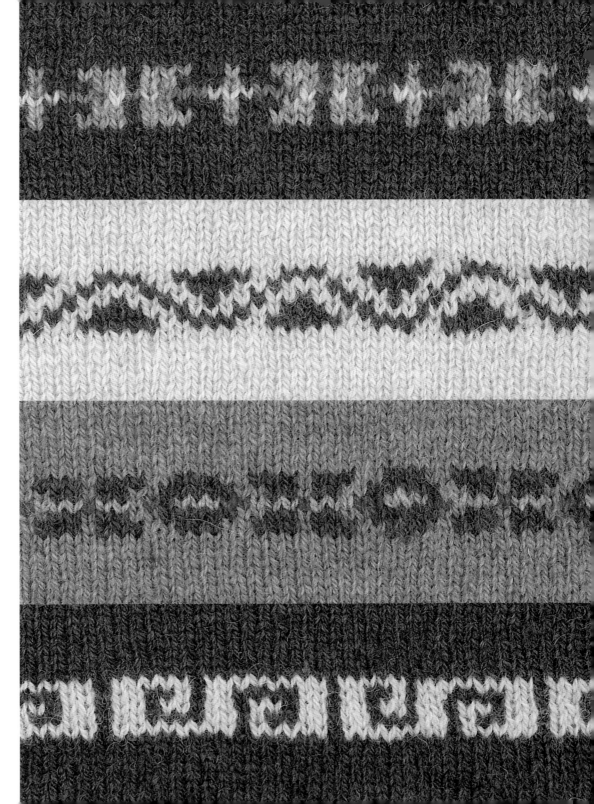

Black and white chart for swatch shown	Color chart for swatch shown	Color variation chart	Repeat pattern chart

93 **6** ROWS **3** STITCHES

One row has been deleted to create this repeat.

94 **6** ROWS **3** STITCHES

The motif has been reversed to create this repeat.

95 **6** ROWS **4** STITCHES

Black and white chart for swatch shown	Color chart for swatch shown	Color variation chart	Repeat pattern chart

96 **6** ROWS **6** STITCHES

One row has been deleted to create this repeat.

97 **6** ROWS **6** STITCHES

98 **6** ROWS **8** STITCHES

One pattern stitch has been removed to create this repeat.

Black and white chart
for swatch shown

Color chart for swatch shown

Color variation chart

99 6 ROWS 10 STITCHES

100 6 ROWS 11 STITCHES

101 6 ROWS 14 STITCHES

Repeat pattern chart

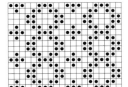

One row has been deleted to create this repeat.

One row has been deleted to create this repeat.

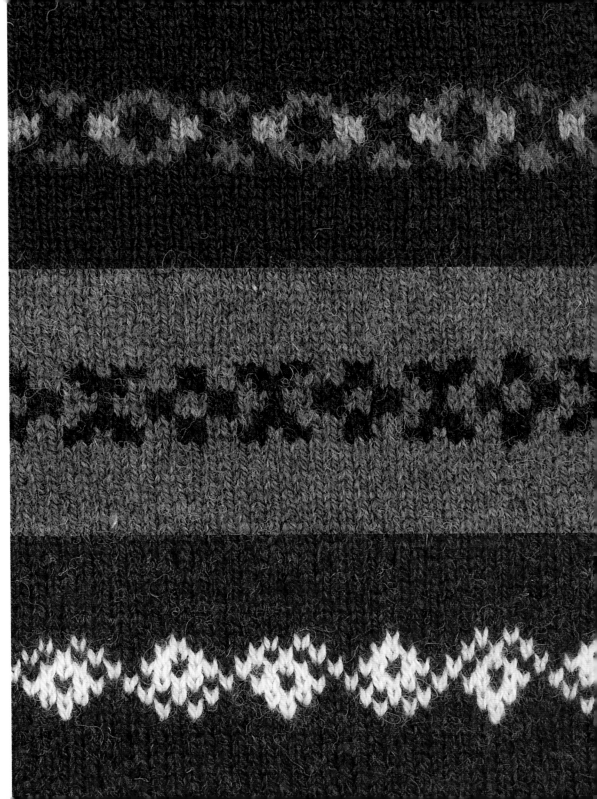

Black and white chart
for swatch shown

Color chart for swatch shown

Color variation chart

Repeat pattern chart

102 **7** ROWS **4** STITCHES

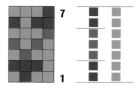

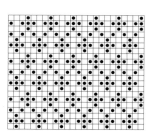

103 **7** ROWS **4** STITCHES

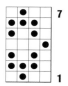

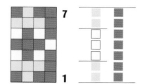

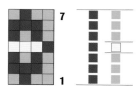

One row has been deleted to create this repeat.

104 **7** ROWS **5** STITCHES

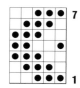

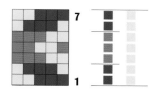

The motif has been reversed to create this repeat.

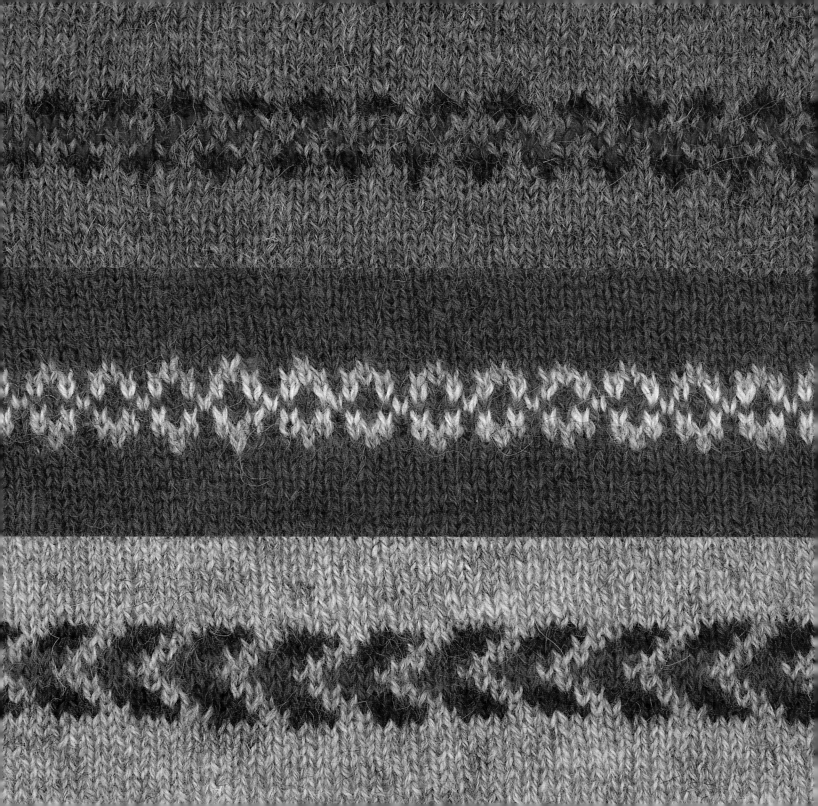

Black and white chart for swatch shown

Color chart for swatch shown

Color variation chart

Repeat pattern chart

105 7 ROWS 6 STITCHES

One row has been deleted to create this repeat.

106 7 ROWS 6 STITCHES

107 7 ROWS 6 STITCHES

One row has been deleted to create this repeat.

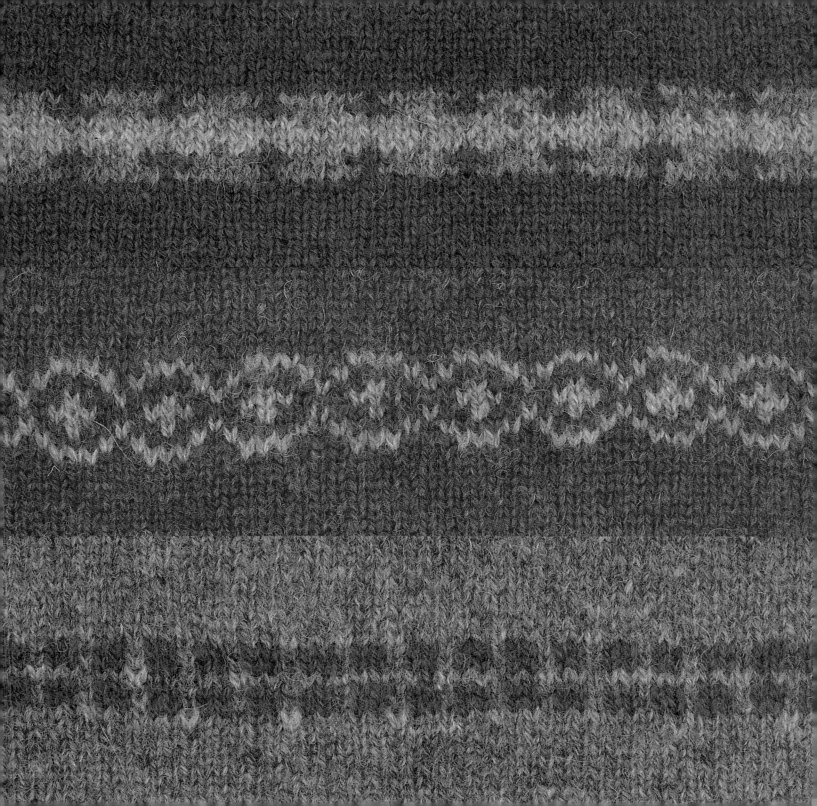

Black and white chart for swatch shown

Color chart for swatch shown

Color variation chart

Repeat pattern chart

108 7 ROWS 7 STITCHES

109 7 ROWS 8 STITCHES

110 7 ROWS 8 STITCHES

One row has been deleted to create this repeat.

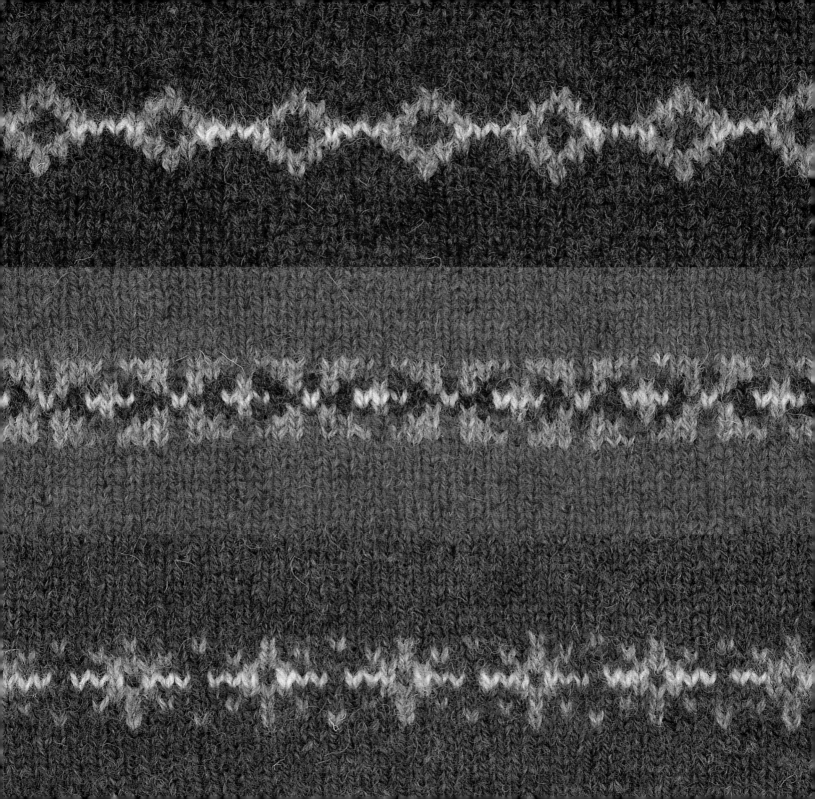

Black and white chart
for swatch shown

Color chart for swatch shown

Color variation chart

Repeat pattern chart

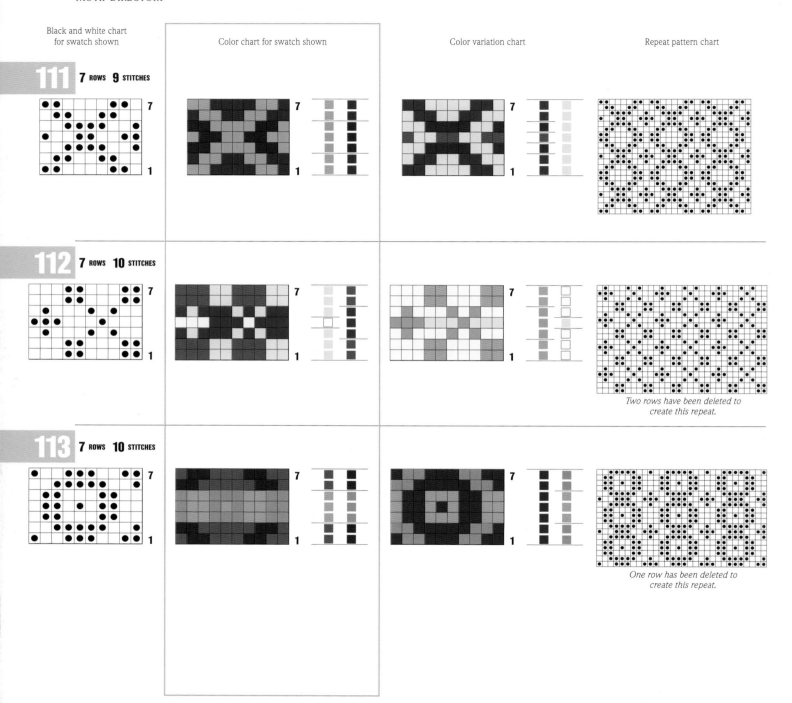

111 7 ROWS 9 STITCHES

112 7 ROWS 10 STITCHES

*Two rows have been deleted to
create this repeat.*

113 7 ROWS 10 STITCHES

*One row has been deleted to
create this repeat.*

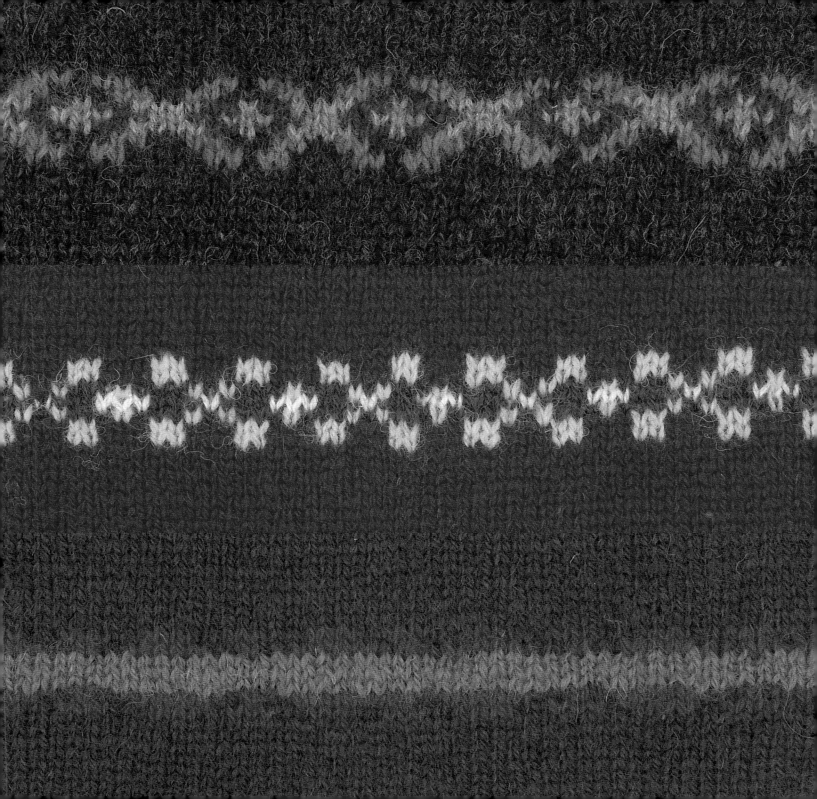

Black and white chart
for swatch shown

Color chart for swatch shown

Color variation chart

114 **7** ROWS **10** STITCHES

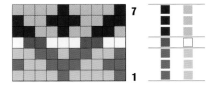

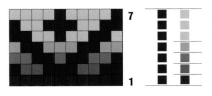

115 **7** ROWS **12** STITCHES

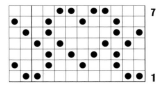

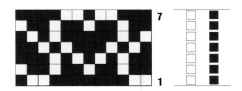

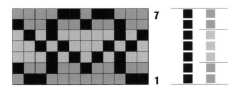

116 **7** ROWS **14** STITCHES

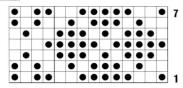

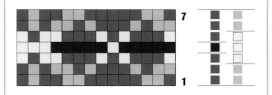

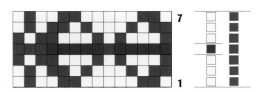

Repeat pattern chart

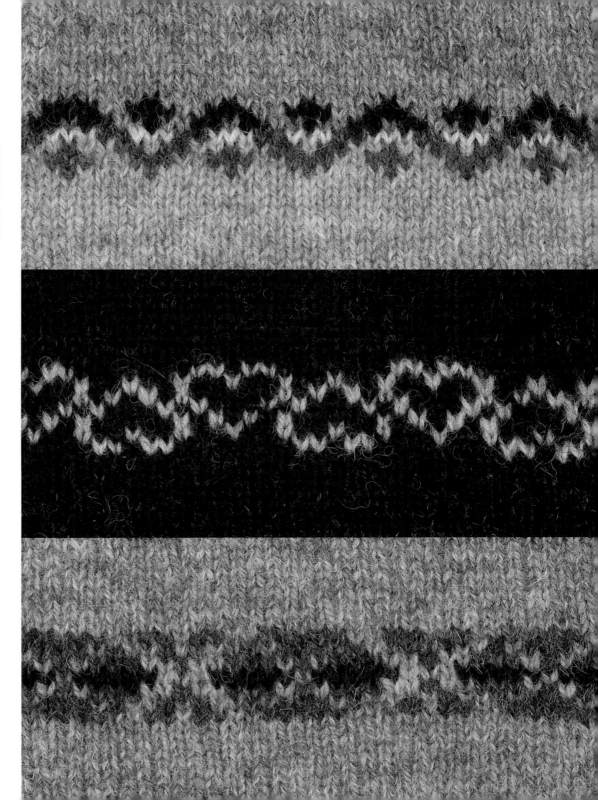

One row has been deleted to create this repeat.

Extra pattern stitches have been added to create this repeat.

Black and white chart
for swatch shown

Color chart for swatch shown

Color variation chart

117 **7** ROWS **14** STITCHES

118 **7** ROWS **15** STITCHES

119 **7** ROWS **16** STITCHES

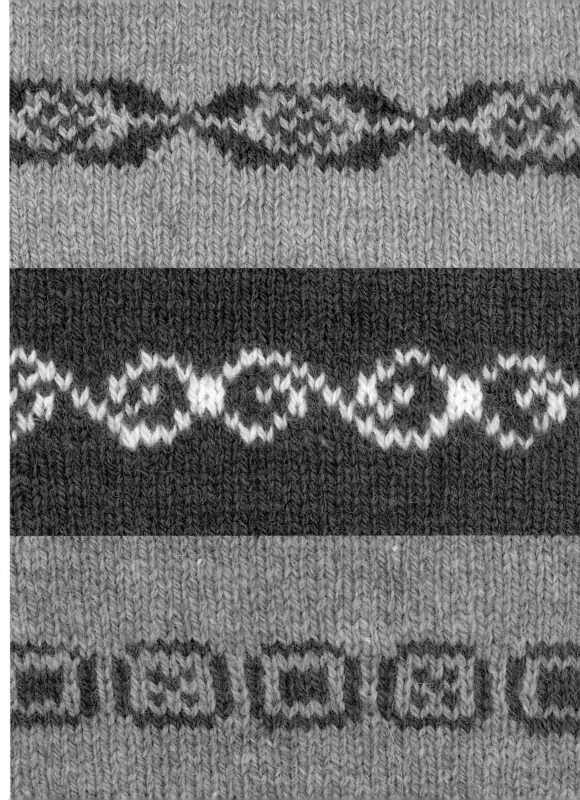

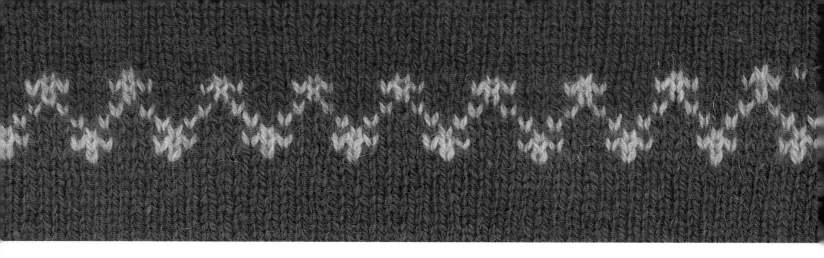

120 8 ROWS 6 STITCHES

Black and white chart
for swatch shown

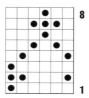

Repeat pattern chart

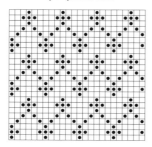

Color chart for swatch shown

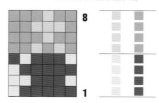

Color variation chart

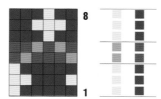

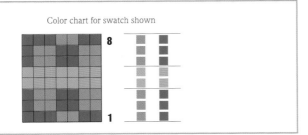

Black and white chart
for swatch shown

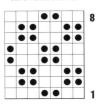

Color chart for swatch shown

8

1

Color variation chart

8

1

Repeat pattern chart

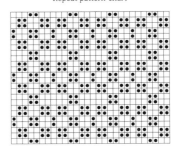

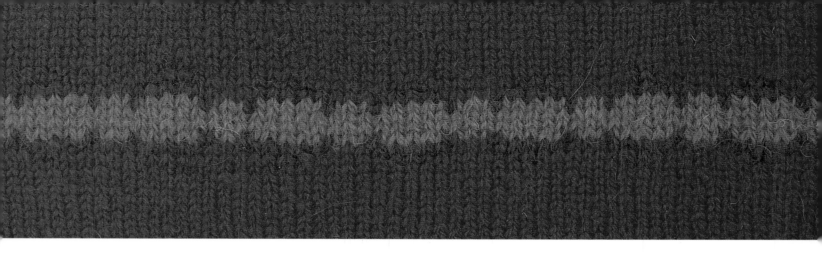

122 **8** ROWS **8** STITCHES

Black and white chart
for swatch shown

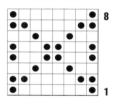

Repeat pattern chart

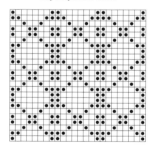

Color chart for swatch shown

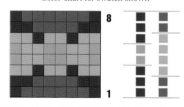

Color variation chart

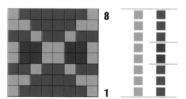

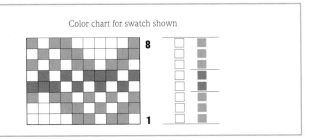

Color chart for swatch shown

Black and white chart
for swatch shown

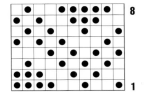

Color variation chart

Repeat pattern chart

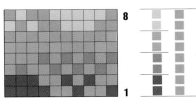

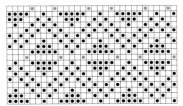

*Extra pattern stitches have been added to
create this repeat.*

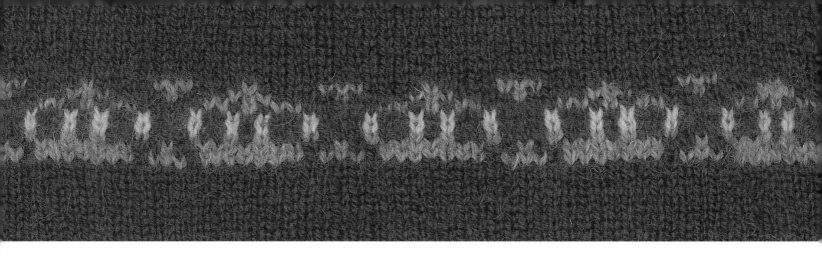

124 **8** ROWS **12** STITCHES

Black and white chart
for swatch shown

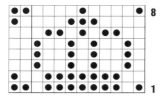

Repeat pattern chart

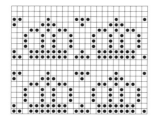

Color chart for swatch shown

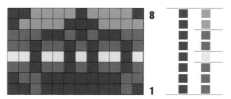

Color variation chart

114

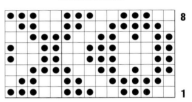

Color chart for swatch shown

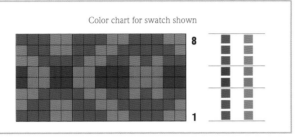

8

1

Black and white chart
for swatch shown

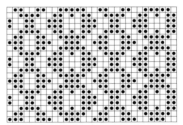

8

1

Color variation chart

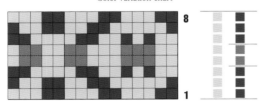

8

1

Repeat pattern chart

*One row has been deleted to
create this repeat.*

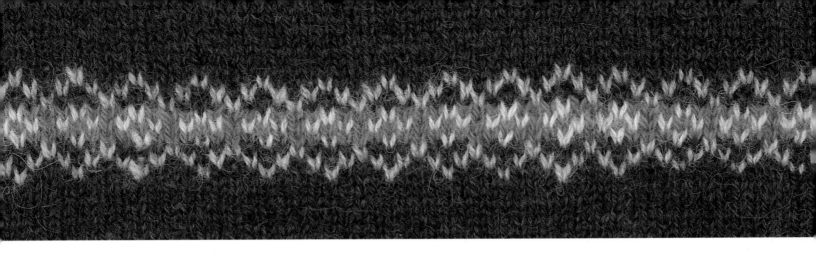

126 **9** ROWS **4** STITCHES

Black and white chart
for swatch shown

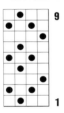

9

1

Repeat pattern chart

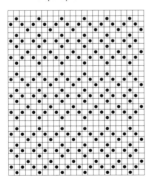

Color chart for swatch shown

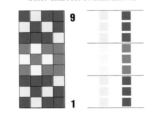

9

1

Color variation chart

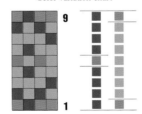

9

1

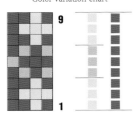

Color chart for swatch shown

Black and white chart
for swatch shown

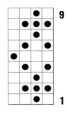

Color variation chart

Repeat pattern chart

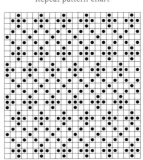

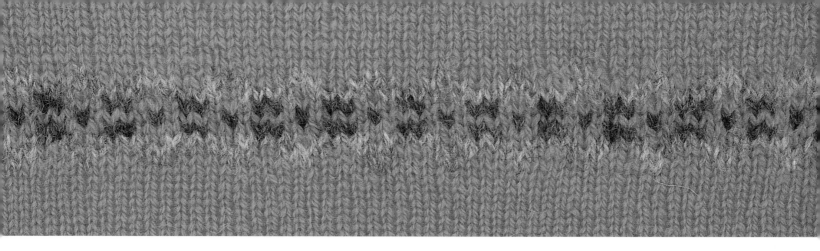

128 **9** ROWS **5** STITCHES

Black and white chart
for swatch shown

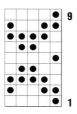

Repeat pattern chart

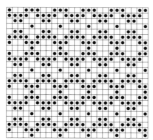

*One row has been deleted to
create this repeat.*

Color chart for swatch shown

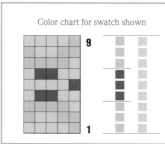

Color variation chart

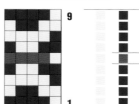

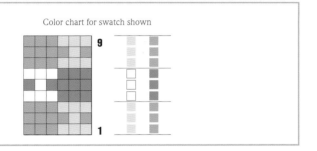

Color chart for swatch shown

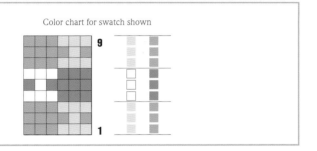

Black and white chart
for swatch shown

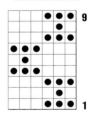

Color variation chart

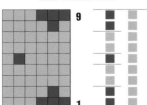

Repeat pattern chart

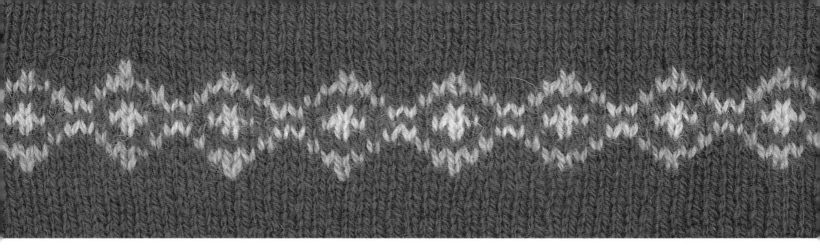

130 9 ROWS 7 STITCHES

Black and white chart
for swatch shown

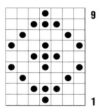

Repeat pattern chart

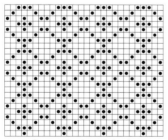

*One row has been deleted to
create this repeat.*

Color chart for swatch shown

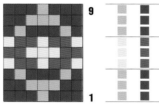

Color variation chart

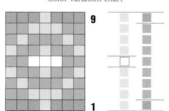

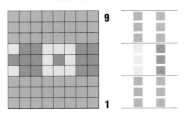

Color chart for swatch shown

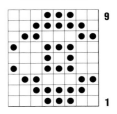

Black and white chart
for swatch shown

Color variation chart

Repeat pattern chart

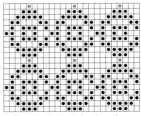

*Extra pattern stitches have been
added to create this repeat.*

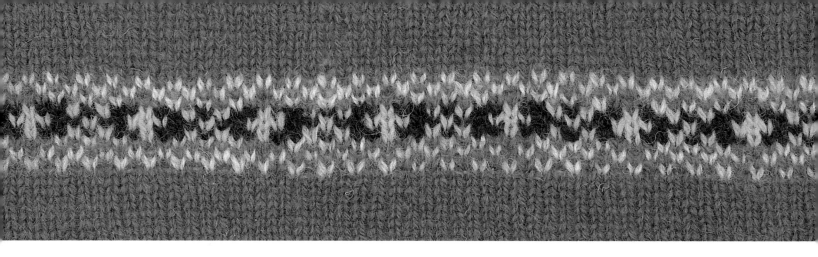

132 **9** ROWS **8** STITCHES

Black and white chart
for swatch shown

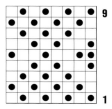

Repeat pattern chart

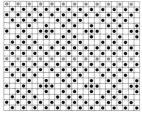

*Extra pattern stitches have been
added to create this repeat.*

Color chart for swatch shown

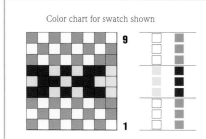

Color variation chart

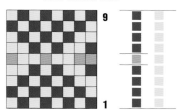

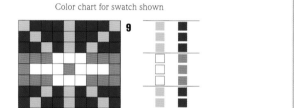

Color chart for swatch shown

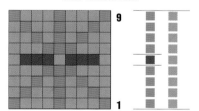

9

1

Black and white chart
for swatch shown

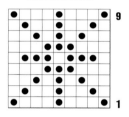

9

1

Color variation chart

9

1

Repeat pattern chart

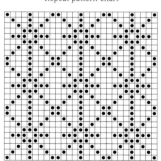

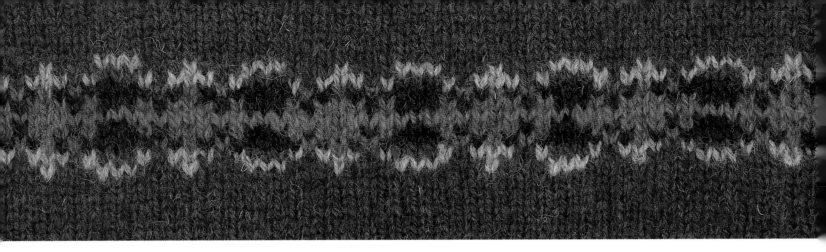

9 ROWS **10** STITCHES

Black and white chart
for swatch shown

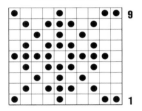

Repeat pattern chart

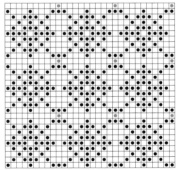

*Extra pattern stitches have been added
to create this repeat.*

Color chart for swatch shown

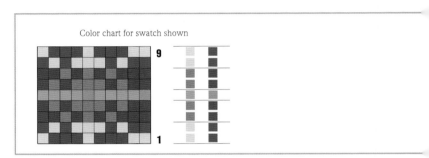

Color variation chart

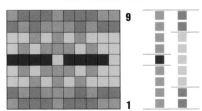

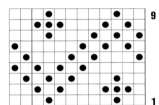

Color chart for swatch shown

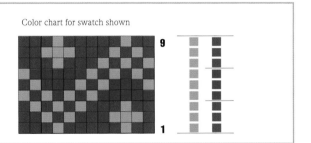

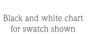
Black and white chart for swatch shown

Color variation chart

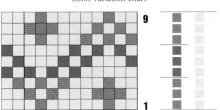

Repeat pattern chart

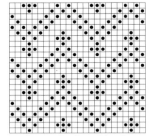

One row has been deleted to create this repeat.

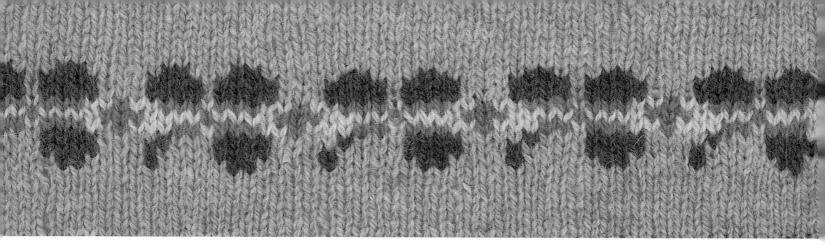

9 ROWS **12** STITCHES

Black and white chart
for swatch shown

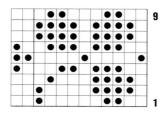

9

1

Repeat pattern chart

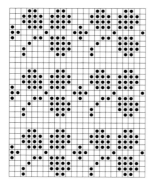

Color chart for swatch shown

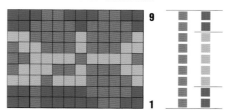

9

1

Color variation chart

9

1

Color chart for swatch shown

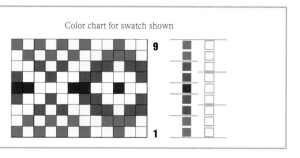

Black and white chart
for swatch shown

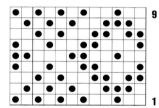

Color variation chart

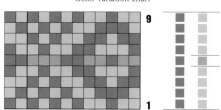

Repeat pattern chart

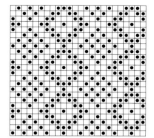

*One row has been deleted to
create this repeat.*

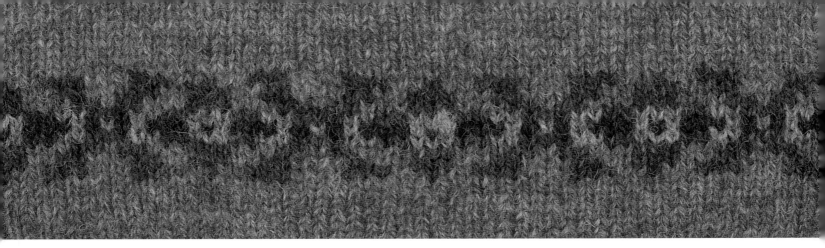

Black and white chart for swatch shown

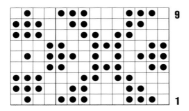

9

1

Repeat pattern chart

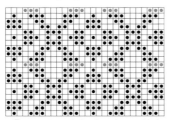

Extra pattern stitches have been added to create this repeat.

Color chart for swatch shown

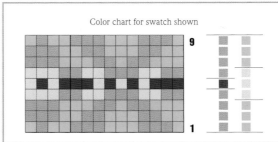

9

1

Color variation chart

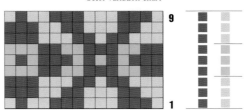

9

1

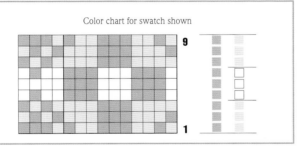

Color chart for swatch shown

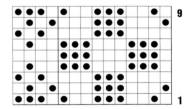

9

1

Black and white chart for swatch shown

9

1

Color variation chart

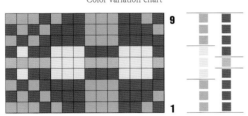

9

1

Repeat pattern chart

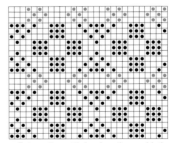

Extra pattern stitches have been added to create this repeat.

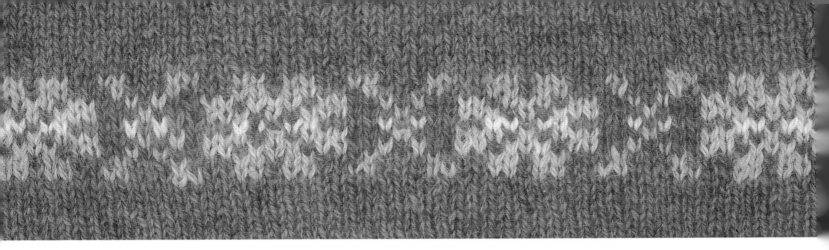

140 9 ROWS 16 STITCHES

Black and white chart for swatch shown

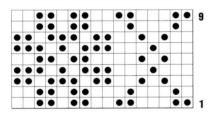

Repeat pattern chart

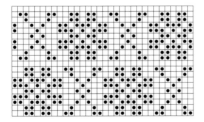

Color chart for swatch shown

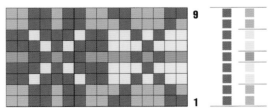

Color variation chart

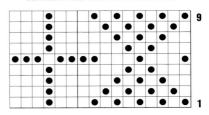

Color chart for swatch shown

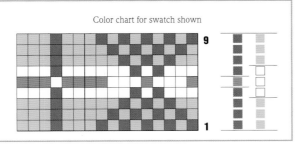

Black and white chart for swatch shown

Color variation chart

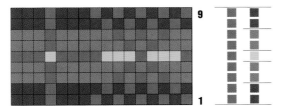

Repeat pattern chart

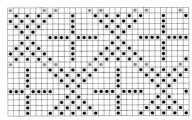

*Extra pattern stitches have been added
to create this repeat.*

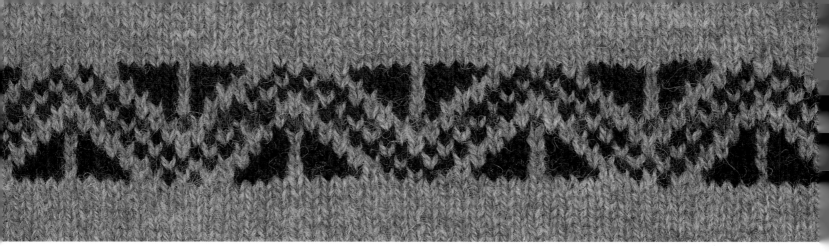

142 **9** ROWS **16** STITCHES

Black and white chart for swatch shown

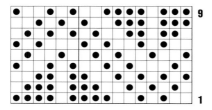

9

1

Repeat pattern chart

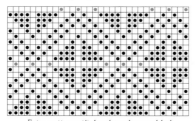

*Extra pattern stitches have been added
to create this repeat.*

Color chart for swatch shown

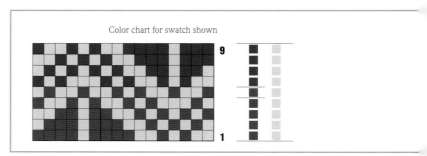

9

1

Color variation chart

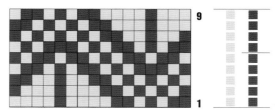

9

1

132

Color chart for swatch shown

9

1

Color variation chart

9

1

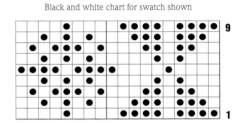

Black and white chart for swatch shown

9

1

Repeat pattern chart

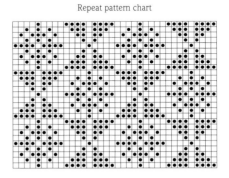

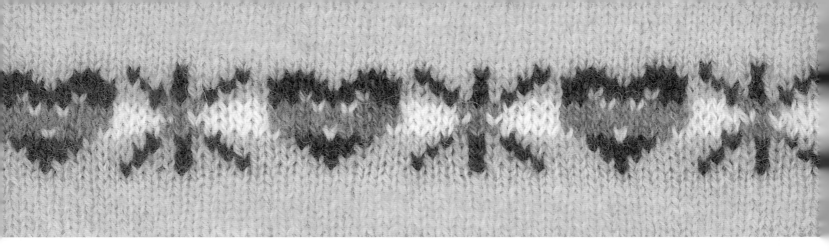

9 ROWS **20** STITCHES

Black and white chart for swatch shown

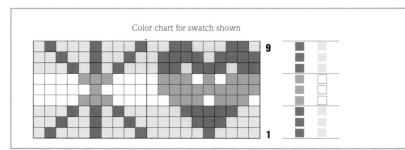

9

1

Repeat pattern chart

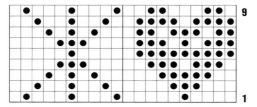

*Pattern stitches have been added and removed
to create this repeat.*

Color chart for swatch shown

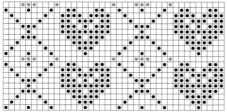

9

1

Color variation chart

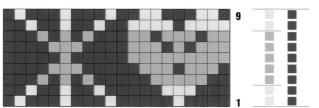

9

1

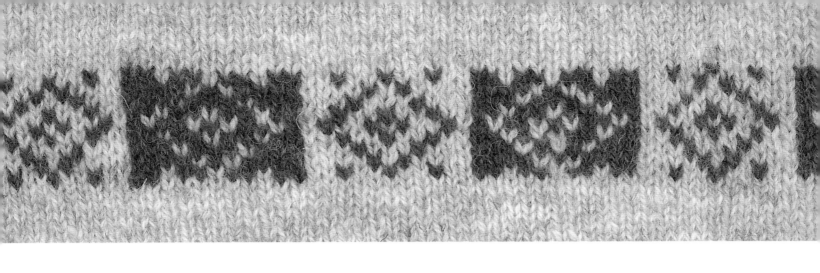

Color chart for swatch shown

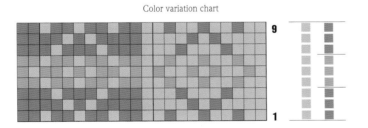

9

1

Black and white chart for swatch shown

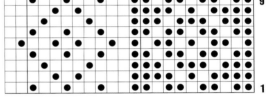

9

1

Color variation chart

9

1

Repeat pattern chart

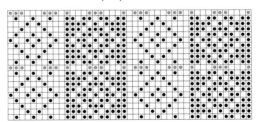

Extra pattern stitches have been added to create this repeat.

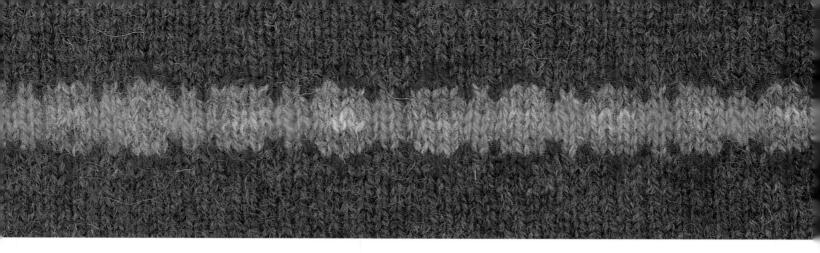

10 ROWS 6 STITCHES

Black and white chart
for swatch shown

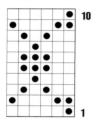

10

1

Color chart for swatch shown

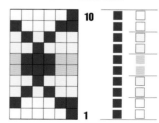

10

1

Repeat pattern chart

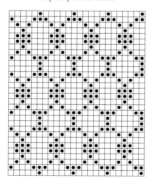

Color variation chart

10

1

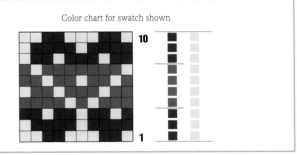

Color chart for swatch shown

10

1

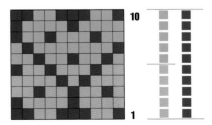

Black and white chart
for swatch shown

10

1

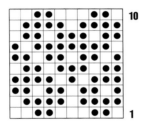

Color variation chart

10

1

Repeat pattern chart

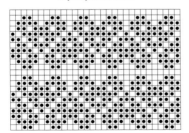

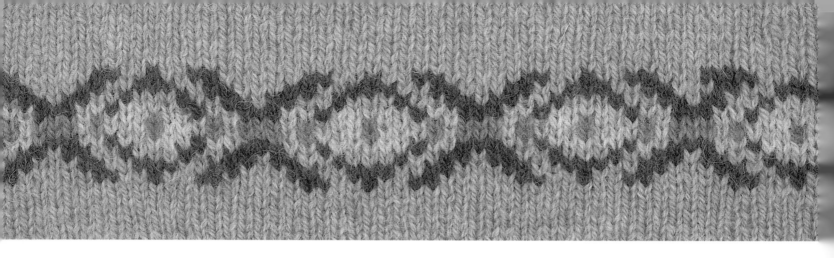

148 10 ROWS 14 STITCHES

Black and white chart for swatch shown

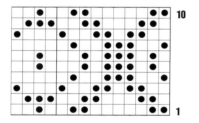

Repeat pattern chart

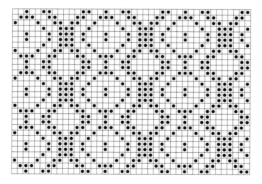

Color chart for swatch shown

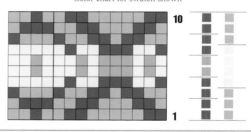

Color variation chart

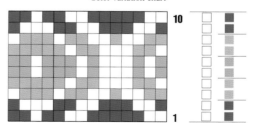

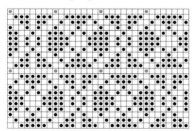

Color chart for swatch shown

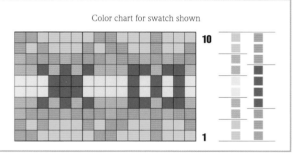

Black and white chart for swatch shown

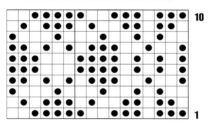

Color variation chart

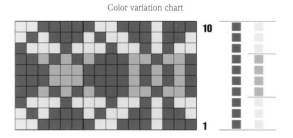

Repeat pattern chart

*Extra pattern stitches have been added
to create this repeat.*

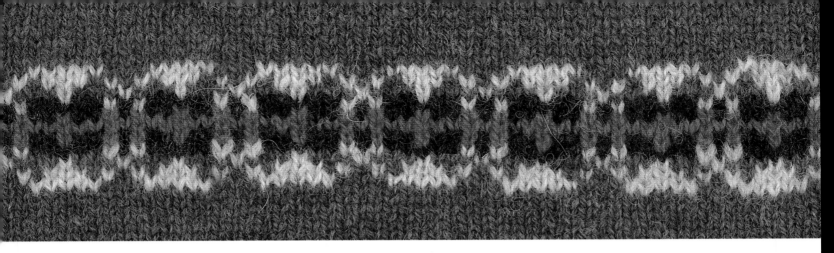

11 ROWS **8** STITCHES

Black and white chart
for swatch shown

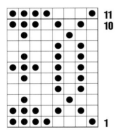

Color chart for swatch shown

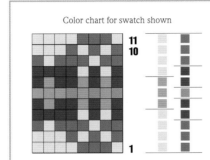

Repeat pattern chart

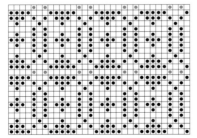

*Extra pattern stitches have been added
to create this repeat.*

Color variation chart

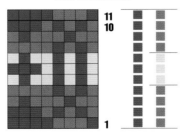

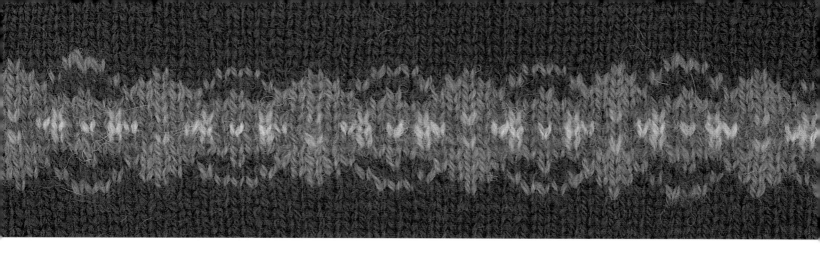

Color chart for swatch shown

11
10

1

Color variation chart

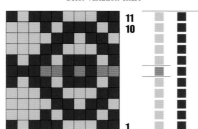

11
10

1

Black and white chart
for swatch shown

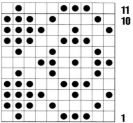

11
10

1

Repeat pattern chart

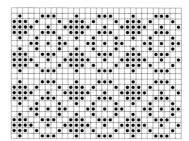

141

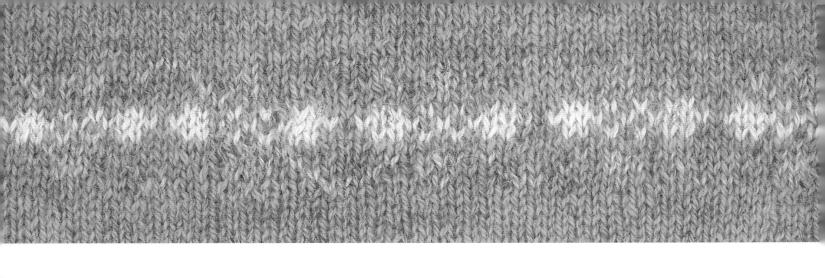

152 **11** ROWS **12** STITCHES

Black and white chart
for swatch shown

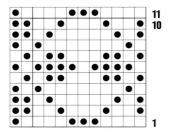

11
10

1

Repeat pattern chart

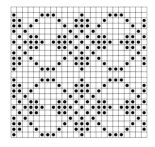

Color chart for swatch shown

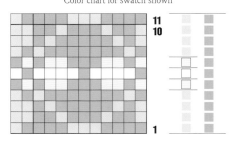

11
10

1

Color variation chart

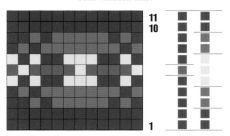

11
10

1

Color chart for swatch shown

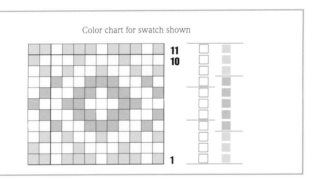

Color variation chart

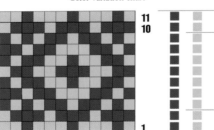

Black and white chart
for swatch shown

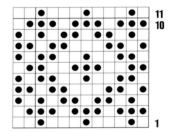

Repeat pattern chart

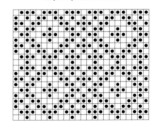

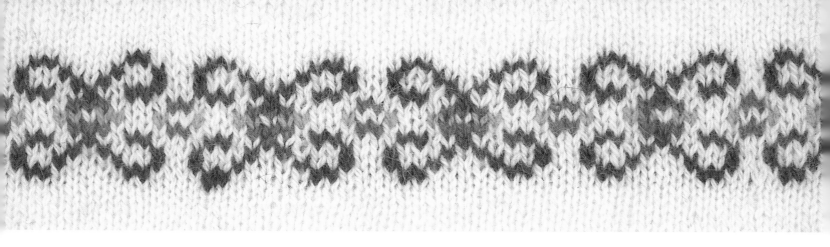

Black and white chart for swatch shown

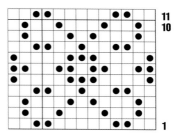

11
10

1

Repeat pattern chart

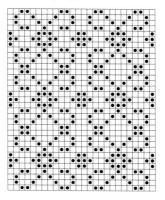

Color chart for swatch shown

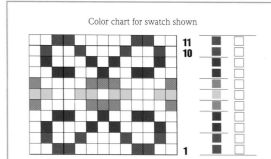

11
10

1

Color variation chart

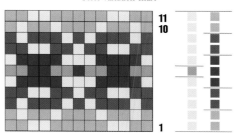

11
10

1

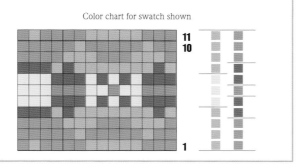

Color chart for swatch shown

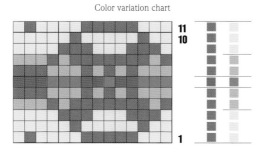

Black and white chart for swatch shown

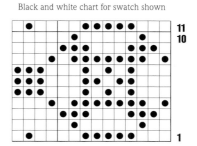

Color variation chart

Repeat pattern chart

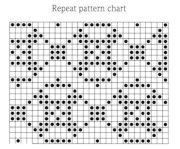

145

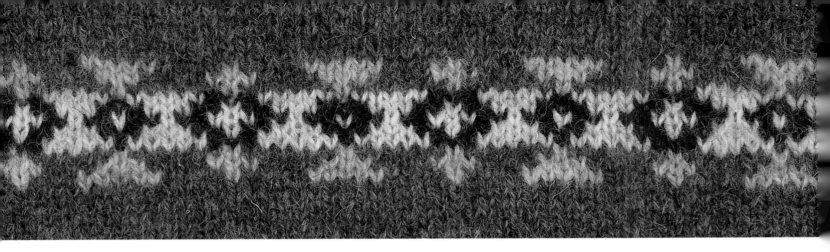

11 ROWS **14** STITCHES

Black and white chart for swatch shown

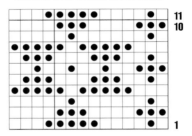

Color chart for swatch shown

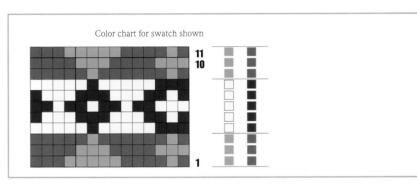

Repeat pattern chart

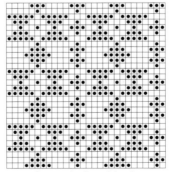

One row has been deleted to create this repeat.

Color variation chart

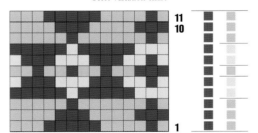

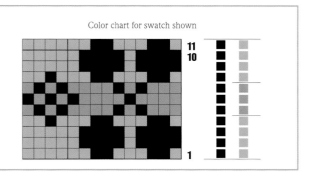

Color chart for swatch shown

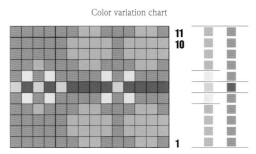

11
10

1

Black and white chart for swatch shown

11
10

1

Color variation chart

11
10

1

Repeat pattern chart

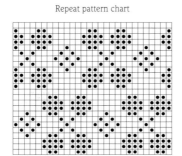

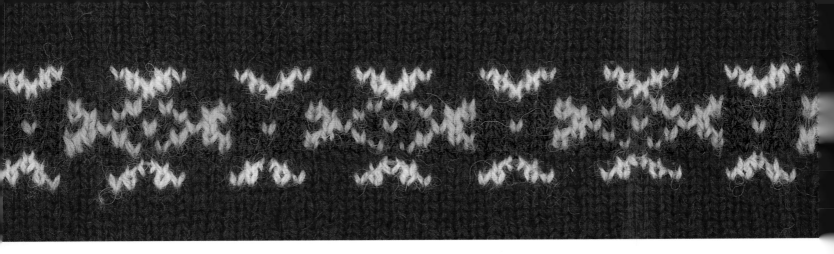

158 **11** ROWS **16** STITCHES

Black and white chart for swatch shown

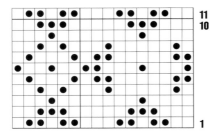

Repeat pattern chart

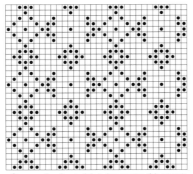

One row has been deleted to create this repeat.

Color chart for swatch shown

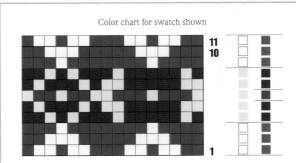

Color variation chart

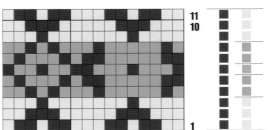

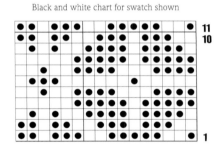

Color chart for swatch shown

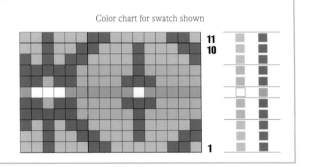

11
10

1

Color variation chart

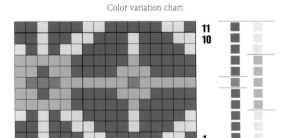

11
10

1

Black and white chart for swatch shown

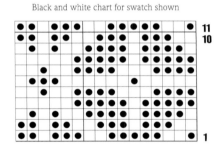

11
10

1

Repeat pattern chart

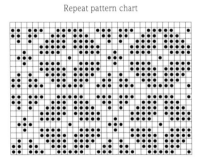

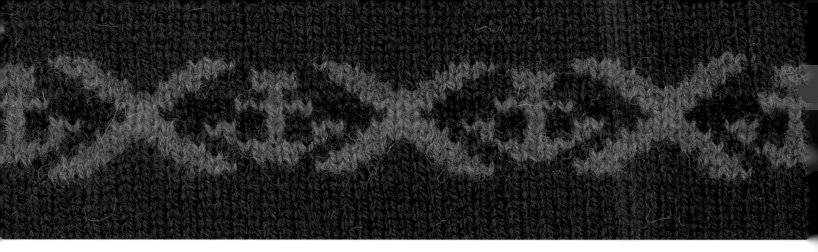

160 11 ROWS 17 STITCHES

Black and white chart for swatch shown

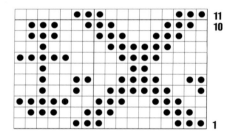

Repeat pattern chart

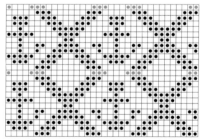

*Extra pattern stitches have been added
to create this repeat.*

Color chart for swatch shown

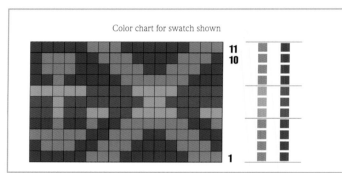

Color variation chart

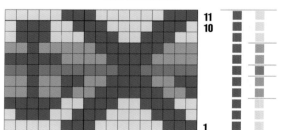

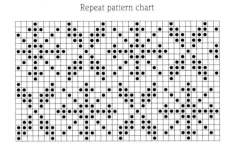

Color chart for swatch shown

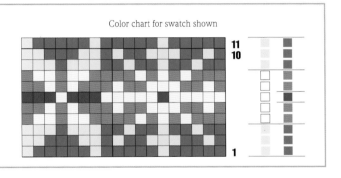

Black and white chart for swatch shown

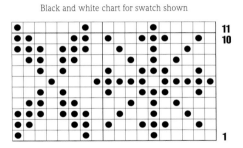

Color variation chart

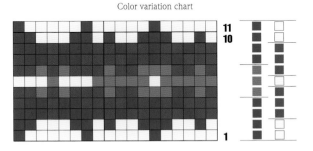

Repeat pattern chart

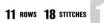

151

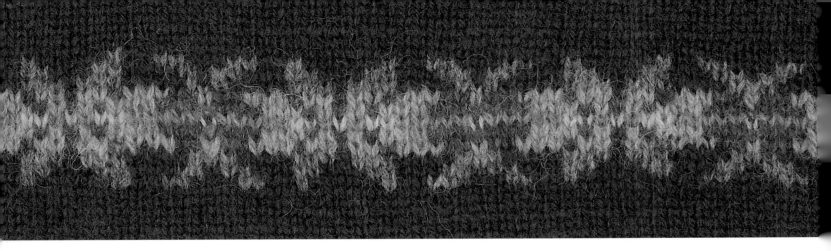

162 11 ROWS 18 STITCHES

Black and white chart for swatch shown

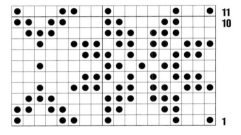

Repeat pattern chart

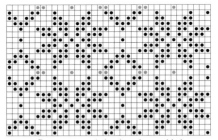

*Extra pattern stitches have been added
to create this repeat.*

Color chart for swatch shown

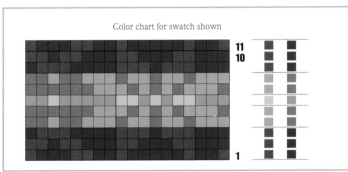

Color variation chart

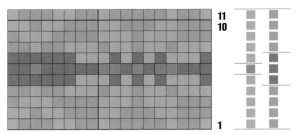

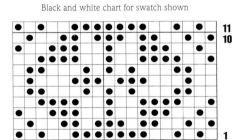

Color chart for swatch shown

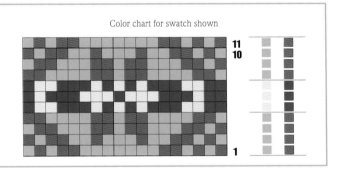

11
10

1

Black and white chart for swatch shown

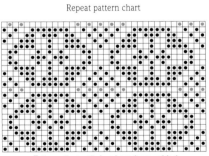

11
10

1

Color variation chart

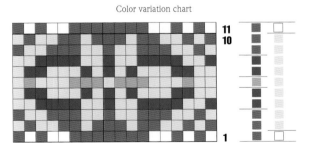

11
10

1

Repeat pattern chart

*Extra pattern stitches have been added
to create this repeat.*

153

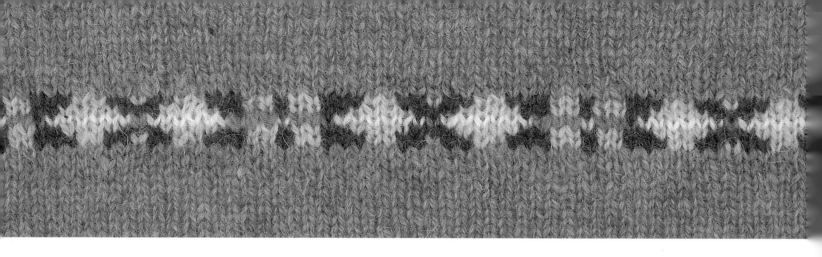

Black and white chart for swatch shown

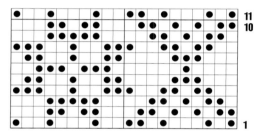

Repeat pattern chart

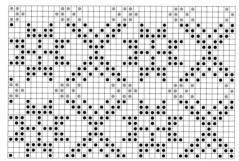

Extra pattern stitches have been added to create this repeat.

Color chart for swatch shown

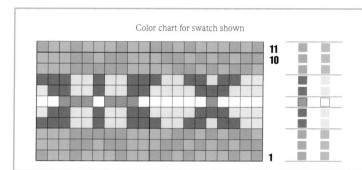

Color variation chart

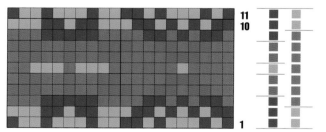

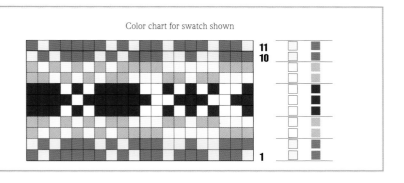

Color chart for swatch shown

Black and white chart for swatch shown
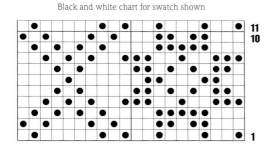

Color variation chart
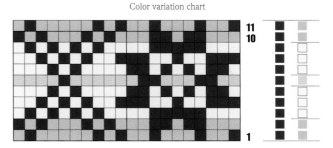

Repeat pattern chart
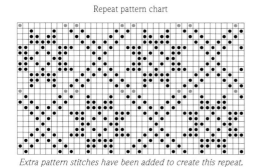

Extra pattern stitches have been added to create this repeat.

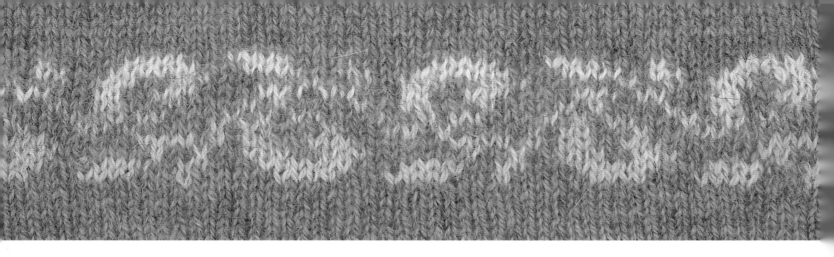

166 | **11** ROWS **20** STITCHES

Black and white chart for swatch shown

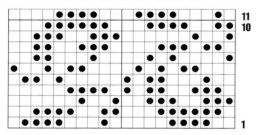

Repeat pattern chart

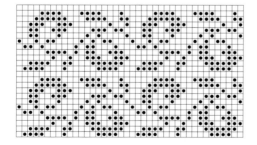

Color chart for swatch shown

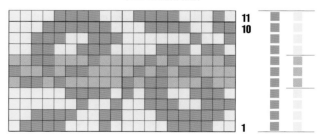

Color variation chart

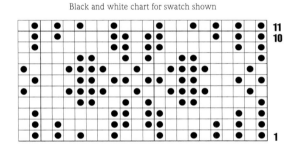

Color chart for swatch shown

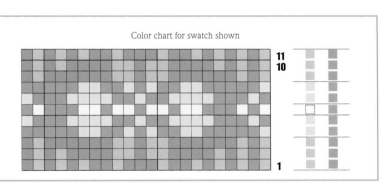

Color variation chart

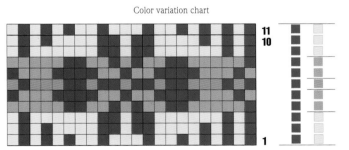

Black and white chart for swatch shown

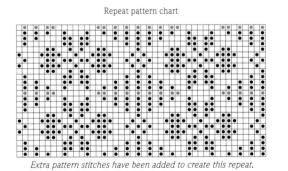

Repeat pattern chart

Extra pattern stitches have been added to create this repeat.

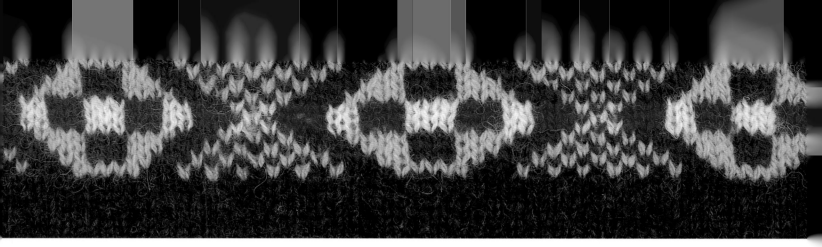

168 | **11** ROWS **22** STITCHES

Black and white chart for swatch shown

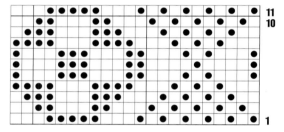

Repeat pattern chart

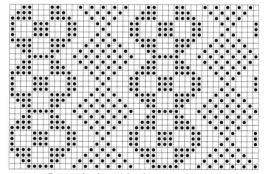

One row has been deleted to create this repeat.

Color chart for swatch shown

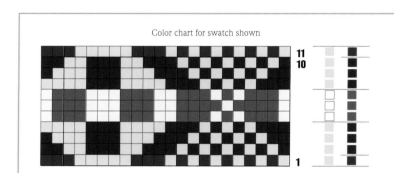

Color variation chart

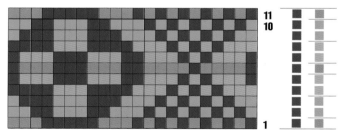

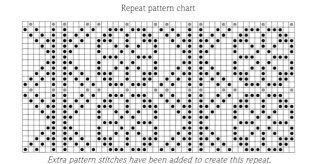

Color chart for swatch shown

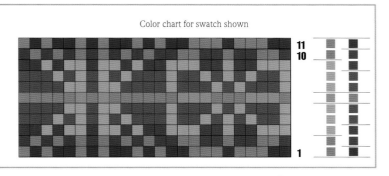

Black and white chart for swatch shown

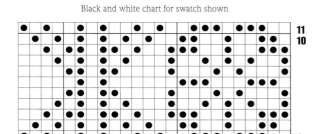

Color variation chart

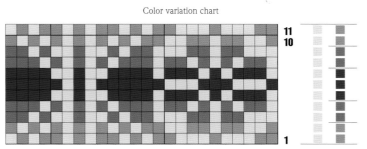

Repeat pattern chart

Extra pattern stitches have been added to create this repeat.

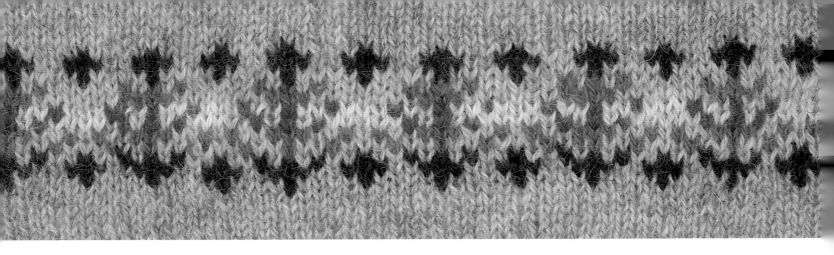

170 **12** ROWS **10** STITCHES

Black and white chart
for swatch shown

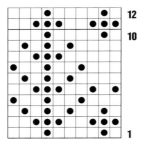

12
10
1

Color chart for swatch shown

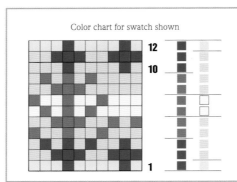

12
10
1

Repeat pattern chart

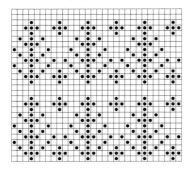

Color variation chart

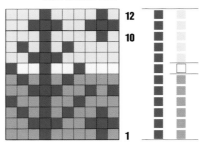

12
10
1

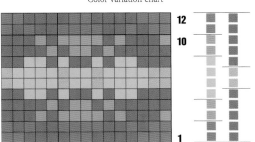

Color chart for swatch shown

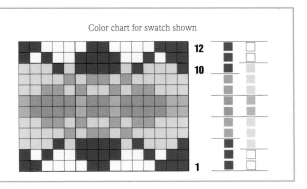

Black and white chart
for swatch shown

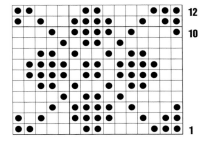

Color variation chart

Repeat pattern chart

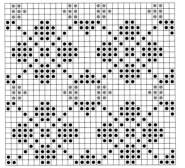

*Extra pattern stitches have been added
to create this repeat.*

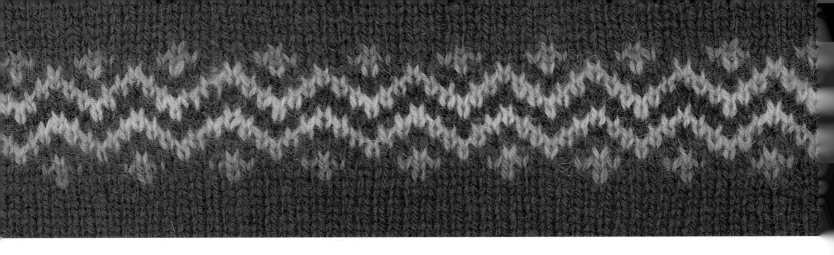

172 13 ROWS 6 STITCHES

Black and white chart
for swatch shown

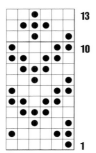

Repeat pattern chart

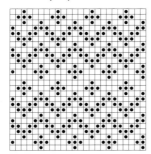

Color chart for swatch shown

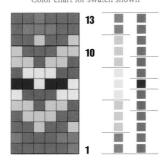

Color variation chart

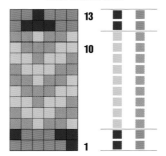

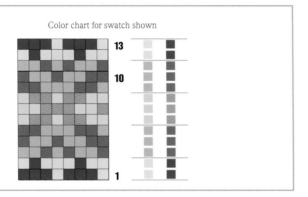

Color chart for swatch shown

Black and white chart
for swatch shown

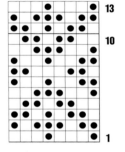

Color variation chart

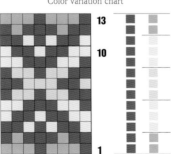

Repeat pattern chart

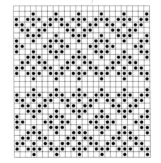

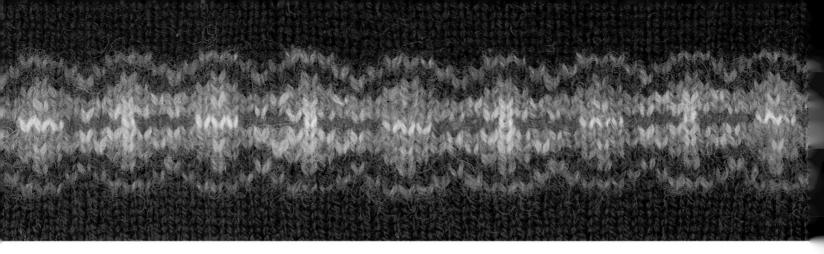

13 ROWS **12** STITCHES

Black and white chart
for swatch shown

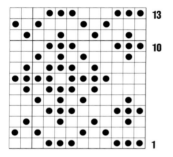

Repeat pattern chart

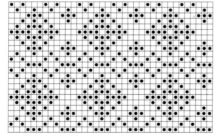

One row has been deleted to create this repeat.

Color chart for swatch shown

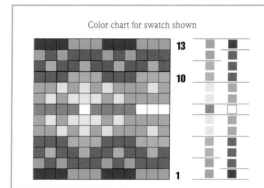

Color variation chart

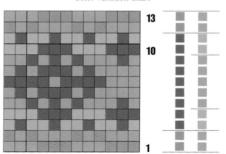

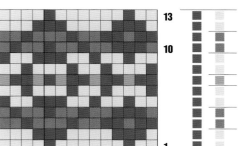

Color chart for swatch shown

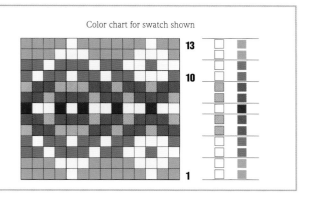

Black and white chart
for swatch shown

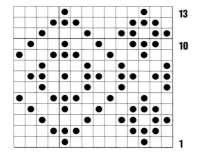

Color variation chart

Repeat pattern chart

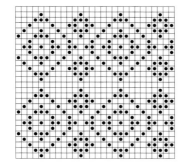

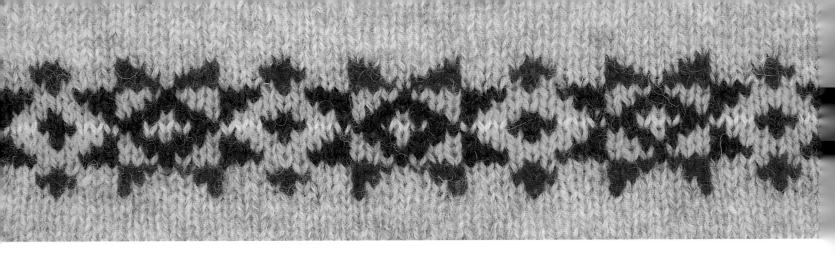

176 13 ROWS 16 STITCHES

Black and white chart for swatch shown

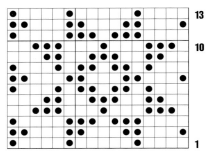

Color chart for swatch shown

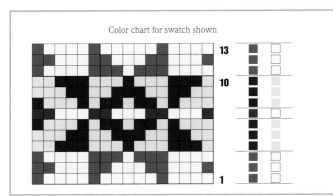

Repeat pattern chart

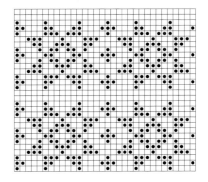

Color variation chart

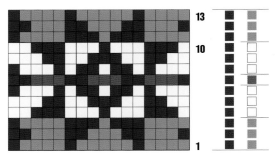

166

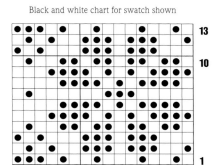

Color chart for swatch shown

13

10

1

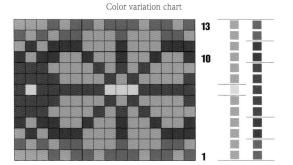

Color variation chart

13

10

1

Black and white chart for swatch shown

13

10

1

Repeat pattern chart

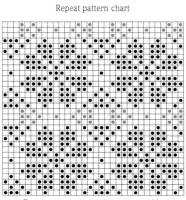

*Extra pattern stitches have been added
to create this repeat.*

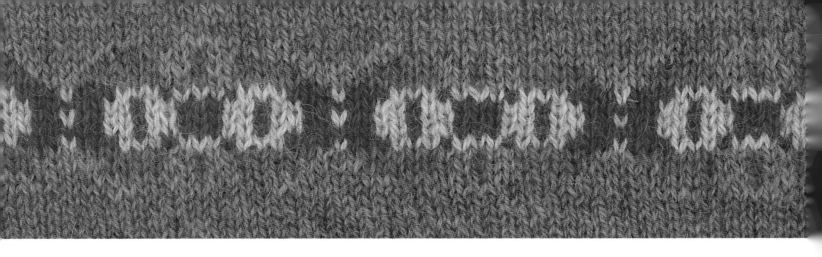

178 13 ROWS 18 STITCHES

Black and white chart for swatch shown

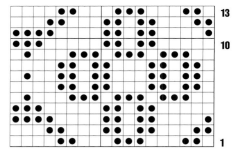

Repeat pattern chart

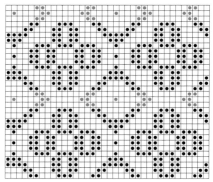

*Extra pattern stitches have been added
to create this repeat.*

Color chart for swatch shown

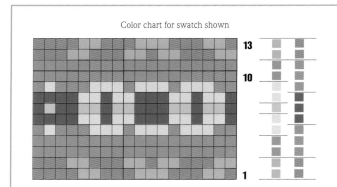

Color variation chart

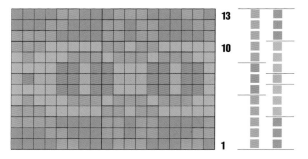

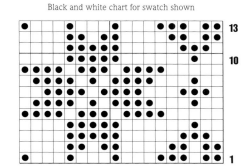

Color chart for swatch shown

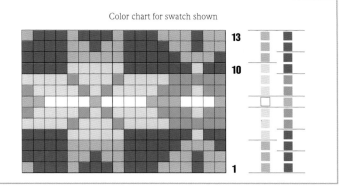

Color variation chart

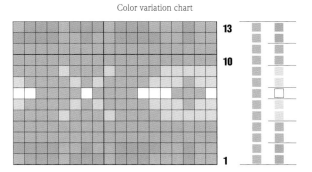

Black and white chart for swatch shown

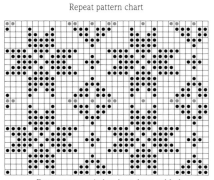

Repeat pattern chart

*Extra pattern stitches have been added
to create this repeat.*

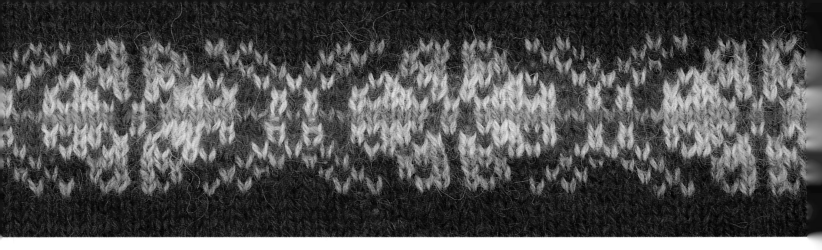

180 | **13** ROWS **20** STITCHES

Black and white chart for swatch shown

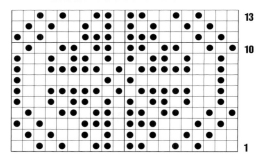

13

10

1

Repeat pattern chart

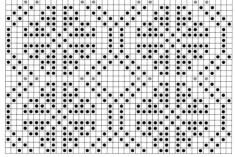

Extra pattern stitches have been added to create this repeat.

Color chart for swatch shown

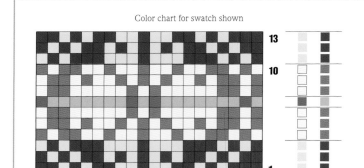

13

10

1

Color variation chart

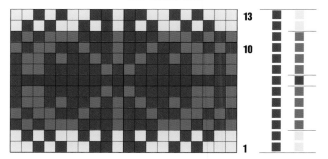

13

10

1

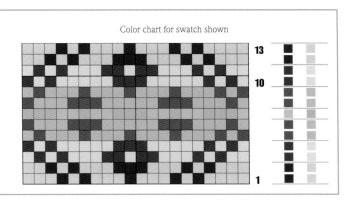

Color chart for swatch shown

Black and white chart for swatch shown

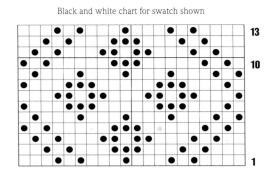

Color variation chart

Repeat pattern chart

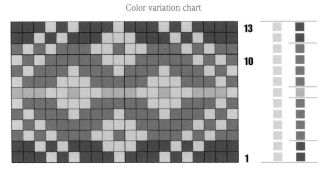

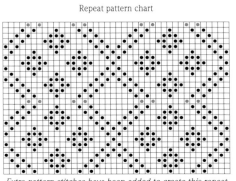

Extra pattern stitches have been added to create this repeat.

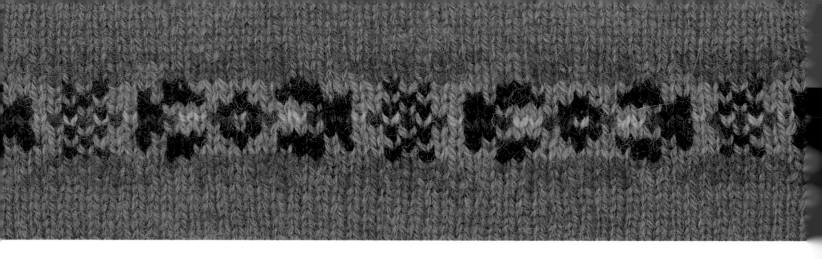

182 13 ROWS 22 STITCHES

Black and white chart for swatch shown

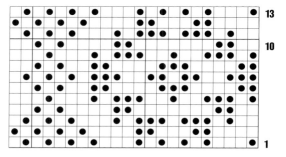

Repeat pattern chart

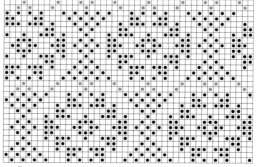

Extra pattern stitches have been added to create this repeat.

Color chart for swatch shown

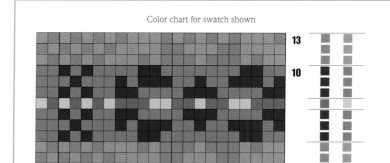

Color variation chart

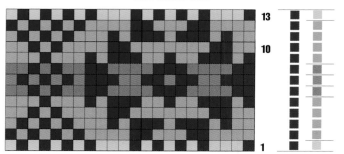

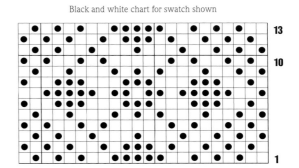

Color chart for swatch shown

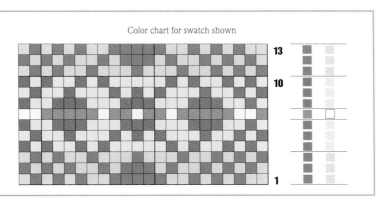

13

10

1

Black and white chart for swatch shown

13

10

1

Color variation chart

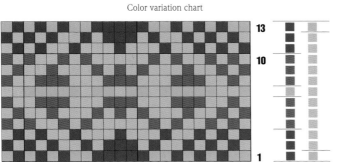

13

10

1

Repeat pattern chart

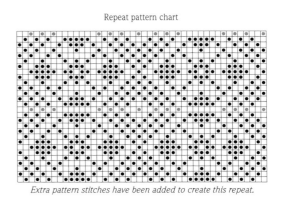

Extra pattern stitches have been added to create this repeat.

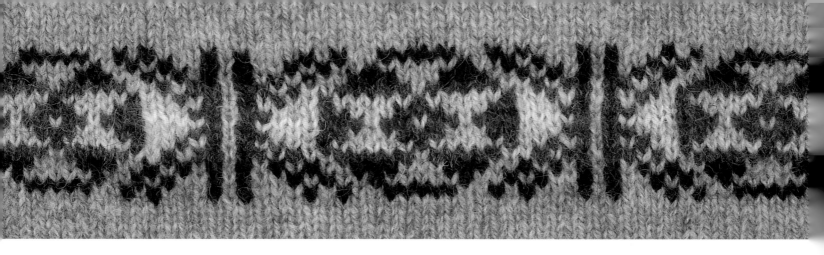

184 13 ROWS 24 STITCHES

Black and white chart for swatch shown

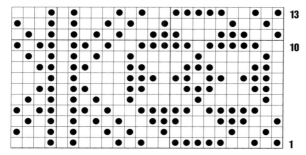

Repeat pattern chart

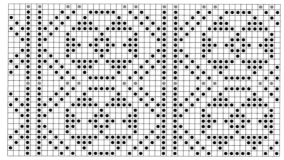

Extra pattern stitches have been added to create this repeat.

Color chart for swatch shown

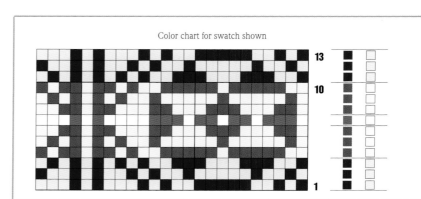

Color variation chart

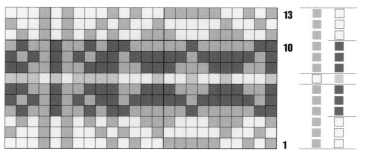

174

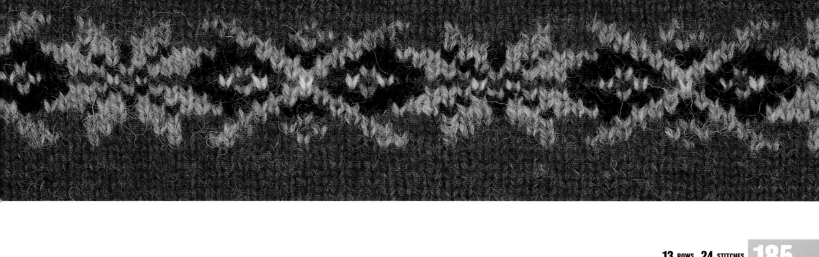

Color chart for swatch shown

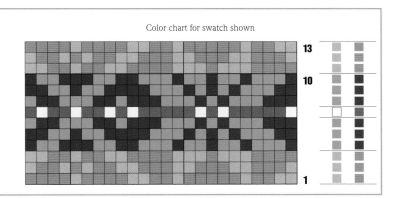

Black and white chart for swatch shown

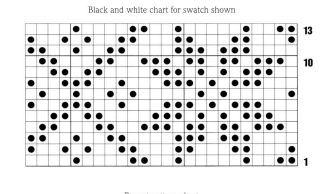

Color variation chart

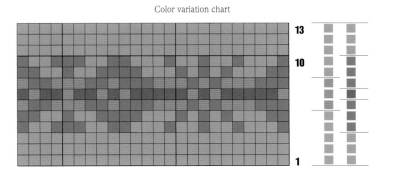

Repeat pattern chart

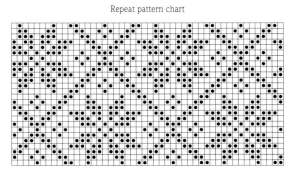

186 **15** ROWS **16** STITCHES

Black and white chart for swatch shown

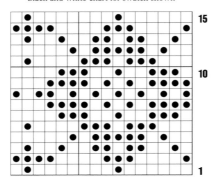

Color chart for swatch shown

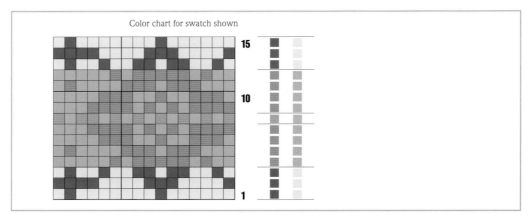

Color variation chart

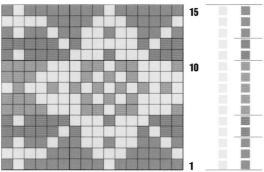

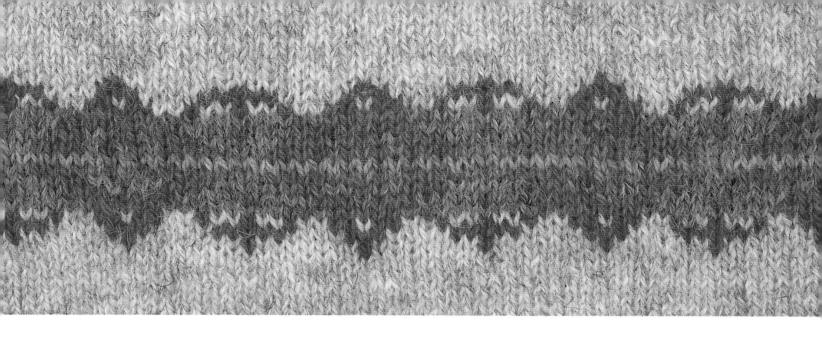

Repeat pattern chart

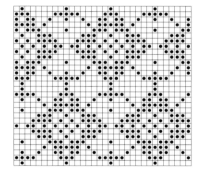

Mix and Match

Pairing Motif 186, which has a 16 stitch repeat, with Motif 52, which has a stitch repeat of 4, means that garments can be made in any multiple of 16 (see page 39). The background color of Motif 186 is the same as the first three rows of the background in Motif 52. Flipping the motif horizontally and placing the same backgrounds together sets off Motif 186, giving it a zigzag edge.

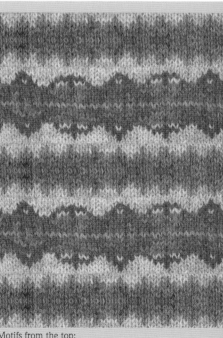

Motifs from the top:
52 52 186 52 52 186 52 52

187 **15** ROWS **18** STITCHES

Black and white chart for swatch shown

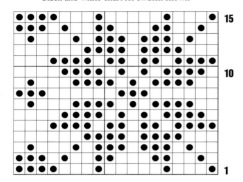

Color chart for swatch shown

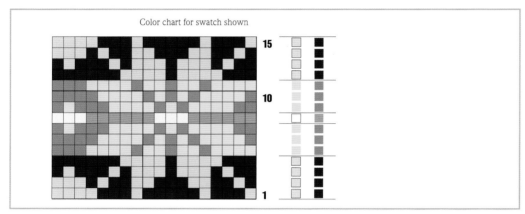

Color variation chart

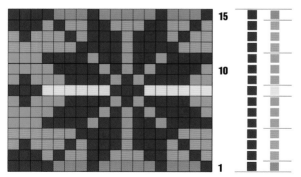

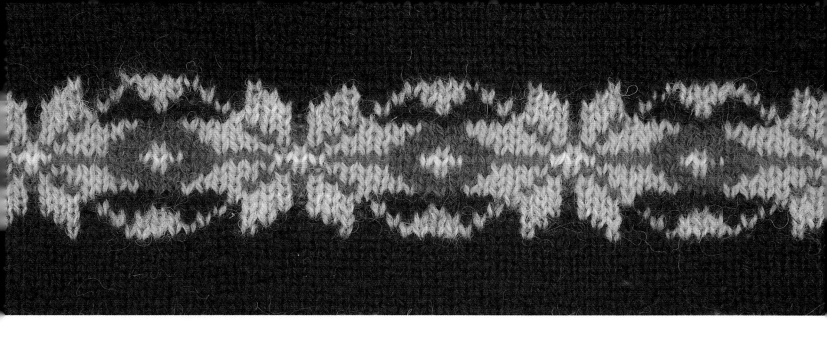

Repeat pattern chart

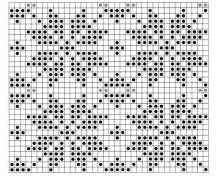

Extra pattern stitches have been added to create this repeat.

Mix and Match

The backgrounds of Motif 187 and Motif 133 are lightened by interspersing them with Motif 132, which has a light seeding against a pale blue background and an accent of navy. It is possible to use up different colors or dyelots of dark blue, reserving each for a different motif.

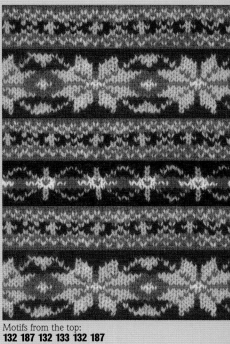

Motifs from the top:
132 187 132 133 132 187

179

188 **15** ROWS **20** STITCHES

Black and white chart for swatch shown

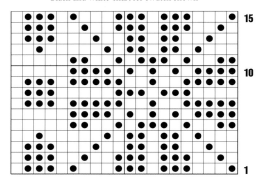

Color chart for swatch shown

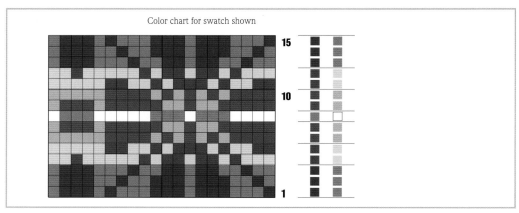

Color variation chart

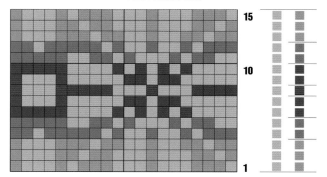

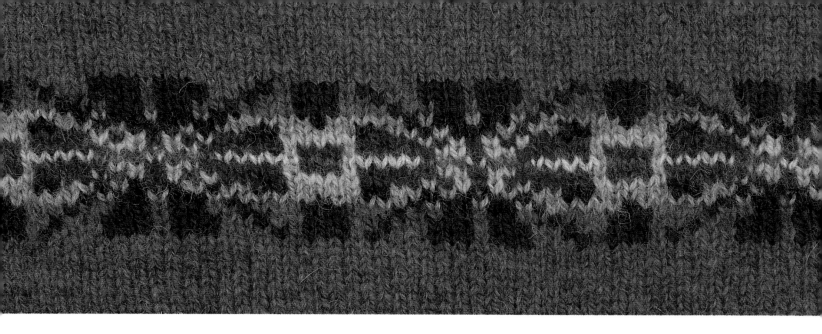

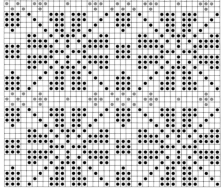

Repeat pattern chart

*Extra pattern stitches have been added
to create this repeat.*

Mix and Match

Motif 188, which has a stich repeat of 20, and Motif 134, which has a stitch repeat of 10, will always match up. Motif 63 has a stitch repeat of 9; however, since it is only 4 rows high, it does not interfere with the harmony of the knitting, instead lending a bold accent to the piece.

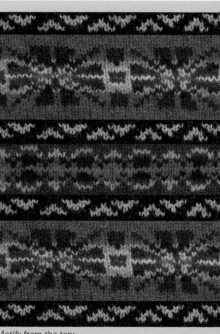

Motifs from the top:
63 188 63 134 63 188 63

189 **15** ROWS **22** STITCHES

Black and white chart for swatch shown

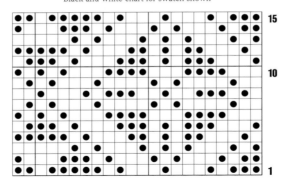

Color chart for swatch shown

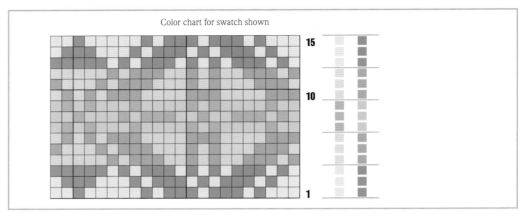

Color variation chart

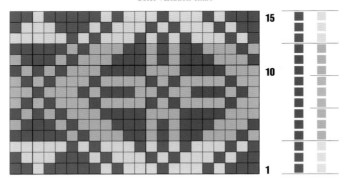

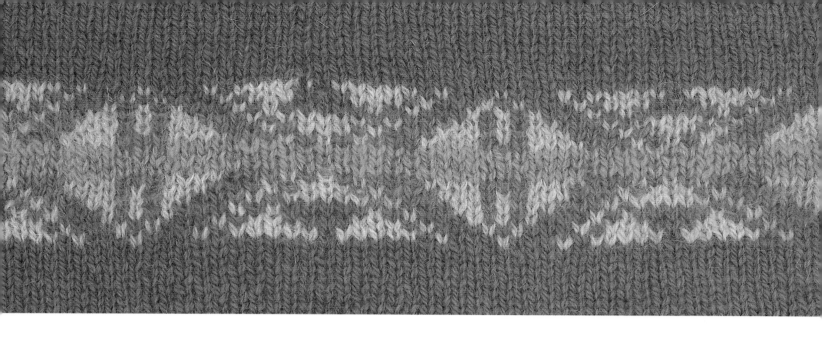

Repeat pattern chart

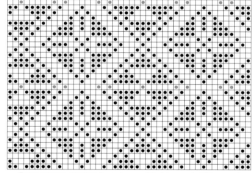

Extra pattern stitches have been added to create this repeat.

Mix and Match

Stitch repeats of 22 (Motif 189), 8 (Motif 40) and 6 (Motif 129) are represented here. Though seemingly mismatched, the fluidity of Motif 40, and the solid regularity of Motif 129 make this sequence work, never causing the eye to see an imbalance.

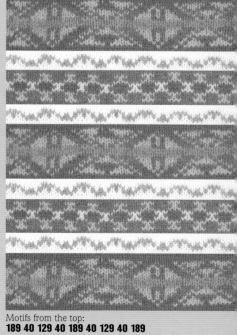

Motifs from the top:
189 40 129 40 189 40 129 40 189

190 15 ROWS 24 STITCHES

Black and white chart for swatch shown

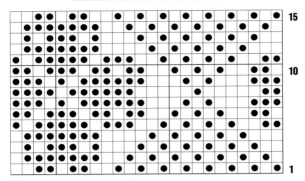

Color chart for swatch shown

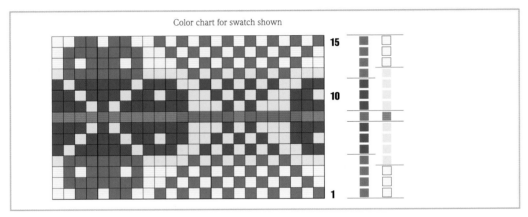

Color variation chart

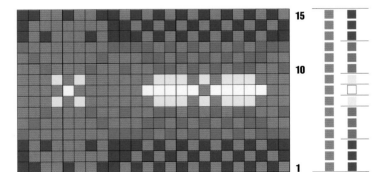

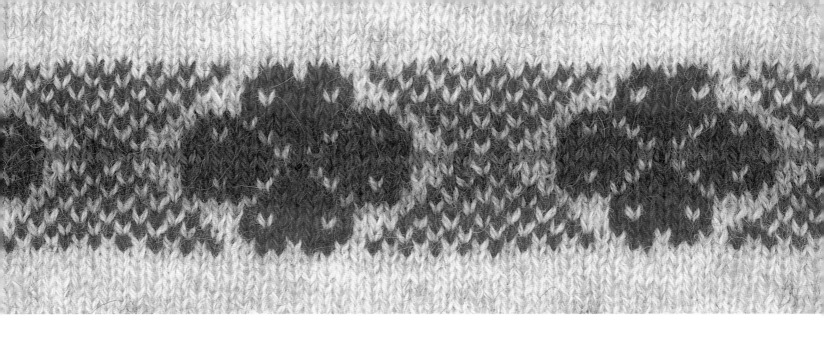

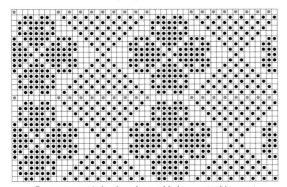

Repeat pattern chart

Extra pattern stitches have been added to create this repeat.

Mix and Match

The serpentine shapes in Motif 65 are a lovely counterpoint to the heart-shaped "petals" of Motif 190, while the tiny OXOs of Motif 67 bring a rhythmic continuity to the design; the red pulls all the motifs together.

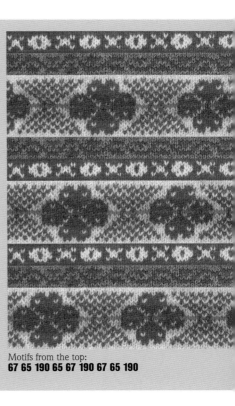

Motifs from the top:
67 65 190 65 67 190 67 65 190

185

191 15 ROWS 26 STITCHES

Black and white chart for swatch shown

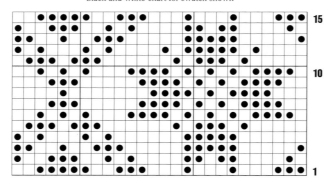

Color chart for swatch shown

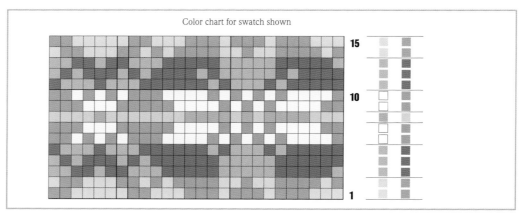

Color variation chart

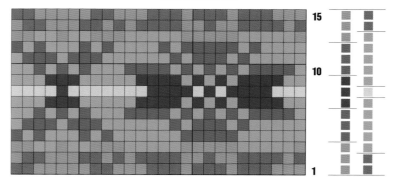

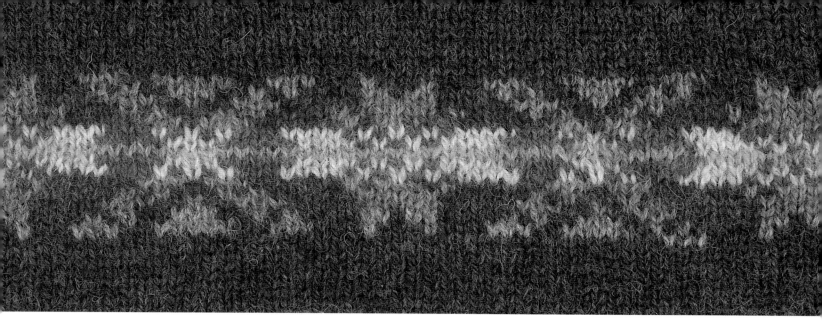

Repeat pattern chart

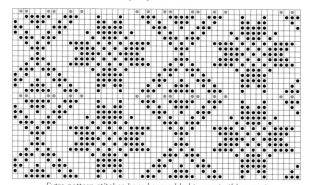

Extra pattern stitches have been added to create this repeat.

Mix and Match

In this arrangement the two motifs with pale colorways (Motifs 123 and 153) bring out the light pattern colors of Motif 191, which has a somewhat dark background. In turn, the snowflake design of Motif 191 softens the two very angular, geometric peeries.

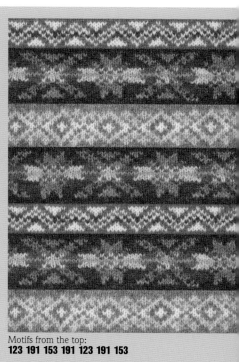

Motifs from the top:
123 191 153 191 123 191 153

192 **15** ROWS **27** STITCHES

Black and white chart for swatch shown

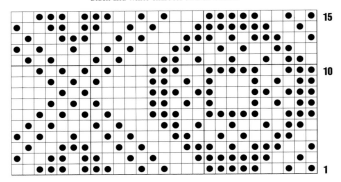

Color chart for swatch shown

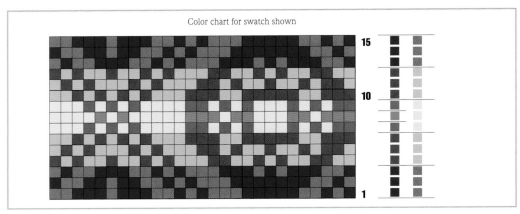

Color variation chart

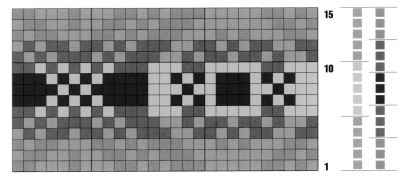

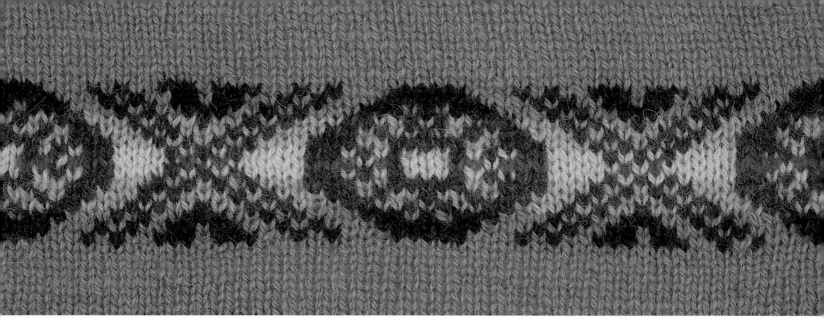

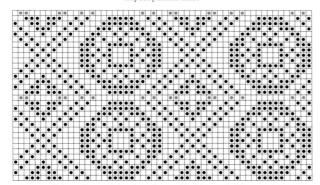

Repeat pattern chart

Extra pattern stitches have been added to create this repeat.

Mix and Match

Contrasting one vibrant peerie with another of a mild coloring really makes this set pop. Peerie patterns with stitch counts of 2 or 3 (like Motif 7 and Motif 10) are so small that slight inconsistencies in stitch count will not be noticed.

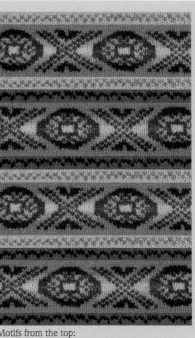

Motifs from the top:
7 192 7 10 192 10 7 192 7 10 192 10

189

193 15 ROWS 30 STITCHES

Black and white chart for swatch shown

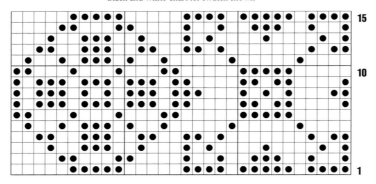

Color chart for swatch shown

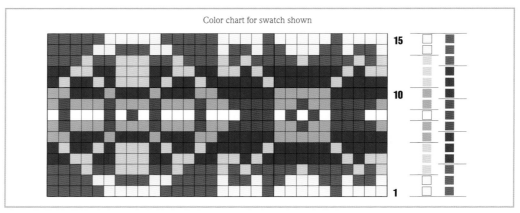

Color variation chart

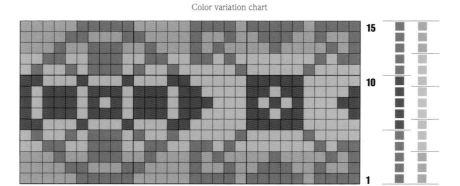

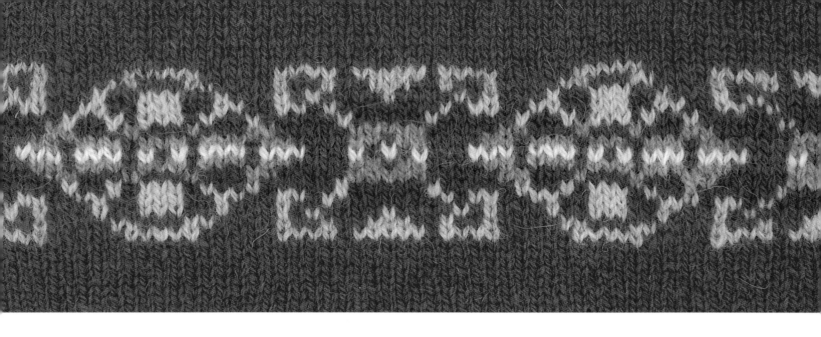

Repeat pattern chart

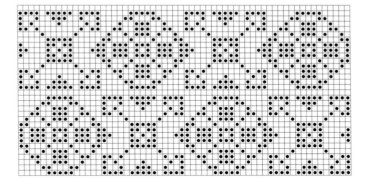

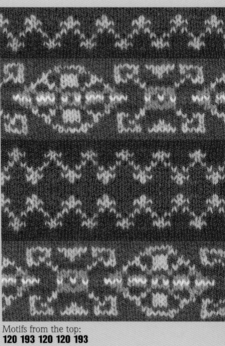

Mix and Match

Motif 193, which has a stitch repeat of 30, is matched with Motif 120, which has a stitch repeat of 6, so that all multiples of 30 will work as a total stitch count (see page 39). To make things interesting, Motif 120 has been flipped vertically to create a dramatic graphic effect.

Motifs from the top:
120 193 120 120 193

Black and white chart for swatch shown

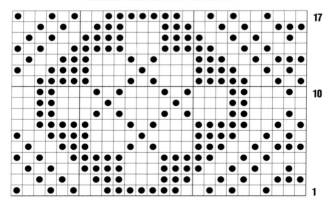

194 17 ROWS 26 STITCHES

Color chart for swatch shown

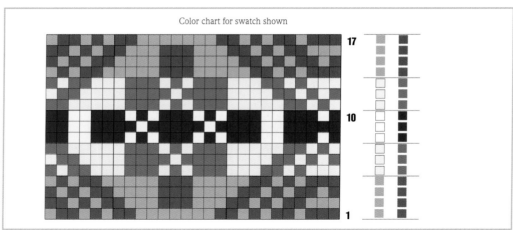

Color variation chart

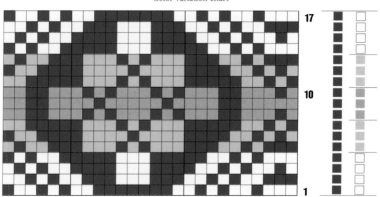

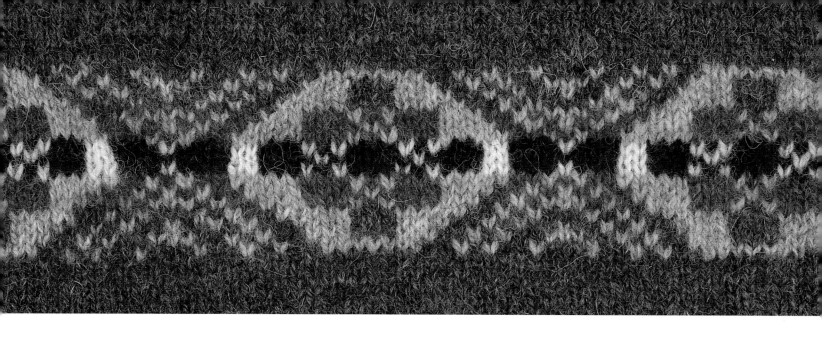

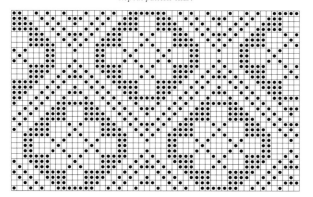

Repeat pattern chart

Mix and Match

Using natural sheep colors creates a beautiful and surprisingly sophisticated garment. Subtle shading lends depth, and clever varied use of sheep black punctuates the garment. When working with slightly mismatched stitch counts, it is important to center each motif down the center of the garment, or alter the motifs slightly for a perfect match (see page 38).

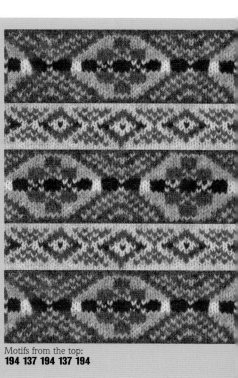

Motifs from the top:
194 137 194 137 194

195 17 ROWS 28 STITCHES

Black and white chart for swatch shown

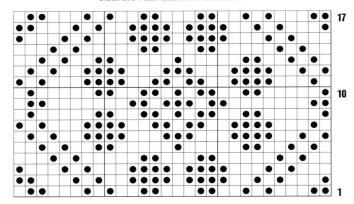

Color chart for swatch shown

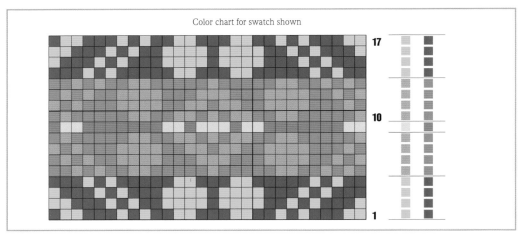

Color variation chart

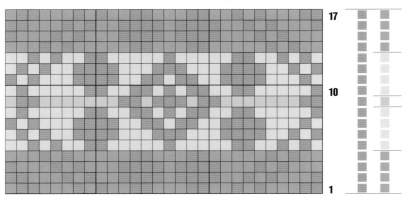

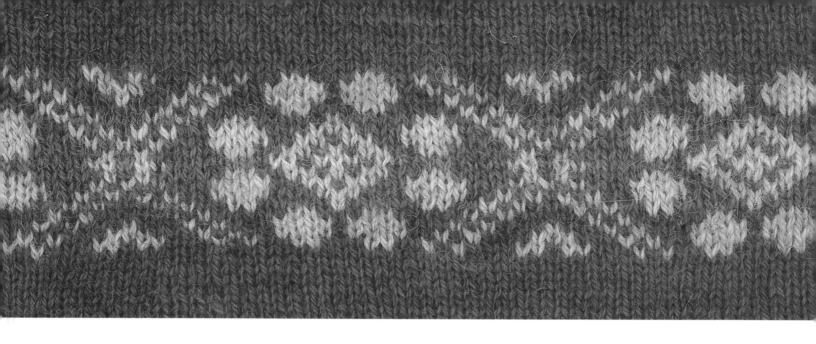

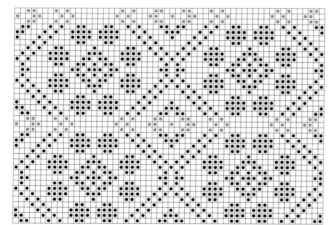

Repeat pattern chart

Extra pattern stitches have been added to create this repeat.

Mix and Match

Even the brightest colorways can look flat if grouped together; just pairing Motif 195 and Motif 50 would read this way. However, pulling in purple, with Motif 49, lends a bright, cheerful accent, while the coolness of turquoise in Motif 121 lends balance to the arrangement. Offsetting Motif 195 keeps the eye moving, creating a lively and less rigid structure.

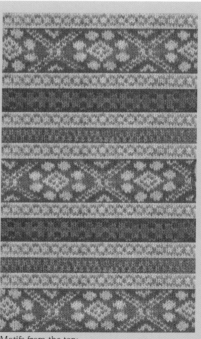

Motifs from the top:
50 195 50 121 50 49 50 195 50 121 50 49 50 195

196 **17** ROWS **30** STITCHES

Black and white chart for swatch shown

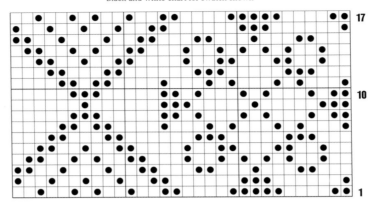

Color chart for swatch shown

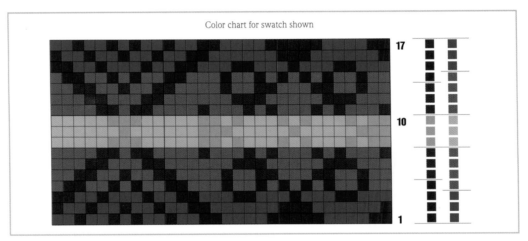

Color variation chart

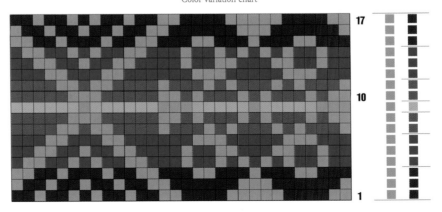

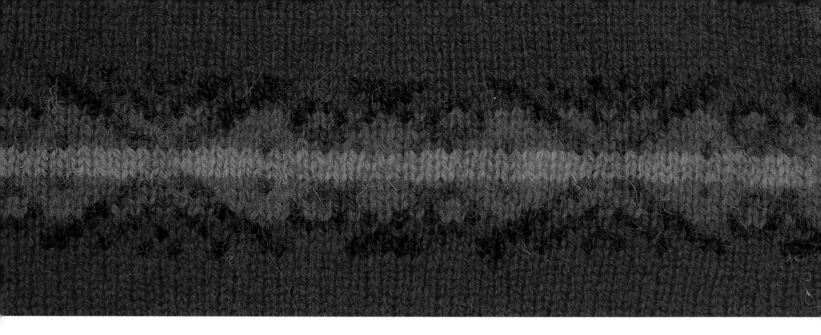

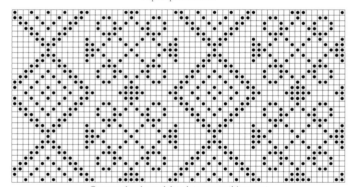

Repeat pattern chart

One row has been deleted to create this repeat.

Mix and Match

Motif 196 is offset by two peerie patterns, arranged in two different ways throughout the garment. Motif 55, with the red background, complements the reds, while Motif 99 anchors the blues. Careful positioning of these two peeries, instead of rigid repetition, keeps the piece interesting.

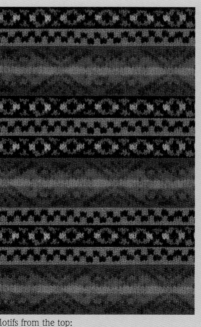

Motifs from the top:
99 55 196 99 55 99 196 55 99 55 196

197 **19** ROWS **24** STITCHES

Black and white chart for swatch shown

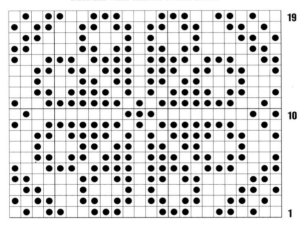

Color chart for swatch shown

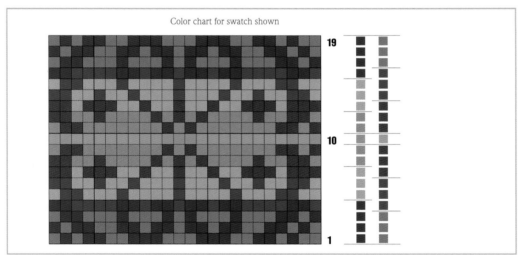

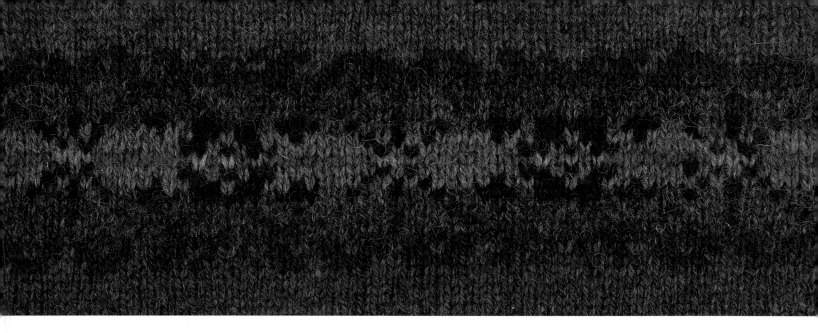

Color variation chart

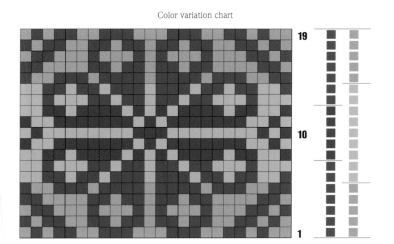

19

10

1

Repeat pattern chart

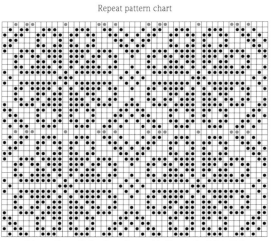

Extra pattern stitches have been added to create this repeat.

198 **19** ROWS **28** STITCHES

Black and white chart for swatch shown

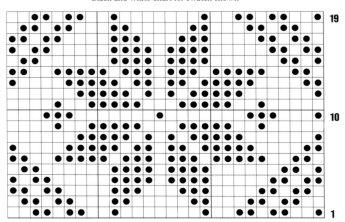

Color chart for swatch shown

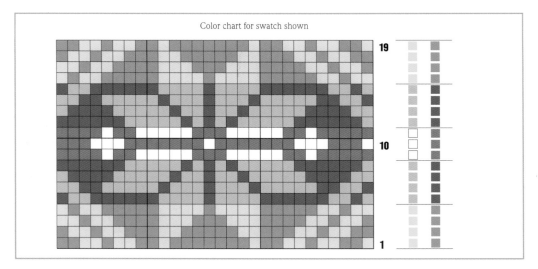

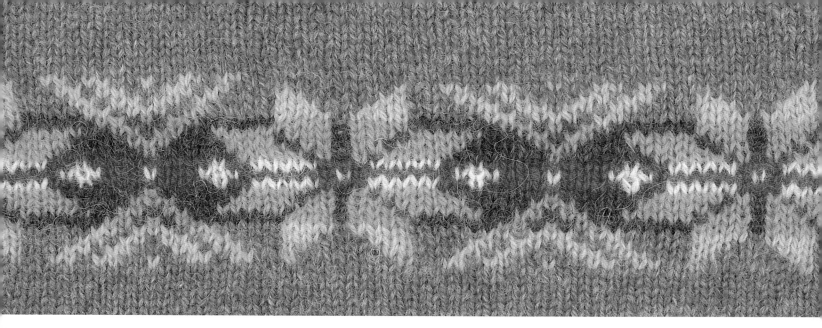

Color variation chart

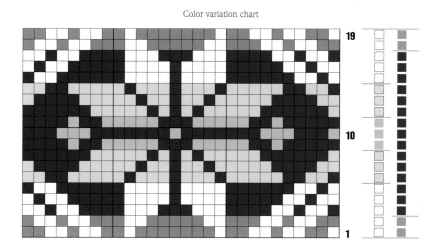

19

10

1

Repeat pattern chart

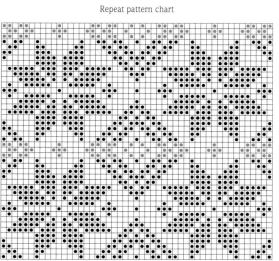

Extra pattern stitches have been added to create this repeat.

199 19 ROWS 30 STITCHES

Black and white chart for swatch shown

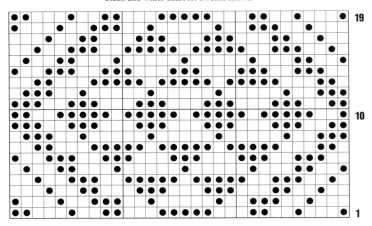

19

10

1

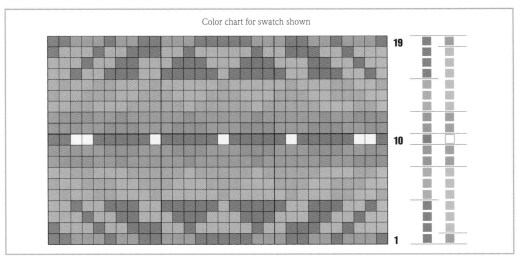

Color chart for swatch shown

19

10

1

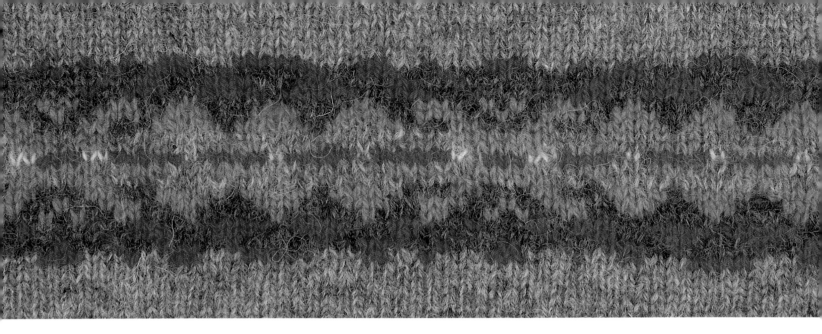

Color variation chart

19

10

1

Repeat pattern chart

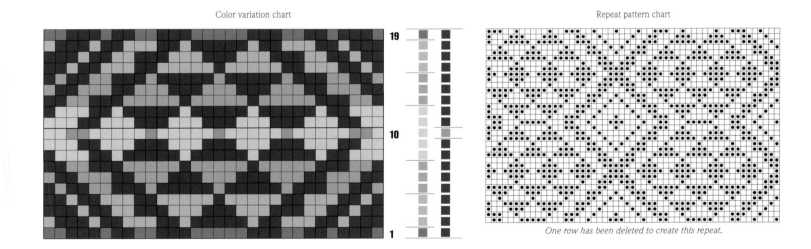

One row has been deleted to create this repeat.

200 **19** ROWS **24** STITCHES

Black and white chart for swatch shown

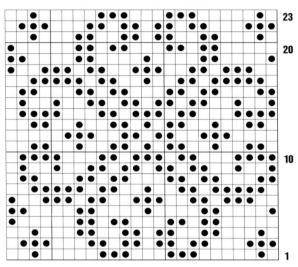

Color chart for swatch shown

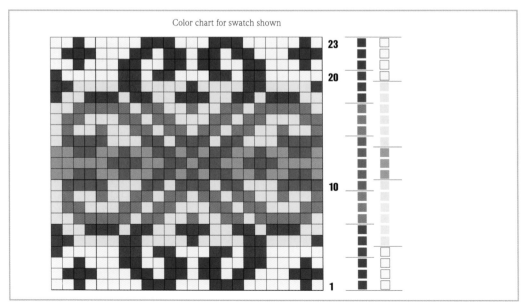

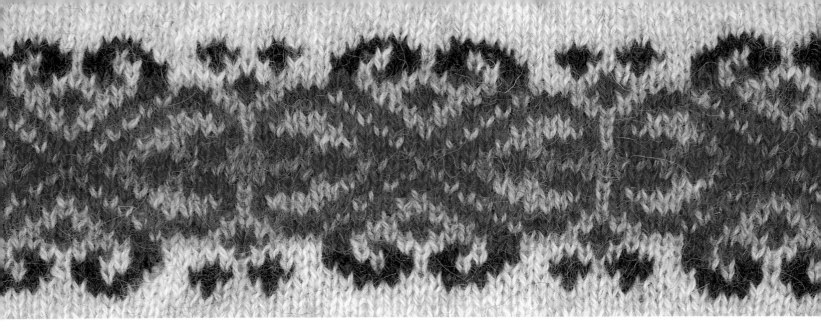

Color variation chart

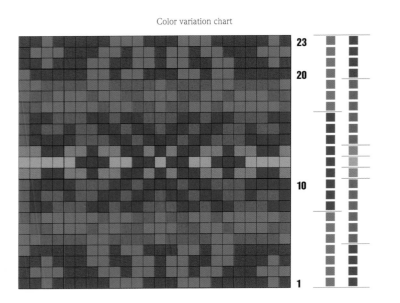

Repeat pattern chart

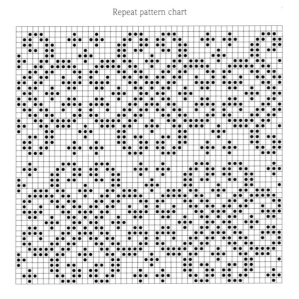

23

20

10

1

INDEX

RESOURCES

Allen, John. *Fabulous Fair Isle*. New York: St Martin's Press, 1991.

Don, Sarah. *Fair Isle Knitting*. New York: Dover Publications, 2007.

Feitelson, Ann. *The Art of Fair Isle Knitting*. Loveland, Colorado: Interweave Press, 2009.

Lovick, Elizabeth. *Knitting Fair Isle*. www.northernlace.co.uk

Macgregor, Mary. *Fair Isle Knitting Patterns*. Lerwick, Shetland: Shetland Times Publishing, 2009.

McGregor, Sheila. *The Complete Book of Traditional Fair Isle Knitting*. New York: Scribners, 1986.

Noble, Carol Rasmussen. *Knitting Fair Isle Mittens and Gloves*. New York: Lark Books, 2002.

Pearson, Michael. *Traditional Knitting*. New York: Dover Publications, 2011.

Radcliff, Margaret. *The Essential Guide to Color Knitting Techniques*. North Adams, Massachusetts: Storey Publishing, 2008.

Rowe, Mary. *Knitted Tams*. Loveland, Colorado: Interweave Press, 1989.

Rutt, Richard. *A History of Hand Knitting*. Loveland, Colorado: Interweave Press, 2003.

Smith, Mary and Chris Bunyan. *A Shetland Knitter's Notebook*. Lerwick, Shetland: Shetland Times Publishing, 1991.

Smith, Mary and Liddle, Maggie. *A Shetland Pattern Book*. Lerwick, Shetland: Shetland Times Publishing, 1991.

Starmore, Alice. *Alice Starmore's Book of Fair Isle Knitting*. New York: Dover Publications, 2009.

Sundbø, Annemore. *Everyday Knitting: Treasures from a Ragpile*. Bygland, Norway: Torridal Tweed, 2001.

CREDITS

I'd like to thank my Mom and Dad, my whole family, and my wonderful pack of girls: Barbie, Tina, Jane, Emily, Liz, Sian, Jeni, Astrig, Beth, who had the vision, and Anne, who thought of me. Special thanks to Dr. Carol A. Christiansen of the Shetland Museum, who generously took time out of her busy schedule to take me to the "stores" for a special viewing of antique scarves. Finally, many thanks to Gudrun Johnston and her wonderful family, who invited me to Shetland, showed me the islands, and opened their hearts and home. Thank you.

Quarto would like to thank the following for supplying yarn for the motifs featured:

Jamieson's, www.jamiesonsofshetland.co.uk: 52–55, 60–61, 72–75, 84–87, 94–95, 100–101, 104–105, 112–114, 122–123, 131, 133–134, 137, 141, 145–146, 148, 152, 154, 157–158, 162, 164, 166, 172, 175, 178–179, 188–189, 196–197, 200–203

Jamison & Smith, www.shetlandwoolbrokers.co.uk: 56–57, 62–65, 76–77, 80–83, 96–97, 102–103, 106–107, 115, 117–118, 124, 128, 132, 135–137, 140, 143, 150, 155, 159, 161, 165, 167, 171, 174, 180–181, 186–187, 192–193, 198–199

Harrisville, www.harrisville.com: 66–69, 90–93, 108–110, 119–120, 126, 129, 138, 144, 149, 153, 163, 169, 173, 182–183, 190–191

Elemental Affects, www.elementalaffects.com: 58–59, 70–71, 78–79, 88–89, 98–99, 111, 116, 121, 125, 130, 139, 142, 147, 151, 156, 160, 168, 170, 176–177, 184–185, 194–195, 204–205

Quarto would also like to thank the following for supplying images for inclusion in this book:

Shetland Museum and Archives, www.shetland-museum.org.uk: 8bl, 10t, 12tr, 30bl, 35

Mary Jane Mucklestone: 39

All other photographs and illustrations are the copyright of Quarto Publishing plc. While every effort has been made to credit contributors, Quarto would like to apologize should there have been any omissions or errors—and would be pleased to make the appropriate correction for future editions of the book.

Explore more Fair Isle-inspired motifs and patterns with these classic knitting resources from INTERWEAVE

The Art of Fair Isle Knitting
History, Technique, Color & Patterns

Ann Feitelson

ISBN 978-1-59668-138-5
$24.95

Northern Knits
Designs Inspired by the Knitting Traditions of Scandinavia, Iceland, and the Shetland Isles

Lucinda Guy

ISBN 978-1-59668-171-2
$24.95

Color Style
Innovative to Traditional, 17 Inspired Designs to Knit

Ann Budd, Pam Allen

ISBN 978-1-59668-062-3
$24.95

INTERWEAVE KNITS

From cover to cover, *Interweave Knits* magazine presents great projects for the beginner to the advanced knitter. Every issue is packed full of captivating smart designs, step-by-step instructions, easy-to-understand illustrations, plus well-written, lively articles sure to inspire.
Interweaveknits.com

knitting daily shop
shop.knittingdaily.com